well taught in domestic habits &
economy. We returned on board at 8.
Monday 26. We spent the morning
examining some Indian curiosities,
Mr. D had collected for us. I wished
if possible to obtain some of the Medecine
Mens implements & tools. & now as
far as I can, will explain to you,
this Medecine work.—
It is the great imposture among the
Indians: having its force, in their
superstitious dread of Evil Spirits:
It only the Medecine Man, can bind
& cast out. Physics, he has none.
His operations are, a course of

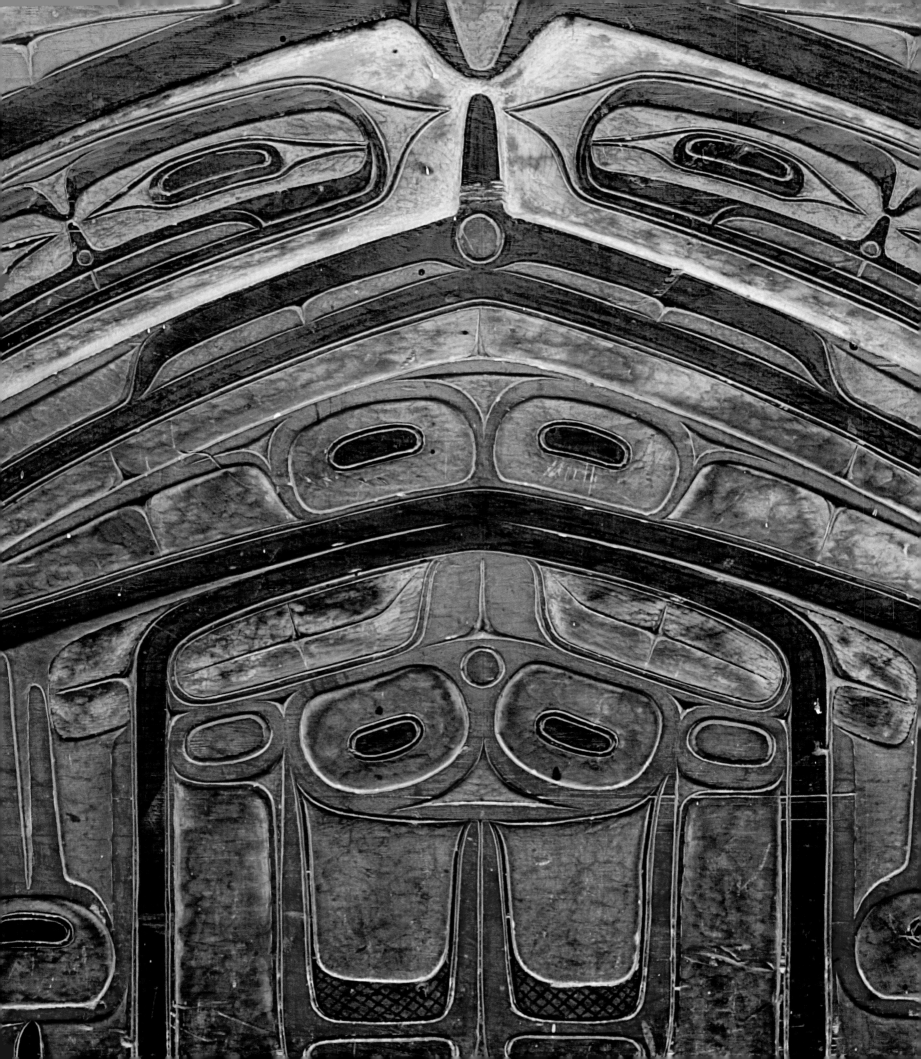

Tsimshian Treasures:
The Remarkable Journey of the
Dundas Collection

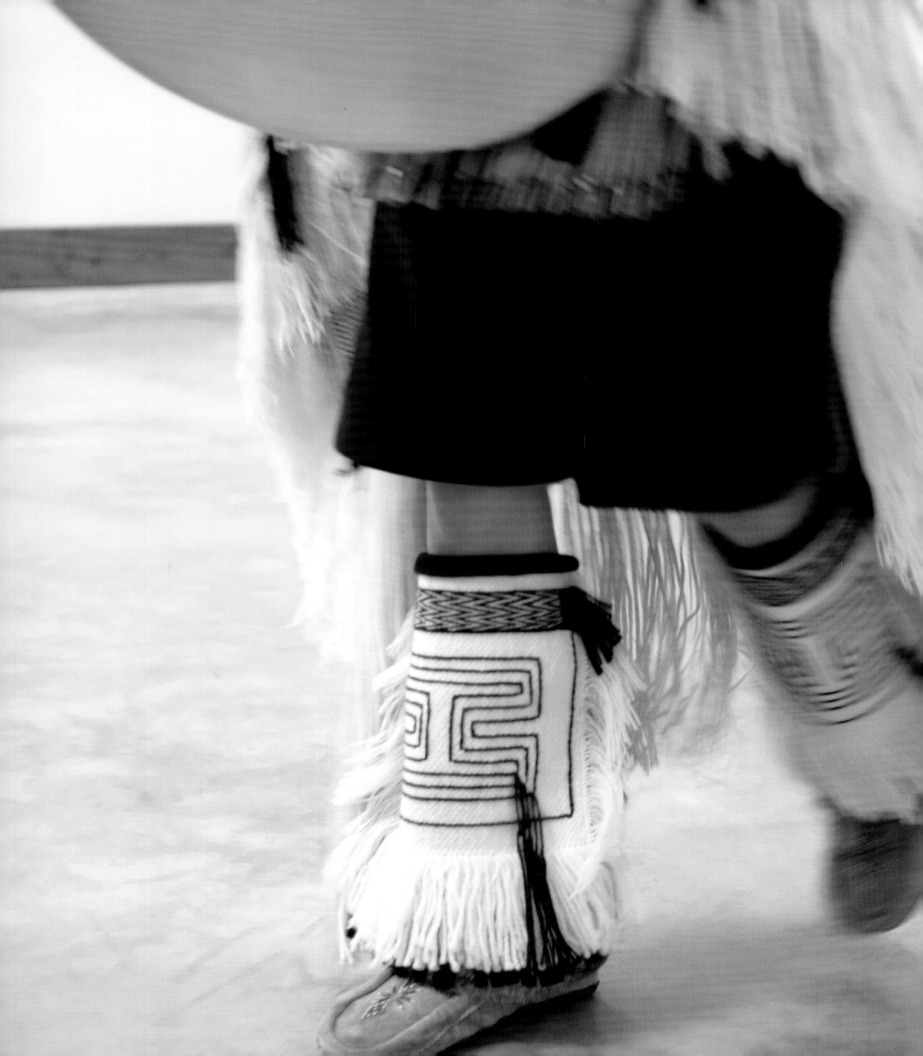

Tsimshian Treasures:
The Remarkable Journey of the Dundas Collection

Donald Ellis, Editor

Steven Clay Brown
Bill Holm
Alan L. Hoover
Sarah Milroy
William White

Donald Ellis Gallery
Dundas, Ontario / New York

Douglas & McIntyre
Vancouver / Toronto

University of Washington Press
Seattle

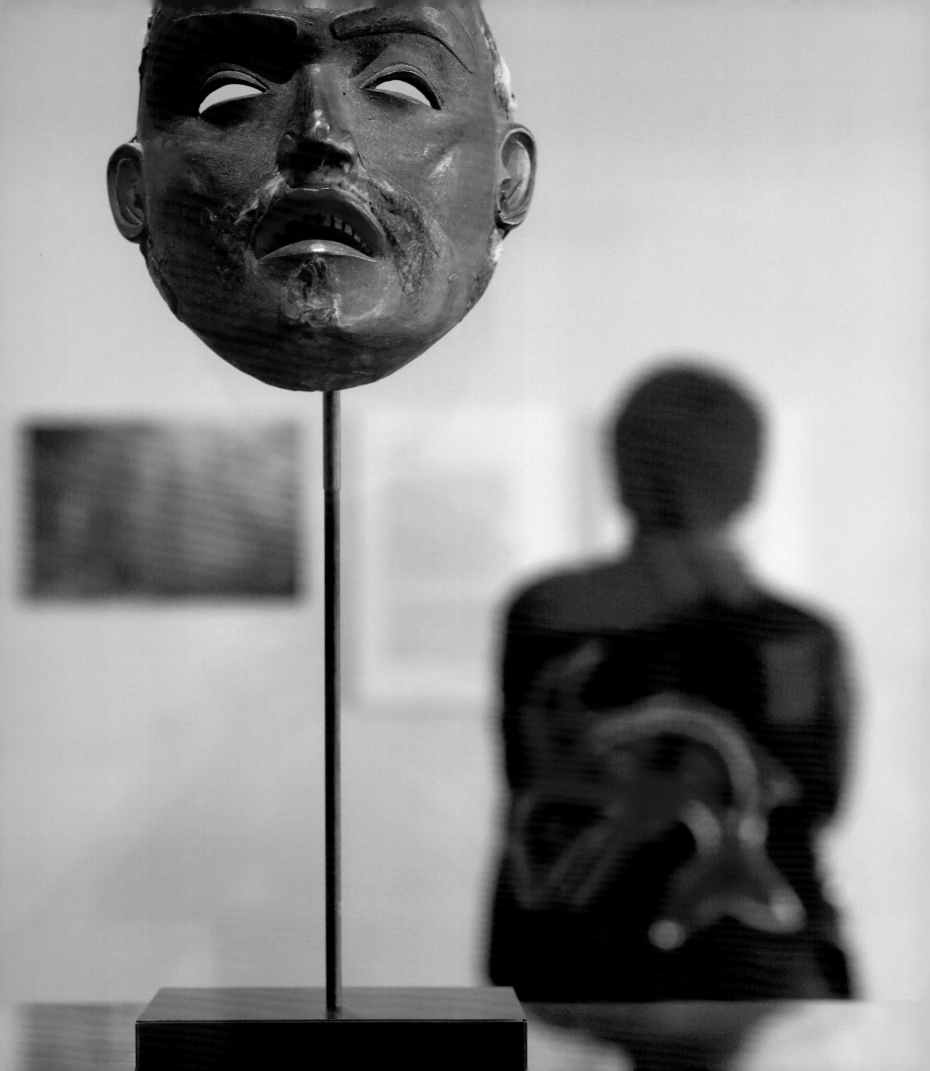

In memory of Kenneth Roy Thomson

07 08 09 10 11 5 4 3 2 1

Donald Ellis Gallery Ltd.
R.R. #3
Dundas, Ontario
Canada L9H 5E3
www.donaldellisgallery.com

Douglas & McIntyre Ltd.
2323 Quebec Street, Suite 201
Vancouver, British Columbia
Canada V5T 4S7
www.douglas-mcintyre.com

University of Washington Press
P.O. Box 50096
Seattle, WA 98145-5096
U.S.A.
www.washington.edu/uwpress

Library and Archives Canada Cataloguing in Publication
Tsimshian treasures: the remarkable journey of the Dundas Collection / Donald Ellis, editor; Steven Clay Brown... [et al.]

Co-published by: Donald Ellis Gallery Ltd.
ISBN 978-1-55365-332-5

1. Tsimshian art—Exhibitions. 2. Tsimshian Indians—Antiquities—Exhibitions.
3. Dundas Collection of Northwest Coast American Indian Art—Exhibitions.
I. Ellis, Donald, 1957- II. Brown, Steven C. III. Donald Ellis Gallery

E99.T8 T84 2007 704.03'97412807111 C2007-902758-X

Library of Congress Cataloging-in-Publication
Tsimshian treasures: the remarkable journey of the Dundas Collection / Donald Ellis, editor; Steven Clay Brown... [et al.]

p. cm.
Includes bibliographical references.
ISBN-13: 978-0-295-98738-5 (hardback: alk. paper)
ISBN-10: 0-295-98738-3 (hardback: alk. paper)

1. Dundas, R. J.—Ethnological collections. 2. Dundas, R. J.—Art collections.
3. Tsimshian art—Exhibitions. I. Title.
E99.T8T76 2007 2007020369

Jacket and book design by Barb Woolley, Hambly & Woolley Inc.
Jacket photography by Shannon Mendes
Pre-press by Somerset Graphics Co. Ltd.
Printed and bound in Canada by Friesens
Printed on acid-free paper

We gratefully acknowledge the financial support of the Canada Council for the Arts, the British Columbia Arts Council, the Province of British Columbia through the Book Publishing Tax Credit, and the Government of Canada through the Book Publishing Industry Development Program (BPIDP) for our publishing activities.

"We truly believe the spirits of our ancestors are held in these objects."

– William White

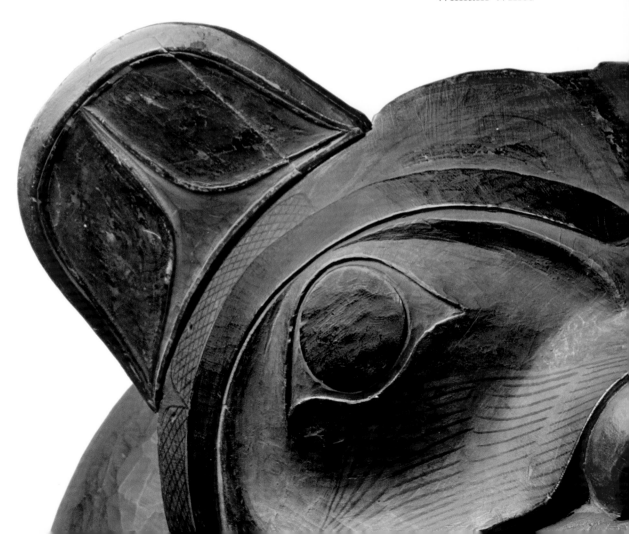

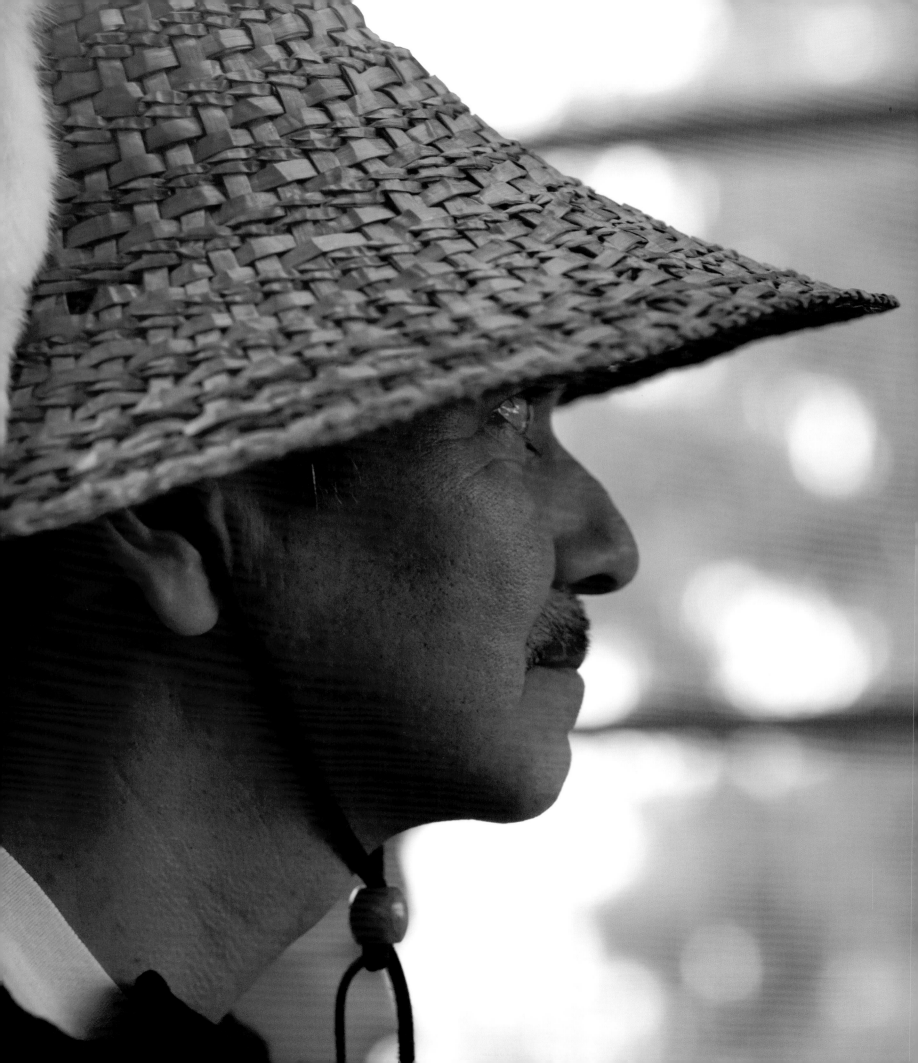

Contents

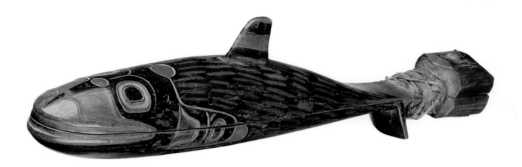

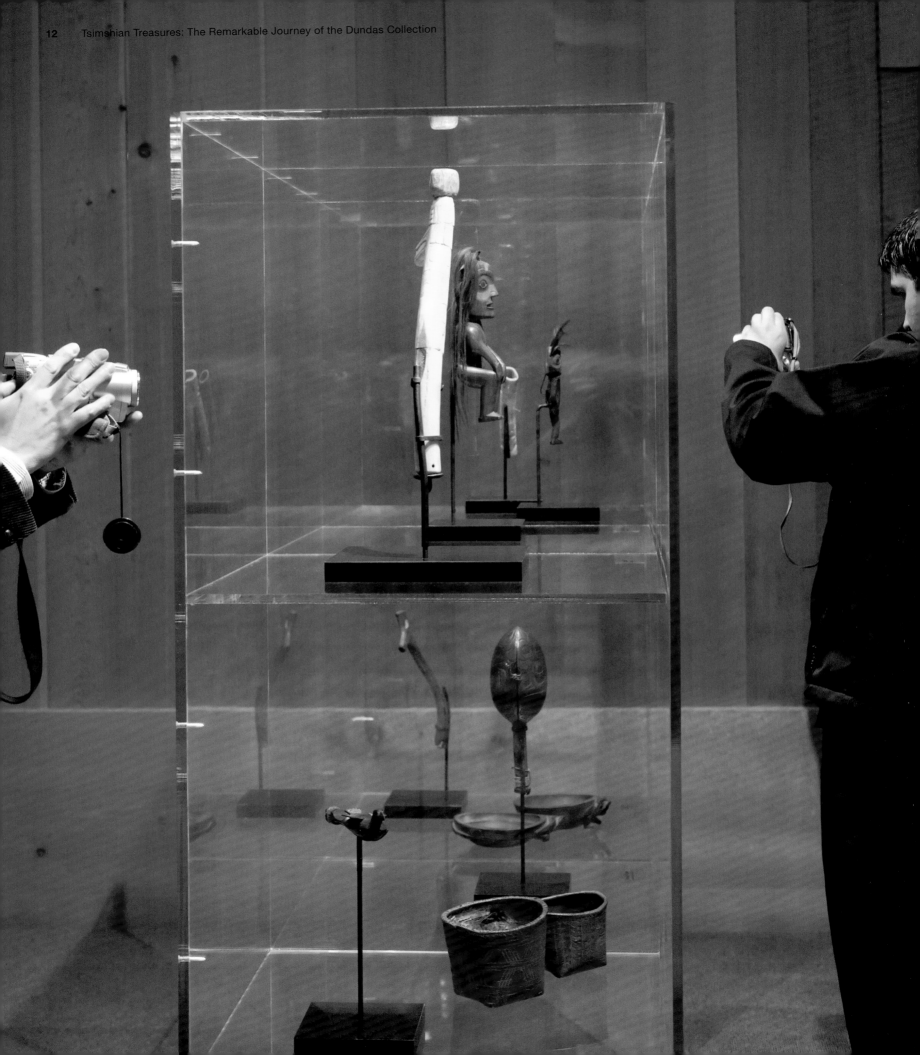

Lost, Then Found:
A Canadian Cultural Legacy
by Donald Ellis

Preface

As a young art dealer in the early 1980s, I had heard rumours of an eccentric gentleman in England who possessed an extraordinary collection of historic artworks from the Northwest Coast of Canada. Reportedly the collection had passed down through several generations of his family, and had an important documented history leading back to its acquisition in Canada in the 19th century.

Following leads however tenuous is the foundation of an art dealer's work. Understandably intrigued, I immediately planned a trip to England. I managed to arrange a meeting with the owner, Simon Carey, at his home in Hampstead, north of London, not far from the Heath. A narrow walkway behind a large Victorian home led to the small Carey cottage, and my first glimpse of the collection, haphazardly displayed among piles of books and newspapers. Mr. Carey served tea and cake and we chatted pleasantly, although I found it difficult to focus as my eyes flitted from object to object. As our talks progressed, Mr. Carey allowed me to handle many of the objects including the extraordinary human face mask illustrated on the cover of this book. It was the most beautiful work of art I had ever held. Mr. Carey also showed me the original journals of his great-grandfather, the Reverend Robert J. Dundas, who had travelled to the west coast of Canada in the middle of the 19th century. Although nothing transpired that day and no business was conducted, it was immediately apparent to me that this group of objects, with their rich history, belonged to Canada and all Canadians. They had to be returned.

Thus began an odyssey that would endure for the next two-and-a-half decades. I visited Mr. Carey on occasion and wrote letters periodically attempting to accommodate the Carey family's needs, and the needs and abilities of Canadian institutions. While I was certainly not the only dealer or auction house pursuing this prize, I felt that as a Canadian acting on behalf of Canadian interests I was in a strong position. On one occasion, in desperation, I attempted to use the fact that I lived in Dundas, Ontario, to my advantage. Of these overtures, all were uniformly rejected. Simon Carey was a difficult man, and although he professed a desire to return his family's heirlooms to Canada, he set ever-higher hurdles in the path toward that goal. One issue we both seemed to agree on was keeping the collection intact. So it was a great surprise to most involved when news surfaced of an auction to be held in New York in October 2006. The collection was to be dismantled.

In the months leading up to the sale, there was strong interest in the collection from two institutions in British Columbia. Negotiations toward a strategy of joint ownership ensued; however, it all depended on government funding. Negotiations continued until the final hour, and at 7:30 the evening before the sale, I was informed by a museum representative that only nominal funds would be made available, a sum in no way sufficient

to secure the Dundas Collection, or even a reasonable portion. Remarkably, 15 minutes later, I received a call from two members of the Thomson family who had read a newspaper article the day before, written by Sarah Milroy. *The Globe and Mail* journalist had lamented the lack of interest shown by the Canadian government in pursuing the collection. If the Dundas Collection were to return, clearly it would only be by means of private funding. Over that long night, we had endless discussions, developed a strategy, and slept little.

The next morning the salesroom was buzzing with anticipation. There had not been a public auction of Native American art of this magnitude in over 30 years. Our strategy was to bid aggressively from the outset and it worked. Ultimately the sale totaled $7 million U.S. – an auction record in this field. More importantly, Canadian individuals and museums succeeded in acquiring well over $6 million of this total. The vast majority, and certainly all the most important objects in the Dundas Collection, would be returning to Canada.

I am extremely grateful to the individuals who gave their time and financial support to facilitate the return of this important cultural legacy. Grant Hughes of the Royal BC Museum was instrumental and extraordinarily focused in organizing the museum exhibition, "Treasures of the Tsimshian from the Dundas Collection," in what is certainly record time. This book would not have been possible without the brilliant work of Barb Woolley of Hambly & Woolley Inc. in the conception, design and production of this publication. I would like to thank Bill Holm, Alan Hoover, Steven Brown, Sarah Milroy and William White for their thoughtful essays. The images of the objects in this book are a result of the tireless efforts of Frank Tancredi, with whom I have worked for many years. Shannon Mendes's remarkable series of photographs adds a dramatic human element and highlights the fact that while these objects are from the distant past, the Tsimshian remain a vibrant, living people. I would be remiss in not mentioning Mary Ann Bastien, my partner in life, business and all things. She worked relentlessly as fact checker, proofreader and editor on this publication and provided constant encouragement and support.

Lastly, I am profoundly grateful to Sherry Brydson and David Thomson. It was their deep passion and conviction that made possible the Dundas Collection's return. Through the efforts of these two extraordinary Canadians, the tremendous artistic achievements of the Tsimshian will be further recognized. I hope these events will reinforce how we can, collectively, compete on the world stage and play a major role in the return of significant Canadian cultural treasures.

Donald Ellis
Dundas, May 2007

An Introduction to
the Collection
by Bill Holm

Foreword

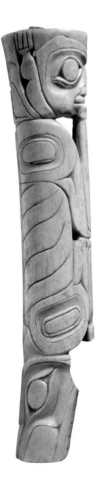

In the fall of 1979, a gentleman from London came to my office in the Burke Museum of Natural History and Culture in Seattle with some very interesting pictures to show me. My guest was Professor Simon Carey, the great-grandson of the Reverend Robert James Dundas. He brought colour slides of a group of objects that his great-grandfather had acquired on October 26, 1863, in the mission town of Metlakatla on the northern British Columbia coast, some 116 years earlier. Three years before our meeting, I had travelled through most of Europe and North America examining and photographing Northwest Coast material in over 100 museums and private collections, but I had never seen these objects! Some of the artworks in his slides were among the very finest, and they were all remarkable because they were acquired at a known place and time, unlike so many of the Northwest Coast objects found in museums and private collections around the world.

Although there are Northwest Coast collections with earlier acquisition dates, the great era of museum collecting was in the closing years of the 19th century. Those artifacts, numbering in the thousands, left the coast 30 years after Rev. Dundas acquired his treasures. Most of the objects from this region that survive today have little or no real documentation establishing their place of origin or when they were made. This collection gives us a remarkable measure, a time capsule of the arts of the Tsimshian in the early years of outsider contact. Because of this, the Dundas collection stands out as a unique and valuable source of information, eminently useful in establishing the characteristics of northern British Columbia Native art in the middle years of the 19th century.

The Northwest Coast was changing rapidly in the early 1860s, when three Britons of diverse backgrounds came together on the remote northern coast of British Columbia. All three of these men possessed shared ideas of good and bad, of Christianity and Victorian society versus their perspective of Native culture. One of the three was Rev. Robert Dundas, an Anglican minister who had come to Victoria in 1859, at age 27. He was a member of the Church Missionary Society, an evangelistic organization associated with the Church of England.

In 1862, a 24-year-old British naval officer, Lieutenant Edmund Hope Verney, came to Victoria. The son of a distinguished English landowner and politician, he had

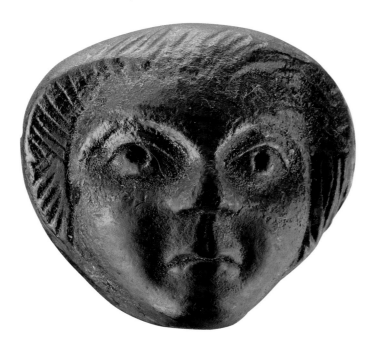

been in the Royal Navy since he was 13, and had served in the Crimean War and the Sepoy Rebellion in India. Verney was commander of the small gunboat HMS *Grappler*, powered by sail and steam. His naval duties left him time to participate in Victoria's cultured society. He came to know or meet all the local officials and celebrities, as well as many of the naval officers, marine surveyors and foreign officials whose names are now sprinkled over the charts of the British Columbia coast. Like Dundas, Verney was of upper-class upbringing. He was opinionated in regard to local politics and politicians, and challenged by the low character of many "frontier" residents and the social habits of the Aboriginal peoples. Paramount was his zealous belief that the Christian religion could bring them all to what he and Rev. Dundas considered to be British standards of civilization.

William Duncan was the third of the young Britons whose fortuitous contact led to the preservation of this group of early Northwest Coast objects. In 1857, when Duncan was 25 years old, he travelled to British Columbia as a lay missionary, trained and sent out by the Church Missionary Society. Duncan was not ordained as a minister, as was Rev. Dundas, but he made up for that with his untiring promotion of church doctrine. He believed that the Tsimshian people he worked with could be re-made into good and productive Christian members of the new British Columbia society. He began his work at the village close to the Hudson's Bay Company post of Fort Simpson, which was founded in 1833. In May of 1862, the same month that Edmund Verney arrived in Victoria, Duncan and his group of Tsimshian converts moved away from the HBC fort to the site of an old unoccupied village called Metlakatla. There they began to build a new town that, over time, fulfilled Duncan's vision of the change from traditional Native culture to a modern, albeit autocratic, society.

It was at this village, a year and a half after Duncan and his flock from Fort Simpson had begun anew at Metlakatla, that Lt. Verney and his minister friend, Rev. Dundas, arrived in the gunboat *Grappler*. The two men were much impressed with the progress Duncan had made with his First Nations converts, and they also admired the relics of Tsimshian culture that Duncan had acquired in his work to eradicate the old Native beliefs and customs. When they left Metlakatla to return to Victoria, both Dundas and Verney had with them significant collections of Native material. Dundas referred to

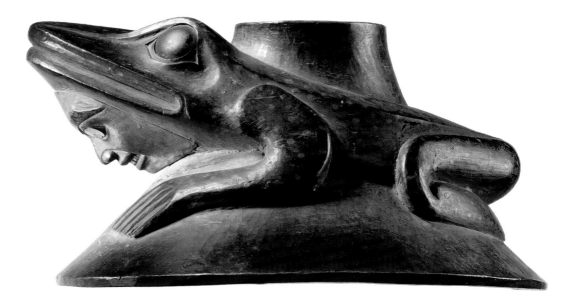

them as *iktas*, or "things," in the trade language of the time, known as Chinook jargon. Apparently he was familiar with that language as he used it correctly several times in his journal of the trip. Among these "things" were masterpieces of Tsimshian art, some of them relics of the ceremonial practices that William Duncan was working so diligently to abolish within his community. Others were workaday tools and utensils that are remarkable today primarily because their age and provenance are documented in the journals and letters of Dundas and Verney. Although we do not know precisely from whom Duncan acquired these objects, we do know that this material went from his hands to those of Dundas, who, when he completed his work in Victoria, B.C., shipped the objects back to his family home in England.

Some of Edmund Verney's collection eventually went to the British Museum, while other objects entered the antiques and "curiosity" market and were dispersed in various private holdings. Remarkably, Robert Dundas's Tsimshian collection survived intact in succeeding generations of his family in Great Britain for nearly a century and a quarter, until finally returning to Canada after many long and difficult trials.

The existence of this group of early Tsimshian objects has been a great discovery, not only for art historical interests but also for the Tsimshian First Nations from whom these cultural materials departed so many years ago. The welcome these objects received when they came back to their home region was an emotional one, even though it was only for a temporary exhibition. Their impact on modern Tsimshian culture will continue for many generations to come.

Bill Holm
Seattle, May 2007

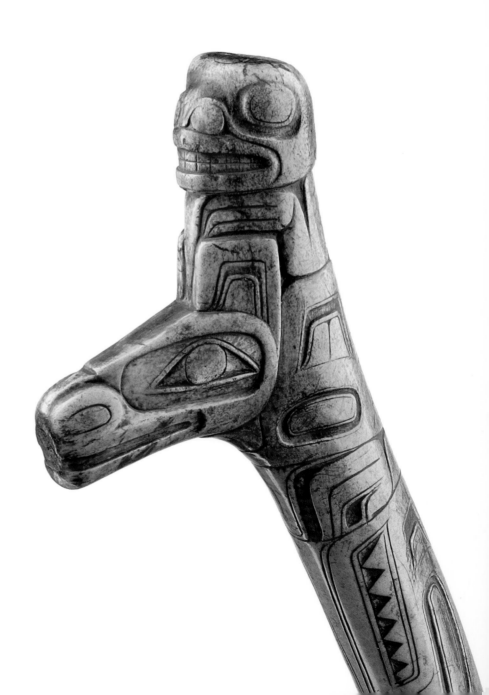

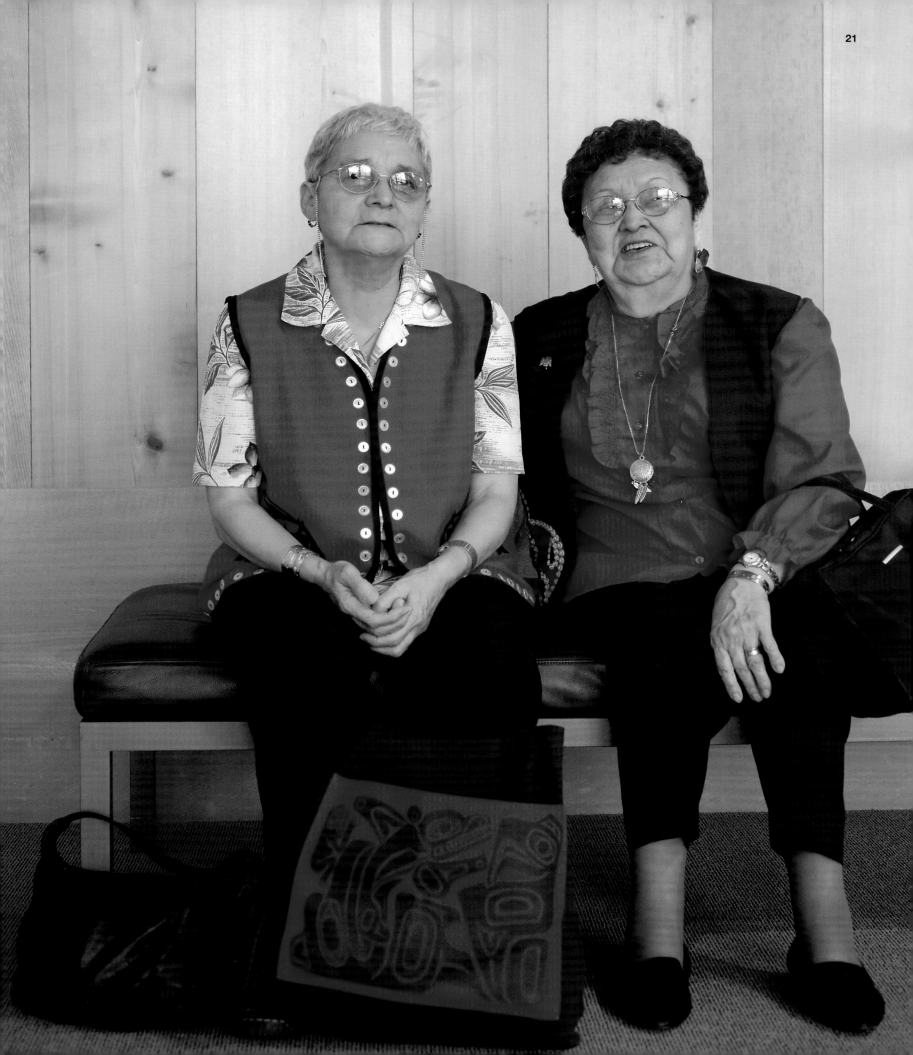

The Eagle Down Dance
by Sarah Milroy

Reflection

The two-hour flight north from Vancouver to Prince Rupert is a voyage between worlds. Moments after takeoff, the sprawl of the Lower Mainland falls away – the miles of freeways and strip malls, the housing developments, the farmland – and an unbounded expanse of raw land and sea opens up: dark blue-grey water, mountains tinged with snow, and an infinity of forests marked here and there with the scars of clear-cutting.

At first, there is sunshine and broken cloud, but soon we are heading into nasty weather. It's the first day of March, after all, and you know what they say about March in British Columbia – in like a lion, out like a wet lion. Rain is streaking the plastic windows of our slightly shopworn Air Canada jet, and the little silvery threads are jostling their way across the pane before disappearing into the cracks.

How different is this experience from that of the Scottish missionary Reverend Robert J. Dundas, who steamed up the coastline aboard the HMS *Grappler* in the fall of 1863? Our trip is quicker, that's for sure. Dundas's journey from Victoria took three weeks and involved many encounters with settlers, missionaries, the region's Aboriginal inhabitants and the occasional whiskey schooner peddling poison in these wild outposts of the empire. On one dark night, his diaries tell us, the *Grappler* was nearly shipwrecked in Millbank Sound, but a shift in the tides delivered the vessel from catastrophe.

Throughout Dundas's journey, his diaries expressed his fervour for the evangelical task at hand. "What I have seen & heard in the last 2 months," he writes, "only serves to press home more strongly, the conviction that for the sins & evils that are amongst the men of this world – be they savages – or be they civilized; there is but one effectual remedy – the regeneration – Life-giving Gospel of the Saviour Christ Jesus."

Our voyage is somewhat less dramatic, and is fuelled by no such firm convictions. Instead of hard tack and ship's biscuits, we are provisioned by Dad's oatmeal cookies wrapped in cellophane, and stale black coffee served in Styrofoam cups. On the plane with me is a mixed bag of fellow travellers – young tree-planter types in their hiking boots, men in polyester suits conferring over their documents (I size them up as government bureaucrats), a young family heading home from a visit with the in-laws and, in the seat beside me, a blond, blue-eyed woman named Janie Wray who runs a whale-watching station with her husband on an island out beyond Hartley Bay. The two of us discuss the recent ferry disaster there and the cetacean behaviours she studies. We talk about the

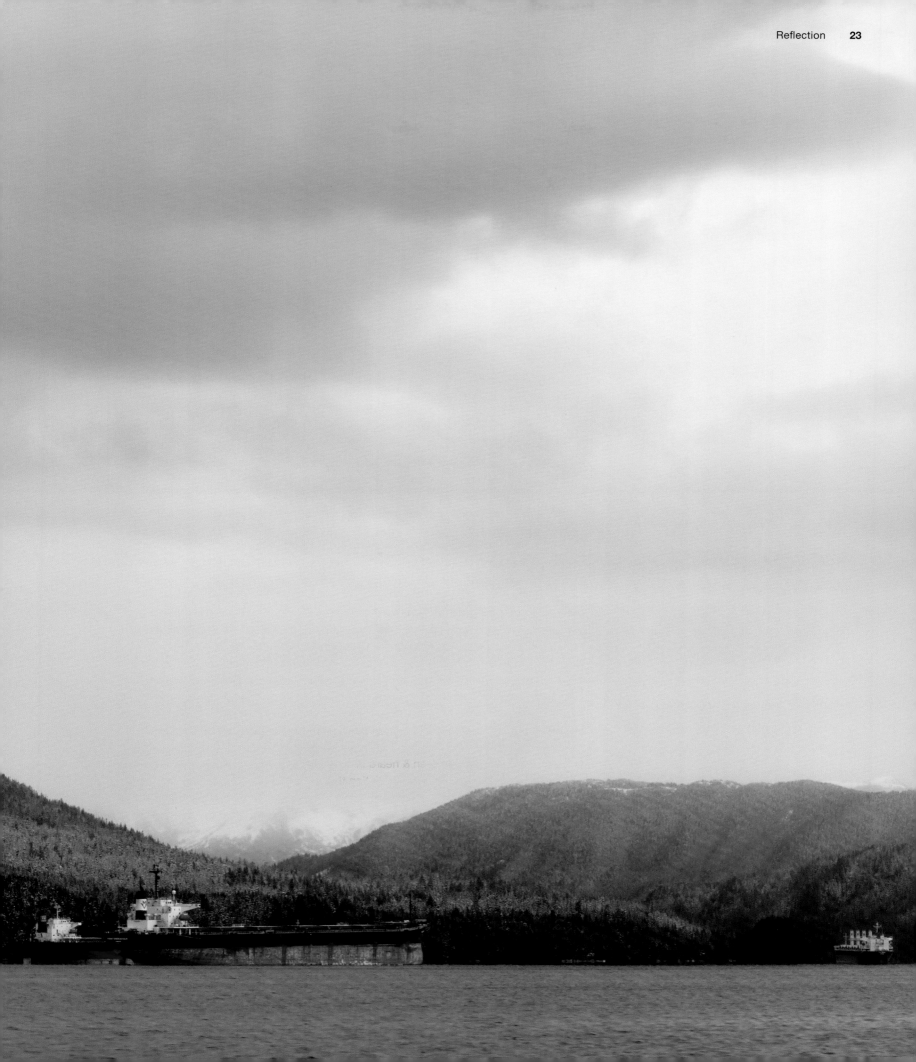

government's latest attempts to put a seismic-testing facility into their waters (foiled by local activism) – all the while heading up the western flank of the continent, deeper and deeper into the wilderness.

Or at least, it's wilderness for a non-Aboriginal person like myself. For the Tsimshian people, whose traditional lands lie here, it's home base, and it has been for 5,000 years or more. Blessed with abundant sea life and a relatively mild climate, this stretch of coastline served as the cradle for one of the most refined Aboriginal cultures of North America, a culture I am coming to celebrate today.

I look around at the other faces on the plane to see if any of them look like anthropologists; I know that there are a number of visitors from Canadian museums making the journey today. Later this afternoon, in Prince Rupert, a selection of works from the Dundas Collection of Northwest Coast art will be unveiled at the Museum of Northern British Columbia: masks, headdresses, clappers, shamanic figures, clubs, spoons, carved feast bowls and other ceremonial and trade objects. Their homecoming marks their return to Tsimshian territory after nearly 150 years of wandering.

Sometime in the early 1860s, these objects were surrendered by their Tsimshian owners to the radical Anglican evangelist William Duncan. For Tsimshian Christian converts of that time, as for many Aboriginal people on the coast, the volunteering of cultural property was the price of entry into God's flock, a sign of fealty to their new faith.

Then, in 1863, at Old Metlakatla, just across the water from present-day Prince Rupert, Duncan either gave or sold the objects to his visitor, Reverend Dundas, who took them home with him to Britain two years later. It's believed that the collection may have been displayed in Manchester, in an exhibition organized by the Church Missionary Society to help raise funds for its work overseas, and perhaps also in Norfolk; but the artifacts finally came to reside with Dundas in Surrey, where he was appointed rector of Albury Parish. When Dundas died, in 1904, the collection was passed on to his son, who installed the objects on the wall of his billiard room in Edinburgh. After the death of Dundas's son, the collection was placed in safekeeping, first in Scotland and then, in 1960, with Reverend Dundas's great-grandson, a psychologist named Simon Carey, who lived above a fish shop in London's Belgravia district.

Carey and his growing family moved to Hampstead in 1970. There, the objects

were placed on display in the drawing room and were often played with by the children, Benjamin and Juliet, until the rising price of Northwest Coast art alerted the family to their possible cultural significance and financial value. But it was not until decades later, in 2006, that Carey decided to sell the collection at Sotheby's in New York. The date was set for October 5. In a strange twist of fate, Carey was diagnosed with inoperable liver cancer just nine days before the sale. He died a few weeks afterwards.

This auction put an end to years of fruitless and often agonized negotiations between Carey and a host of potential buyers, including a number of Canadian museums attempting to bring the collection as a whole back to Canadian soil. In the end, these institutions were unable to get either the federal or provincial governments onside. Looking out the window, I cast my mind back to the tense days leading up to the October auction, when it seemed likely that the collection would be scattered to the four winds. At the eleventh hour, it was a handful of Canadian private collectors who stepped up to the plate: David Thomson and his cousin Sherry Brydson, Michael Audain and Yoshiko Karasawa, Jake and Fiona Eberts, five other anonymous buyers and a few Canadian museums (the Canadian Museum of Civilization, the Royal BC Museum and the Museum of Northern British Columbia). The Prince Rupert showing would be the first unveiling of these artifacts back in Canada, and that makes perfect sense. This is their ancestral home.

As the plane banks for a landing, the city of Prince Rupert comes into view. It seems oddly out of place, an unlikely mini-metropolis abruptly sited in the middle of a vast landscape of mountains and fjords, wreathed in fog and rain. The giant ocean-going freighters at anchor in the harbour are a surprise to me. What are they all doing way out here? On the ferry and bus ride into town, I learn that the city is the terminus for the trains out of Edmonton bearing prairie grain and coal bound for Asia. "It's a two-day shorter trip to Japan from here, compared to Vancouver," says Adrienne Johnston, the proprietor of the Cow Bay Cafe, a local hangout where we would eat lunch later in the day.

Chatting on the bus, she offers to drive me around town if I'm stuck, and shares a little of her local knowledge. "Prince Rupert's motto is: Canada's friendliest city," she tells me. "This is a good place." She fills me in on the vast new container terminal being built out on the fringes of town, a $170-million project that will pick up the slack that came to

the Prince Rupert economy when the pulp mill closed five years ago, taking some 5,000 primary and secondary jobs with it.

This is the big hope, but the Native people I will meet here have grown wary of big hopes. They say most of the jobs at the new port will require training that they do not have, and that the funds for that training are tied up in negotiations that were begun when the decision was made to build on the remains of an old Native village site. The new terminal is now just months away from completion, but still no funding for training is in place.

The new container terminal is the big story in town, but there's also ecotourism – fishing, whale watching, sea kayaking – and the ever-increasing trade from the Alaska-bound cruise ships, which roll in during the summer months, disgorging hundreds of tourists at a time onto the streets, where they forage for things to buy and to eat. It's hard to imagine those crowds as we drive into town on this raw early-spring day. The rain is slanting sideways, and many of the stores are boarded up along the main drag.

At the Crest Hotel we meet our host for the day, the Tsimshian weaver Willy White, who – it immediately becomes clear – is one of the natural leaders of this northern community. He has agreed to drive me and photographer Shannon Mendes around town, and to help us get our story. Short, powerfully built, with bright skeptical eyes and twin abalone earrings that catch the light, he radiates a savvy worldliness and a grounded, no-bullshit vibe. I think to myself: he's like a Tsimshian John Belushi, minus the personal demons.

The first place he takes us to is the Museum of Northern British Columbia, a cedar longhouse-style building with soaring ceilings and spectacular vistas over Prince Rupert Harbour and Chatham Sound. Here, we meet Sam Bryant, the museum's Tsimshian artistic director and a first cousin of Willy's, who will be leading the traditional singing and dancing, and Susan Marsden, who has been the curator of the museum since 1997.

The museum, which opened in its new facility in 1997, was built to provide a destination for Northern tourism and a gathering place for objects relating to the history of the place, both the region's original Aboriginal inhabitants and those who have come here from afar: Europe, North America and Asia. In recent years, the museum has been able to arrange some long-term loans from larger institutions such as the Canadian Museum of Civilization in Hull, Quebec. One display case here holds a carved wooden ceremonial war helmet on loan from the CMC. Like the U'mista Cultural Society in Alert Bay and the soon-to-open Qay'llnagaay Heritage Centre in Skidegate, across the water on Haida Gwaii, this institution represents a new paradigm in museum-making in which stewardship of historic indigenous objects is entrusted back to the communities where they were made.

With a few hours on our hands, we get in Willy's car, and, as the windshield wipers slap back and forth, we hear about his grandmother and how she instilled a sense of place and of belonging in her grandson. "She used to say, as we drove through town: 'That bush over there – that belongs to you. Those berries are yours.' Or she would take us down by the beach, where the new shipping port is being built. We used to go there as kids and gather clams and cockles. She would tell us: 'This is all yours.' " He's not bitter, exactly. He's just letting me know.

Settling in at the Cow Bay Cafe, we eat lunch – Adrienne's chicken quesadillas and squash soup spiced with curry, ginger and lime leaves – and we hear more stories. Willy and Doug Moore, a long-serving board member at the Museum of Northern British Columbia, tell us about the history of the waterfront. Once, there were 28 canneries on

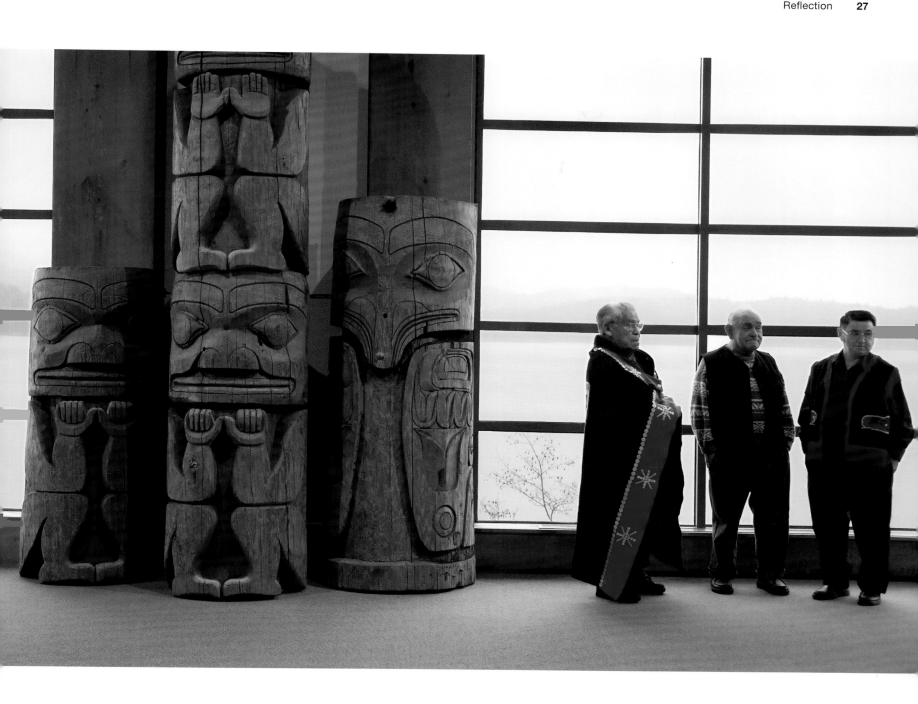

this part of the coast. Now, with the fisheries dried up and federal regulations limiting the catch, just one cannery remains. We hear about Bill Gates's visit to Prince Rupert aboard his yacht, the *Crystal Harmony*. (Twenty-one private jets landed at the Prince Rupert Airport that day, bearing away some of his 500 guests.) We also hear about the Chinese investors who have bought the land where the old pulp mill used to be. The local speculation is that the mill will be torn down; the land will be used as a place to store cargo in transit to Asia. Or maybe the pulp mill will be refurbished and opened again. Nobody knows.

Willy also tells us about his own decision to start teaching weaving to young people. "I realized that if my auntie died and I died, there would be no one left here who knows how to do this," he says. "It was a really conscious thing. Now there are 150 people who know how to make cedar baskets."

He tells me too about how his non-Aboriginal high-school teacher advised him to give up school, since he could only ever hope to be a fisherman. "He said it was a waste," Willy tells me, in between bites, with a shrug. "He said that to a lot of us."

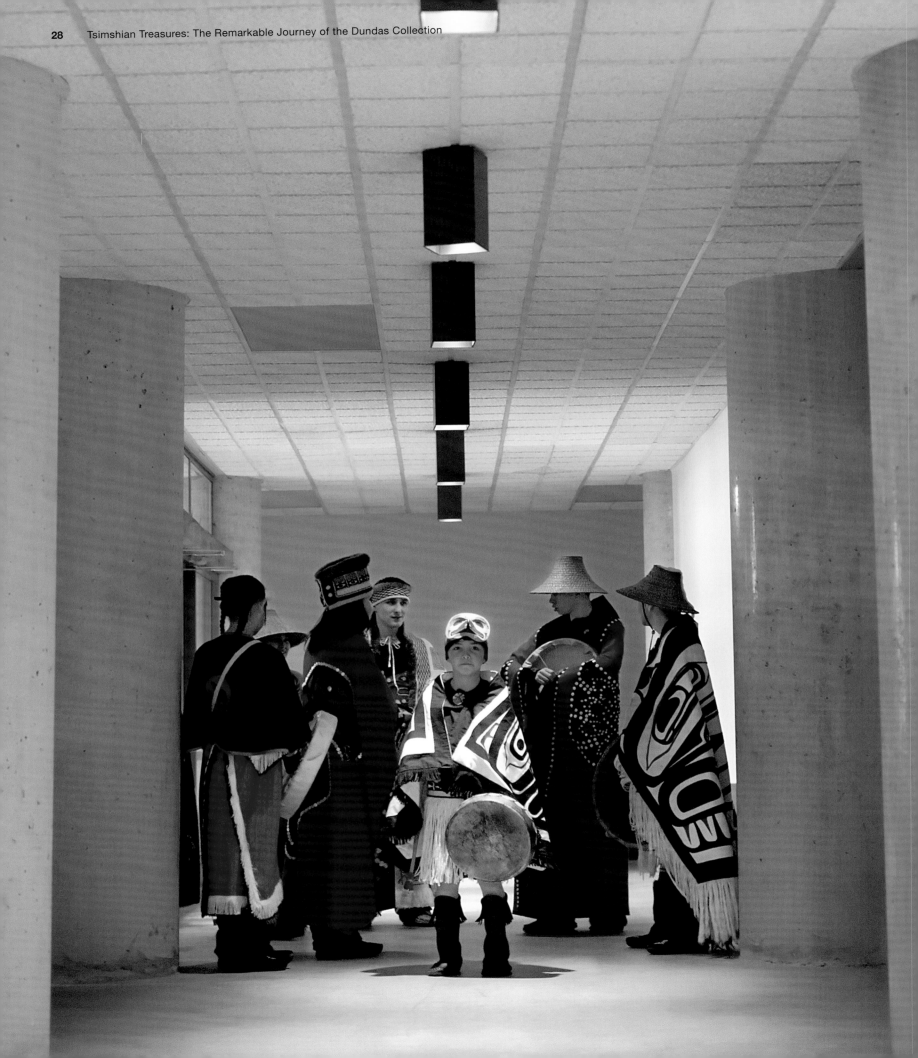

I start to form the impression in my mind of how these people have borne wave upon wave of ever more bizarre outsiders, each with their own interests to pursue and prejudices to inflict. First, the fur traders. Then, the missionaries. Then, the fishermen. The fish canners. The loggers. The guys who ran the mill. Then, shipping. Ecotourism. And, increasingly, cultural tourists and journalists like myself.

At 4 p.m., we gathered at the museum for the ceremony. The sky had turned a leaden grey. It became clear that there would be fewer people here than had been previously anticipated. Looking out the windows of the high-ceilinged meeting hall, on the museum's basement level, we could see why. The whitecaps were building on the darkening seas, and the wind was now howling out of the southeast. Sleet was turning to snow, then back to sleet again, blowing sideways in great gusts.

We learned also that Ben Hughes, one of the tribal elders from Port Simpson, had passed away a few days earlier, and many of the participants in today's ceremony were planning to attend his funeral at the nearby United church later that evening. There would be fewer speeches here at the museum, so that those attending can make it to the funeral service as well. When moments like this arise in the community, nothing else takes precedence. This is not a culture built around photo opportunities.

Very gradually, the hereditary chiefs and dignitaries assembled at the front of the hall, and we – the visiting media and curators from Vancouver, Victoria and Toronto – were given strict protocols on where and when we could stand and move. We waited, and then we waited some more.

Finally, we heard the drums and the ceremony began, with the special guests, the dancers and the musicians entering the hall, many of them dressed in their traditional regalia. In the lead was Sam Bryant's Gwisamiilkgiigolth group; the Tsimshian name translates as "masked dancing from a long time ago." We settled in for the long haul. Speech making, in the Northwest Coast tradition, is not the anxious, tightly focused and essentially competitive undertaking that it is for us in the non-Aboriginal world. Thoughts flow in an unstructured way. It takes time, sometimes many hours, to unfold. This gathering lasted just a little over five hours, but similar events have taken twice as long.

James Bryant, the spokesperson of the Allied Tsimshian Tribes of Lax Kw'alaams and Metlakatla, was the first to take the microphone. His words were sober, and spoken with the weariness of a man who has made the same points a thousand times and has seen no changes come. He talked about the Tsimshian's refusal to accept the white man's claims, and about his people's anger that so many important objects were taken away.

But then his tone shifted. He thanked the collectors who had bought the artworks. Sherry Brydson and her family were in the audience. They seemed to be "people of good faith," he said, and he expressed his gratitude to them for allowing the objects to be shown here first, "so that our children can see them." Then he continued, "We put the spirit back into these things when we put the blessing." It was a bittersweet moment. From the broader Canadian standpoint, these objects have been repatriated, and this is cause for celebration. But for the Tsimshian, the emotional reality is more complex. In six weeks, these objects will leave again and travel on to the south, to the museums and the wider publics that await them there.

Clarence Nelson, the hereditary chief of Metlakatla, came next, appearing in his traditional button blanket and abalone-inlaid frontlet. It fell to him to perform the

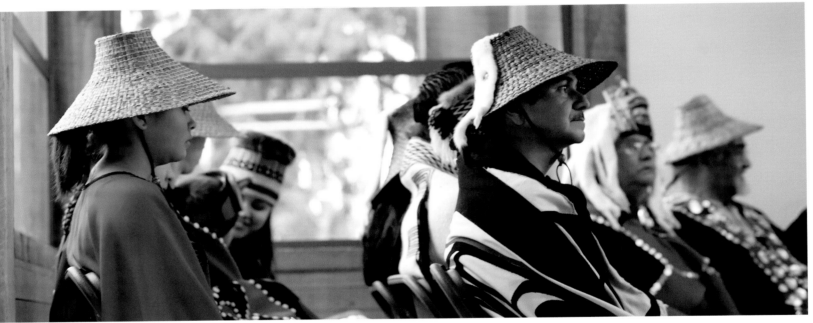

Eagle Down Dance, a Tsimshian tradition honouring guests. In this case, the ritual set the stage for reconciliation between this Aboriginal community and their non-Aboriginal visitors. Before starting, Sam Bryant translated the words of the Tsimshian song. "Come over here. Come and sit with me. It's peaceful here. Come and sit down beside me." He went on to explain the song's significance: "When the dance is over, we can all be together and be at peace in the Tsimshian territory."

The drumming and singing started, and then Nelson began his dance: small, carefully measured steps. Now and again, he reached into his pouch for a few white feathers, which he blew in the four directions. His gestures were restrained but eloquent, full of portent. We watched the eagle down float slowly to the floor and settle there, the soft little tufts symbols of gentleness, understanding and peace drawn from the breast of the great wide-winged predator.

Nelson then spoke about the village of Old Metlakatla, the settlement where Reverend Dundas had acquired the objects from Duncan. Nelson spoke with pride about

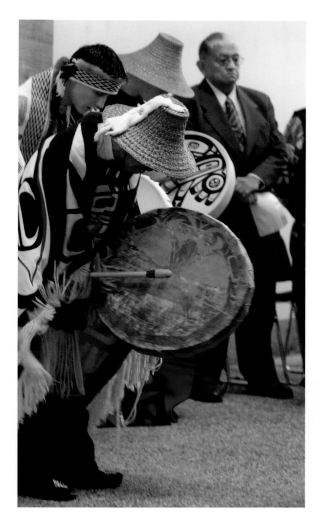

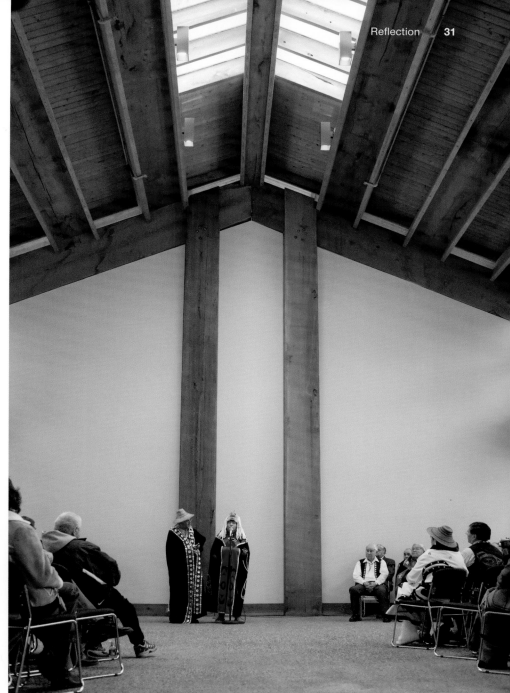

the achievements of those Aboriginal converts, who, under Duncan's direction, had raised the largest Anglican church west of Chicago. Like Nelson, many of the Tsimshian in this community are ardent about their Native heritage and, at the same time, deeply devout Christians.

"They were proud of who they were and what they had accomplished," Nelson said of his converted forebears. The following afternoon, he would take me to the Prince Rupert archives to show me a picture of his grandfather, Job Nelson, the leader of Duncan's marching band and the composer of the Imperial Native March (as well as the Metlakatla Waltz) – a signature tune that the band played in their competitions up and down the coast. The picture showed a handsome man holding his instrument, clad in his blue band uniform. This could have been Brighton, were it not for the uniformly dark complexions of the musicians. In this part of the world, the legacy of contact is complicated. There has been exploitation, but there has also been trade and, at times, shared ambition.

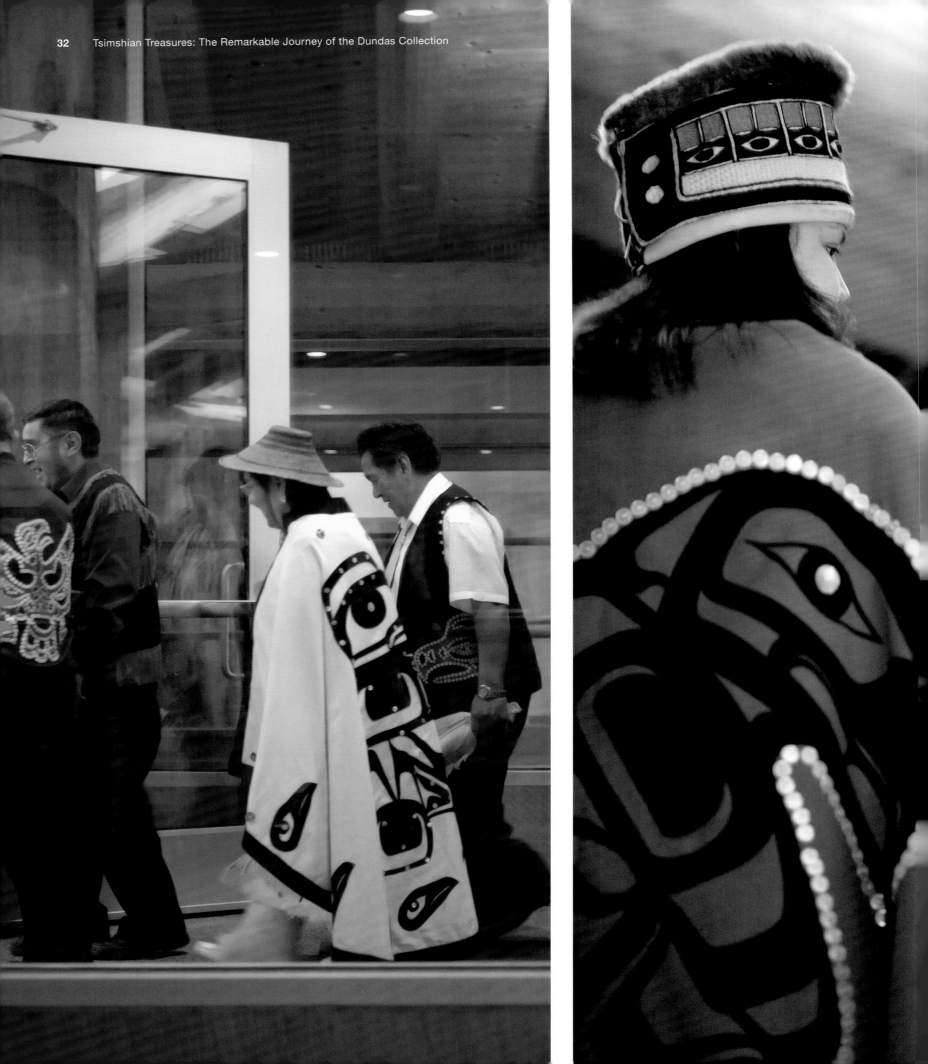

James Bird, a welder who is also hereditary chief Txatkwatk of Hartley Bay (and Susan Marsden's partner), took the floor next and talked about visiting his grandparents, who would occasionally bring out an old mask for ceremonial purposes. "In their kitchen, there were carved bowls and goat-horn spoons," he recalled. "Today, all these things that we used every day are called artifacts. It seems strange to call them that."

Next came a few words from Ben Hill, a Tsimshian ordained minister. Dressed casually in a navy blue windbreaker, he turned to the Bible – Exodus, Chapter 31, to be precise – invoking one of God's speeches to Moses as a way of celebrating the artistry of the Tsimshian people. The works that we will soon see in the galleries upstairs, he said, reveal the glory of the Christian God, working through man. (A few days later, I looked the passage up. "And I have filled him with the spirit of God in wisdom and in understanding," it reads, "and in knowledge and in all manner of workmanship, to devise cunning works, to work in gold, silver and in brass, and in cutting of stones, to set them, and in carving of timber, to work in all manner of workmanship.")

Wes Baker, a high-school teacher who leads the board of the Museum, followed with one of the evening's most carefully crafted but moving speeches. "When we were trying to acquire the collection, I felt a combination of anger, chagrin and resignation with our politicians," he said, recalling the days leading up to the Sotheby's auction. "But not just with our politicians – with Canadians as a whole, whose collective beliefs are transmitted through their politicians. Obviously, they weren't really interested and had decided the collection was too expensive for their budgets. What an opportunity was lost to show that Canadians truly valued the Native part of Canada's history. I'm sure that if Cabot's journal was found...money would have been made available for its purchase."

Baker then went on to express his thanks to the buyers who had stepped forward in the final hour. For him, as for many of us, their decision to take action had felt like a symbolic turning point. Honouring this, Willy White made a presentation to Sherry Brydson and also to Pauline Rafferty, CEO of the Royal BC Museum in Victoria: each woman received a shoulder bag decorated with one of his Chilkat weavings. The gesture was heartfelt, but the moment was strangely awkward. Everyone was trying very hard to make this work.

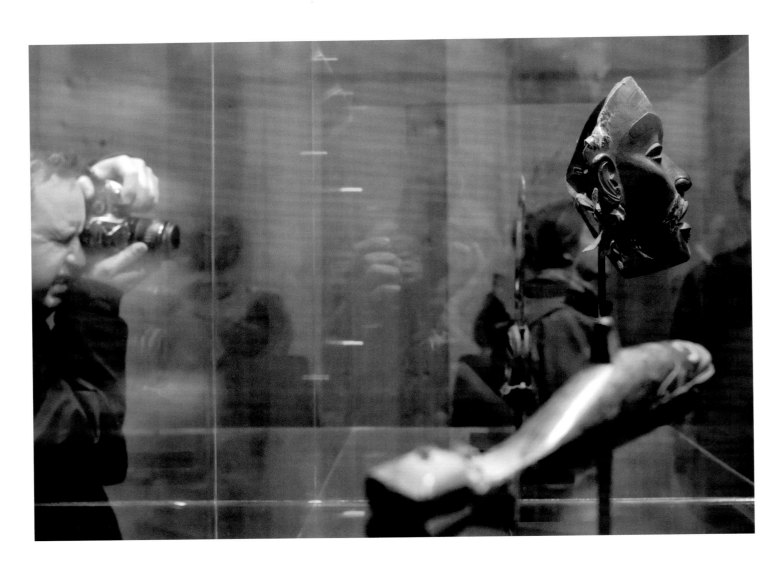

Now, evening was falling, and it was time to head upstairs to the gallery to see the exhibition. The chiefs, the donors and dignitaries followed the dancers out of the hall, and so did the rest of us, waiting for a while in an upstairs hallway while the elders blessed the objects.

Anticipation was high. Most of us knew the collection only from reproduction: the glossy auction catalogue, where each object looms large and lustrous against a black backdrop. It's hard to imagine a more different context for viewing. Entering the gallery at last, I was struck by the delicacy and fineness of these works of art, held aloft in their pristine Plexiglas cases. They looked so wonderfully well preserved, so alive, but also so small and vulnerable. There was a hush, as people filled in the spaces between them, and took their first look – old and young together, outsiders and locals, Native and non-Native people. People were sharing stories, remembering things. People were gesturing, showing each other with their hands how they thought the objects might have been used. They were passing on the knowledge.

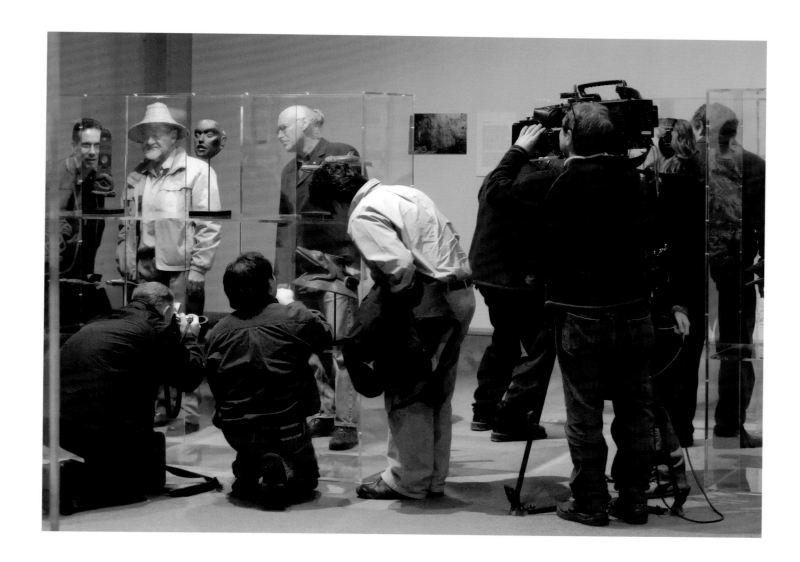

In the crowd was the Tahltan-Tlingit carver Dempsey Bob, there to pay his respects along with a handful of his carving students. He was talking to people about his work at the fledgling Freda Diesing School of Northwest Coast Art in Terrace, an hour-and-a-half drive inland over the mountains, and he was telling stories about his recent trip to Australia to participate in a group exhibition of indigenous artists from the Pacific Rim.

Dempsey is every inch the Aboriginal-art star, and well deserving of the mantle. But looking at the shaman's mask, the most significant object in the exhibition, he was transformed into the student again, humbled before the work of a master. "It's classic Tsimshian style," he said, showing me the ropes. "You can see in the high cheekbones, in how the forms are linked to each other. It's in the clean delicacy of the carving of the nostrils, the eye sockets and eyebrows." Then, he continued, pointing to some scruffy patches along the top and sides, "You can see here where there used to be fur attached."

Watching his face, I could see the object come alive in his mind as something that had been, something that could still be, used. "You know what modern art took from us?"

he said to me finally, speaking of the French Surrealists and their penchant for Northwest Coast art. "They took freedom. We took off the blinders for them, but we never got the credit for it."

Soon, we all took our seats and it was time for more dancing. A cloaked figure in a birdlike mask entered the gallery, his movements evoking the vivid supernatural presence of the ancestors coming to inspect the objects – inquisitive, judicious, alert, mischievous. The dancer was Willy, wearing a mask carved by contemporary Tsimshian artist Terry Starr, and accompanied by his sister Joanne Finlay (she was shaking a rattle carved by Dempsey and decorated with her brother's weaving), but you would never know it was Willy. The effect was breathtaking. It was as if a crack had opened up in our shared reality, and another dimension had emerged into view.

Enjoying food together is an important part of almost any Tsimshian gathering. On this night, we shared a feast, 21st-century global-village style, with platters of sushi made from fresh ocean catch. People milled about, drinking wine and talking for an hour or so, and then it was back to the gallery for more speeches and a Tsimshian reprise of The Black Eyed Peas song "Let's Get It Started," led by Sam Bryant and his group.

Dempsey came to the front and spoke. "I was thinking when they were singing those songs that this is the first time these pieces have heard these drums in 150 years," he said. "When I go to New York and I see these old pieces, I always feel that they want to come home with me."

Sherri Dick spoke next, a stately Haida weaver and the great-granddaughter of the revered artists Charles and Isabel Edenshaw. She seemed to perform an almost ambassadorial role for her neighbouring people. Bill McLennan, an anthropologist from the University of British Columbia's Museum of Anthropology in Vancouver, reminded us of another Haida artist, Bill Reid, and his notion that "teachers will come and go, but the objects will be our teachers forever." And a Cree-Tahltan carver, named Ken Humpherville, asked us to consider our concept of progress: "We have advanced," he said, "but do we have the time now to make our own beautiful utensils? Do we have the time to carve our own bowls like this any more?"

The evening meandered on. Eventually, the speeches got shorter. Soon, we were done. It was time to head out into the lashing rain and the dark starless night, time for us out-of-towners to reconvene for the evening's final chapter in the bar at the Crest Hotel, enacting our own traditional North American ritual of gathering and storytelling over beer, beneath the flickering light of the hockey game.

Once we settled in, I recall thinking: We should remember the past, but guilt alone is immobilizing. So, too, is rage. It distracts us from pursuing a sense of our common humanity. We should honour the past, we should learn its hard lessons, but we should not be oppressed by it. The powerful have always afflicted the powerless; this seems to be one of the most predictable constancies of human nature. But a civilization is to be judged by the measures it puts in place to mitigate against such barbarism. By this criterion, Europeans and their North American progeny have struggled and largely failed to be as civilized as those they have taken dominion over. But every once in a while – like this day – we take a step towards redemption.

Sarah Milroy
Toronto, May 2007

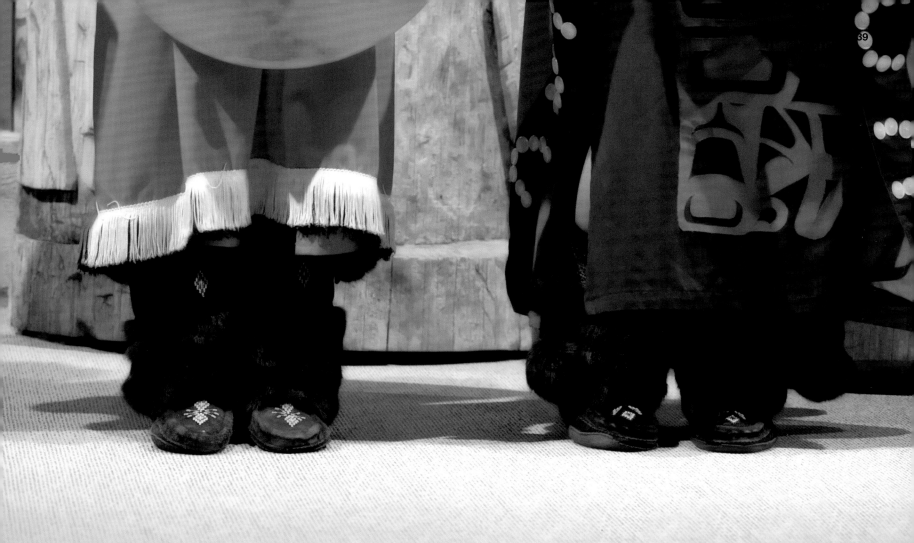

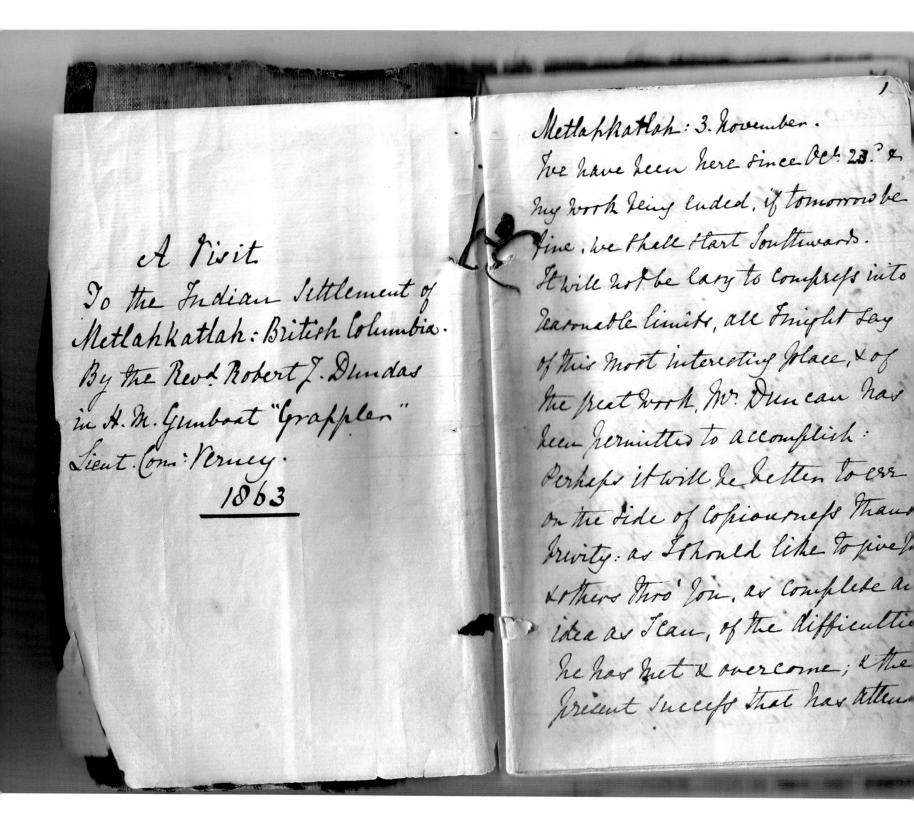

In this excerpt from his journals,
Rev. Robert J. Dundas writes about
visiting the Christian mission at
Metlakatla in 1863.

The Journey

The History of the Dundas Collection
by Alan L. Hoover

In the fall of 1863, the Reverend Robert James Dundas, M.A. (Oxon), accompanied his friend Lieutenant Edmund Hope Verney, the Royal Navy captain of the gunboat HMS *Grappler*, to the northern coast of British Columbia, near what is now the city of Prince Rupert. On October 26, Rev. Dundas acquired artifacts – now known as the Dundas Collection – from William Duncan, the famous Anglican lay missionary who, in 1862, had established the utopian Christian village of Metlakatla.[1] Remarkably, this collection remained in the possession of Rev. Dundas's family for 143 years until it was offered for sale at auction in New York City on October 5, 2006. At this auction, the vast majority of the collection's most important artworks were purchased and brought back to Canada by prominent Canadian citizens, with some assistance from the Canadian Museum of Civilization in Gatineau, Quebec; the Royal British Columbia Museum in Victoria; and the Museum of Northern British Columbia in Prince Rupert.

At the request of the hereditary chiefs of the Allied Tribes of Metlakatla and Lax Kw'alaams, the first public viewing in Canada of the Dundas Collection took place in the city of Prince Rupert in the spring of 2007.

The historical context of how Rev. Dundas acquired this collection is complex, involving a tangled chronicle of interaction between the Tsimshian[2] people of British Columbia's northern coast and the British Empire's colonizing agencies: the Hudson's Bay Company, the Royal Navy and the Anglican Church of England. This book does not attempt to address those larger issues. Instead, it limits itself primarily to an examination of the relationships among four individuals: Rev. Robert Dundas, William Duncan, Lt. Edmund Verney and Paul Ligeex, the Tsimshian chief who converted to Christianity.[3]

Collecting Curiosities: Explorers, Fur Traders and Others, 1774–1841

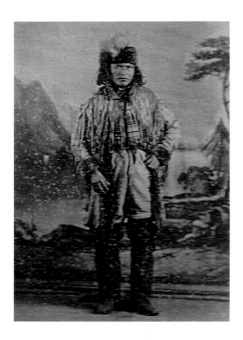

The earliest collections from the Northwest Coast date to the late 18th and early 19th centuries.[4] The more important and better documented of those collections were those obtained by seafaring expeditions commissioned by European powers of the time. Some of these official expeditions were charged with collecting artifacts as an essential part of their quest for geographic and scientific knowledge of the lands and peoples that they encountered.[5] In 1778, British explorer Captain James Cook collected 250 artifacts on the Northwest Coast, which have survived to this day and are scattered among various museums in Europe and the United States.[6] More than 50 artworks from the Northwest Coast survive in Spain's Museo de América. The majority of those objects were collected by the Alejandro Malaspina Expedition (1791–1792), and earlier but smaller collections were obtained by Juan Pérez (1774) and Hezeta/Bodega y Quadra (1775). These artifacts have been described as the "greatest legacy" of those voyages.

Among the objects acquired by Pérez in 1774, off the northwest corner of Langara Island, in Haida Gwaii (Queen Charlotte Islands), is a small ivory charm. It has the earliest acquisition date of all Northwest Coast artifacts in documented collections worldwide.[7] The largest surviving single-voyage collection of ethnographic artifacts from before 1800 was acquired during a voyage in 1791–1792 headed by another Royal Navy officer, Captain George Vancouver. His collection is housed at the British Museum in London. It has been stated that Cook's third expedition obtained larger and more magnificent objects than Vancouver's voyage because the two explorers had different mandates. Cook had been specifically ordered to study indigenous peoples; Vancouver was instructed to conduct surveys and collect natural specimens, so gathering ethnographic objects was not his priority.[8]

Important early collections were also obtained by Russian navigators and officials of the Russian-American Company of fur traders. The bulk of these collections were sent to the Museum of Anthropology and Ethnology in St. Petersburg in Russia. Although there are a few objects whose origins can be traced back to the late 18th century, most of the artifacts in the Russian collections were acquired in the first half of the 19th century. One important Russian collector was I. G. Voznesenskii, who was sent to Russian-American in 1839 to expand the collections of the Russian Academy of Sciences. He had specific instructions, which included a list of artifacts needed by the museum. In addition to the approximately 1,000 artifacts that he'd collected, Voznesenskii kept a diary with excellent drawings of the people, places and objects that he encountered on his travels.[9] Another early collector of Northwest Coast material was Arvid Adolf Etholén, a Finnish governor-general of the Russian-American Company. When his first collection, which was donated in 1825–1826 to the museum of the Turku Academy in Finland, was destroyed by fire, he acquired a subsequent collection in the 1840s, which went to the National Museum of Finland in Helsinki.[10]

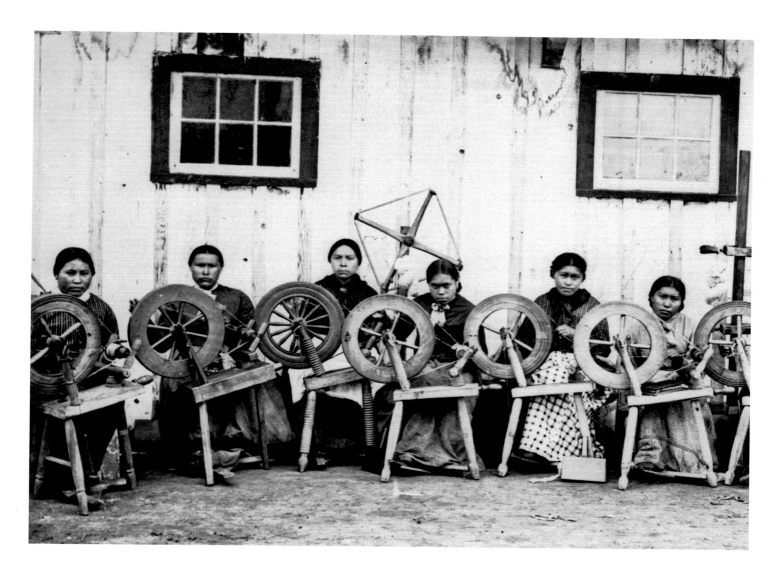

Tsimshian women at Metlakatla spinning wool.

Opposite page: A photograph from the journal of Rev. Robert Dundas.

In the late 18th century, the French also sent a scientific expedition to the Northwest Coast under the command of Jean-François de La Pérouse, who was instructed to obtain "garments, arms, ornaments, utensils, tools, musical instruments, and everything used by the people…[for] the collection intended for His Majesty [King Louis XVI]." La Pérouse sent back journals and illustrations by courier from Petropavlovsk in Russia. Unfortunately, by the time the records of the material reached Paris in 1788, La Pérouse's two ships had disappeared in a cyclone in the Solomon Islands. No artifacts collected by the expedition survived.[11]

Artifacts were also obtained in the late 18th and early 19th centuries by English and American fur traders from the ports of Boston and Salem, Massachusetts. Collecting cultural objects, however, was incidental to these maritime traders, whose primary concern was to obtain sea otter pelts in the Northwest Coast for the flourishing China trade. The demand for pelts had been sparked by Capt. Cook's crew, who sold pelts in Canton at huge profits after bartering for them mere iron nails, uniform buttons and sheet copper. But it should be noted that some English and American seamen collected objects with the intention of displaying them in "cabinets of curiosities" – embryonic museum displays that were popular in London and New England in the late 18th century.

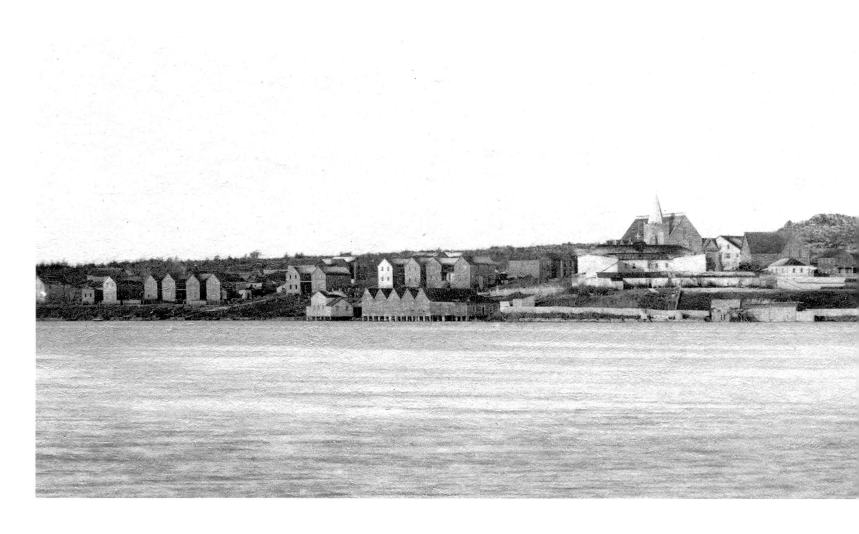

In May of 1862, Anglican lay missionary
William Duncan established the utopian
Christian community of Metlakatla (pictured
above) at an old village site, south of
Fort Simpson at the western edge of
Prince Rupert Harbour.

The types of artifacts they collected were largely determined by the Native peoples who supplied them from the canoes that were paddled out to trade with the ships. The seamen's collections featured fishing gear, tools, weapons and containers, or personal possessions such as bracelets, combs, hats, and blankets. It was not until the end of the maritime fur trade, between 1820 and 1840, that objects such as masks, model canoes and carvings – particularly of argillite, a dense black carbonaceous shale – especially made for trade began to appear in the inventories brought back to home ports. Many of these "souvenir" artifacts are now in public institutions in the eastern United States and Europe.[12]

From the beginning of the maritime fur trade, Native peoples were not just trading furs in exchange for goods. They had also been supplying the traders with foodstuff and locally produced objects including those crafted specifically for trade. On June 29, 1842, the Hudson's Bay Company's journal at Fort Simpson recorded: "About noon the Skettigates Indians arrived in thirteen canoes…. In the evening they traded several Land Otters and martens together with 49 hats & some stone (argillite) pipes." Then, on June 30, the journal reported that "several stone pipes in the course of the day" were traded.[13]

Land-based traders too endeavoured to acquire collections. In a list appended to a letter in 1838, Dr. William Fraser Tolmie, who was also a trader for the Hudson's Bay Company, records artifacts and natural-history specimens that were to be sent to the museum in his hometown

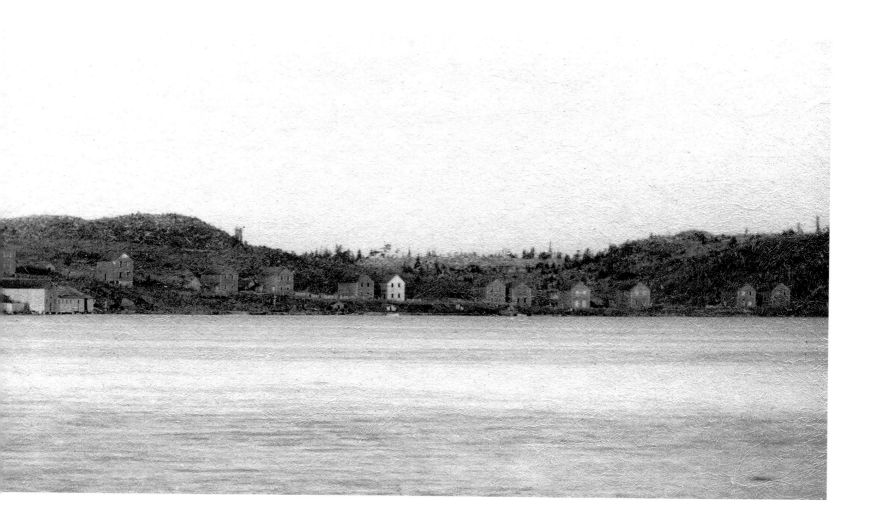

of Inverness, Scotland, via the Hudson's Bay Company ship *Columbia*. On the list are stone pipes (presumably argillite) from the Queen Charlotte Islands, masks "used by the Indians on the N.W.C. [Northwest Coast] at their winter feasts & dances" as well as utilitarian objects such as fish hooks for catching halibut.[14]

A collection of artifacts – obtained at the mouth of the Columbia River in 1841 by the United States Exploring Expedition headed by Lieutenant Charles Wilkes – was probably initially traded to the Hudson's Bay Company post at Fort Simpson by Haida, Tsimshian and Tlingit peoples. Among the objects acquired by Wilkes were argillite and wooden pipes, woven basketry, hats, masks, frontlets (carved wooden headdress plaques) and a raven rattle. The items are presumed to have been given to the expedition by Hudson's Bay Company staff at Fort Vancouver, although according to Dr. Robin Wright, Curator of Native American Art at the Burke Museum of Natural History and Culture, in Seattle, the pipes were given to Wilkes by the captain of the *Columbia*, which had just returned from the northern coast.[15]

The early 1840s heralded the end of significant collecting by explorers, government expeditions and fur traders. The next wave of significant collecting started in the 1860s with the arrival of the Royal Navy and Protestant missionaries on the coast of British Columbia. It was at the very beginning of this period when the Dundas Collection was acquired.

The Reverend
Robert James Dundas

Rev. Robert James Dundas (1832–1904) arrived in Victoria in 1859 as chaplain to the newly appointed first Bishop of Columbia, George Hills. Sent out to the Northwest Coast by the Society for the Propagation of the Gospel in Foreign Parts,[16] Rev. Dundas subsequently became the first rector of St. John's Anglican Church, at the corner of Douglas and Fisgard streets. St. John's, the first church to be consecrated on Vancouver Island, was also known as the "Iron Church" because it was built from prefabricated iron components. Apparently, when it rained or the wind blew, it became difficult to hear the minister's voice over the noise.[17] Rev. Dundas served in this position from 1860 to 1865.[18] He left Victoria in March of 1865 and returned to England after visiting the United States and South America.[19]

Although Rev. Dundas's primary role was to minister to the burgeoning communities of colonists, his participation in the lives of the close-knit Anglican Church groups in Victoria also involved him in pastoral activities aimed at Aboriginal peoples. In January of 1860, he went with Bishop Hills to visit the encampment of Tsimshian people in the Rock Bay area of Victoria Harbour, which was also known as the Tsimshian "ranch."[20] It was here that Rev. Dundas met Arthur Wellington Clah (1831–1916), the Tsimshian-language teacher of lay missionary William Duncan.[21] In April of the same year, Rev. Dundas had a meeting on the "Indian subject" with Bishop Hills; Joseph Pemberton, Vancouver Island's Colonial Surveyor; and Rev. Edward Cridge, the rector at Christ Church. At this time, the group drew up a list of required behaviours for the encampment's Aboriginal residents, similar to those imposed by Duncan in 1862 on the Tsimshian who wanted to become members of his new Christian community at Metlakatla.[22]

In May of 1860, Bishop Hills noted in his journal that Duncan and Rev. Dundas arrived at the same time to see him and, presumably, met each other for the first time. William Duncan had been asked by Bishop Hills to come and work with First Nations people in Victoria.[23] Dundas had been supporting Duncan's mission work even before Duncan had established his Christian village at Metlakatla. In his journal, Bishop Hills wrote on Sunday, January 26, 1862, about the "Indian Missions – Epiphany Collections," noting that $133 had been collected at Christ Church and $69 at St. John's. He recorded that Rev. Dundas had taken the morning service at St. John's,[24] and that a portion of the monies was collected for the mission, ostensibly Metlakatla.

Rev. Dundas was known for his knowledge and interest in the material culture of First Nations peoples. In one of her letters, Miss Sophia Cracroft, a niece of British Royal Navy officer and Arctic explorer Sir John Franklin, commented on her conversation with Rev. Dundas at a dinner party in 1861: "It was altogether a very pleasant evening. I heard a good deal from Mr. Dundas, of the remarkable skill and taste shown by the Indians in carving slate [argillite], which is found in the island [Queen Charlotte Islands] [and is] of very good quality, and in manufacturing bracelets and rings in silver and in gold."[25]

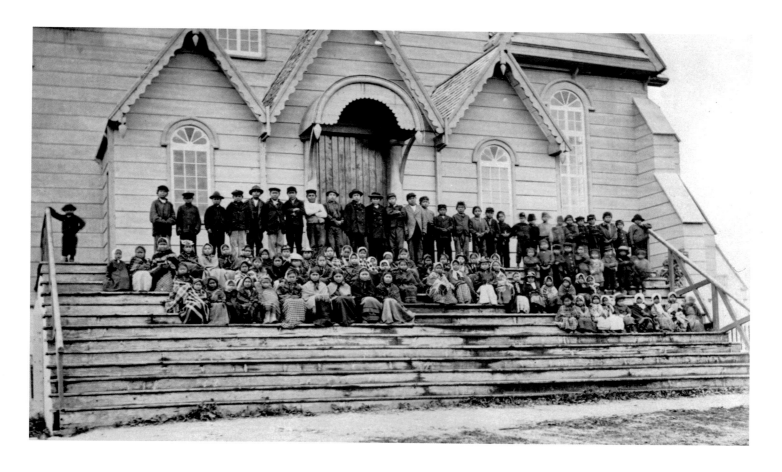

Metlakatla's congregation in front of the village's Anglican church.

As Duncan was not an ordained minister, one reason for Dundas's trip to Metlakatla was to perform baptisms and marriages. In fact, according to his journal, Bishop Hills travelled to Metlakatla in April of 1863 because "Mr. Duncan had urgently pressed for a Clergyman to come and Baptize." After a discussion with Rev. Cridge, Bishop Hills delayed his trip to England, so he could go to Metlakatla with Commander John Pike of the gunship *Devastation*. He felt that a personal visit to the mission "would greatly strengthen my appeal to England could I take with me an account of personal inspection of the work."[26]

It is clear from Rev. Dundas's journal detailing his trip to Metlakatla that he had previously spoken with Duncan about obtaining cultural objects. After being offered some artifacts near the community of Bella Bella in Milbank Sound, at what he thought were exorbitant prices, Rev. Dundas wrote: "I am the less eager at present to possess myself of curiosities, because I gave Duncan a commission to make a selection for me: & I hope to find an assortment at Metlahkatlah."[27]

It is not clear whether Rev. Dundas had written Duncan asking him to assemble artifacts or it was a verbal request made when they met earlier, at Nanaimo, on July 29, 1863. Whatever the previous arrangement, Duncan was not expecting Rev. Dundas to arrive at Metlakatla in October and was delighted to see him.[28]

It is also not clear that, by commissioning Duncan to obtain artifacts, Rev. Dundas intended to pay for them. Rev. Dundas's great-grandson, the late psychology professor Simon Carey, was unable to determine whether payment was made. He suggested, however, that his great-grandfather, who was reportedly not financially well off, and his friend

Opposite page: The Anglican church at Metlakatla.

Lt. Edmund Verney were both keenly aware of the potential value of the objects they were collecting.[29]

Rev. Dundas shipped his collection to England, perhaps under the care of a colleague, Rev. John Sheepshanks, who had arrived in Victoria with him in the summer of 1859. In a letter to his mother in May of 1865, on his way home from Victoria, Rev. Dundas asked after the collection: "I hope S[heepshanks] has returned to you my Indian things safely – I set great store by them after paying dearly for them."[30]

So, perhaps Rev. Dundas did purchase the collection. According to Martha Black, Curator of Ethnology at the Royal BC Museum, it is often difficult to determine the circumstances surrounding material collected by missionaries. How were the artifacts obtained? Was money paid and for what purpose was it used?[31]

Decades later, Carey saved his great-grandfather's collection. After the Second World War, when he discovered that his mother and aunt (Rev. Dundas's granddaughters) were planning to dispose of the "Indian collection," Carey stepped in to become caretaker of the artifacts. Then, in the 1970s, Rev. Dundas's last surviving daughter gave Carey another legacy – his great-grandfather's 14 notebooks and journals covering the time period 1859–1865.[32] It was then that Carey began researching the collection's history in earnest and, as a consequence, realized that his ancestor's artifacts had not been getting the respect that they deserve as precious material testaments to Northwest Coast culture.

In his paper, "The Dundas Collection: Responsibilities of a Private Curator," given at the British Museum conference "Boundaries in the Art of Northwest Coast of America" in May of 2000, Simon Carey wrote: "My own son and daughter used to use them for dressing up in charades, and I remember the screams of Juliet's 5 year old contemporaries when in relation to a class project on Red Indians, her class came to our house to see the things and Benjamin appeared from behind a curtain wearing the portrait mask."[33]

Carey contacted Hermione Waterfield of Christie's, and then Peter Wilson, chairman of Sotheby's, in London, who offered to broker the sale of the collection. They confirmed that he was in possession of not simply old curios, but historically significant objects that deserved better treatment than being used for children's "show and tell." Carey placed the mask and the two antler clubs in his bank's vault for safekeeping.

Over a period of years spent discussing and negotiating with museums and individuals in Britain, Canada and the United States, Carey concluded that his dream of keeping the collection together and finding a solution to death and inheritance taxes was not to be. He also felt he had a second obligation to the collection, which was to publish a well-produced, scholarly catalogue that would keep the collection together, at least in book form, and preserve it in that manner for future study by ethnographers and art historians. Unfortunately, by the time of the public sale of the material at auction, this goal had not been realized."[34]

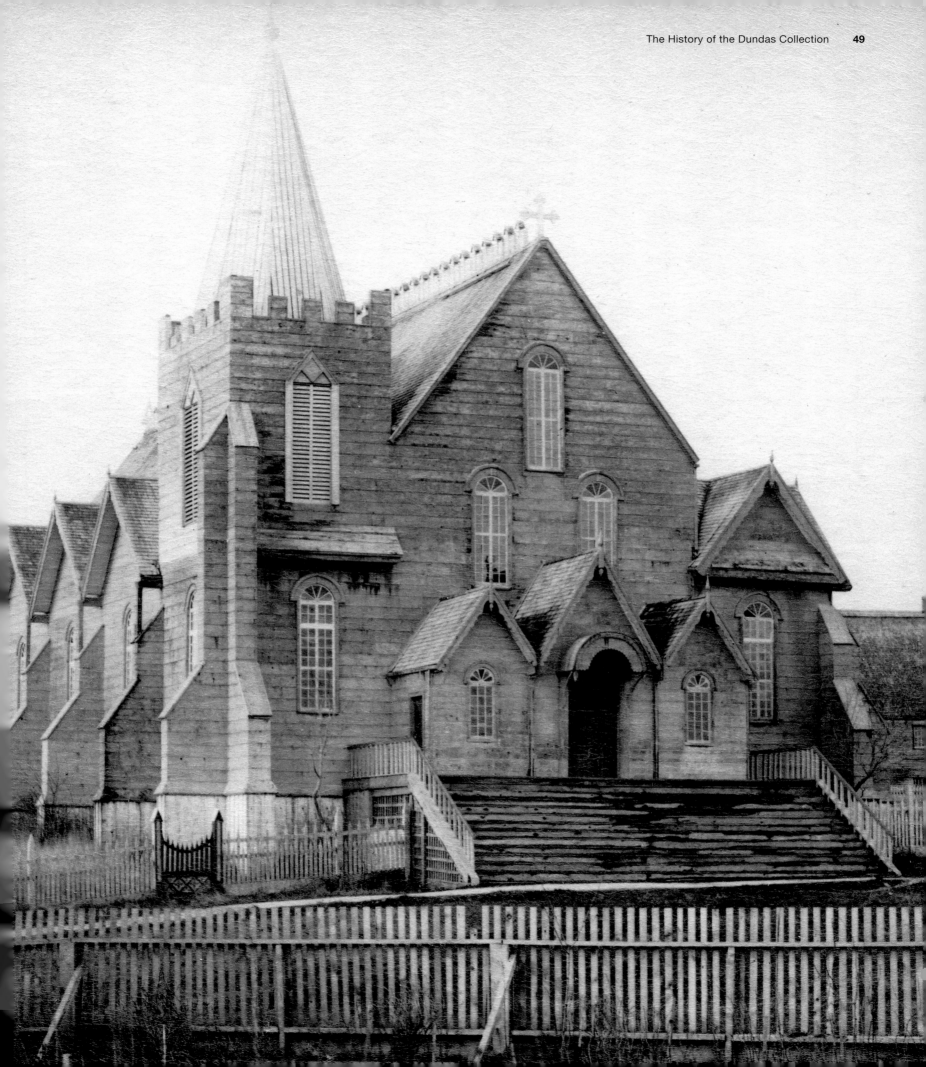

Lieutenant Edmund Hope Verney

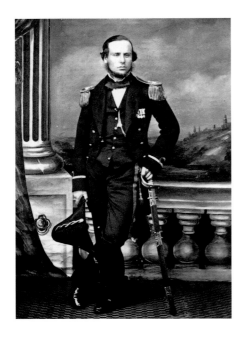

Lt. Edmund Hope Verney (1838–1910) was "a strongly pious Victorian naval officer," wrote Allan Pritchard in his book *Vancouver Island Letters of Edmund Hope Verney*. His father, Sir Harry Verney, was an active member of the Church Missionary Society and cousin to the first Colonial Bishop of Columbia, George Hills.[35] Lt. Verney arrived in Victoria on May 13, 1860, to take command of the gunship *Grappler*, remaining on the coast until June of 1865, when he left for San Francisco. He then travelled overland to the east coast of the United States and home to Britain via Halifax.[36]

The *Grappler* and its sister ship *Forward* were dispatched to various locations on the coast, primarily to deal with the conflict between First Nations peoples and colonists,[37] and to arrest and fine "whiskey sellers," those involved in illegal liquor sales.[38] One of the purposes of the *Grappler*'s voyage in October of 1863 was to intercept schooners engaged in the illegal liquor trade, confiscate their cargoes of contraband alcohol, arrest the crews and, in some cases, seize their vessels.

On October 4, 1863, Rev. Dundas noted in his journal: "All the naval officers commanding vessels on the V. I. [Vancouver Island] Station, hold the Governor's Commission as special Magistrates & Justices of the Peace – so that they can deal summarily with the Whisky traders. The penalty is £100 fine, & confiscation of the vessel & cargo."[39]

Apparently, Rev. Dundas "became EHV's closest friend among the local Anglican clergy." In understanding the story of the genesis of the Dundas Collection, it's also important to note that Rev. Dundas and Verney had a shared interest, a passion for collecting artifacts or, as they were referred to in the 18th and 19th centuries, "curiosities." In fact, Verney had previously acquired collections while in India and Hong Kong.[40]

The two men collected cultural materials on their somewhat tedious voyage up to Metlakatla. Rev. Dundas reports that on October 20, 1863, he purchased two wooden spoons "for a bit of soap," but that "Verney was more lucky." By "luck," Rev. Dundas may have been referring to objects such as two wonderfully carved Heiltsuk chiefs' staffs acquired by Verney, possibly on this same occasion. Hand-printed on one of the staffs, now in the Royal BC Museum collection, is "STAFF. HAIDA, NORTH AMERICA. E.H.V. 1864." Attached to this same staff is a paper label with the typeset header "BEASLEY COLLECTION," and, written in a hand different from that on the first label are the following words: "HAIDA H.M.S. GROWLER 1864 11/-6-1931." The paper label identifies the Royal BC Museum staff as part of the Beasley Collection, but mistakenly gives the name of the ship as the *Growler*, which Verney led in West Africa and the Mediterranean in 1871–1873. The only information recorded about the second, privately owned staff is that it was collected by "the master of H.M.S. Grappler… in 1864."[41]

The Verney Collection was purchased in 1931 by Harry Geoffrey Beasley (1882–1939), a major collector of ethnographic artifacts, from Sir Harry Verney, a descendant of Lt. Verney. In 1944, a substantial portion of the Verney Collection was acquired by the British Museum.[42]

Verney also made a second trip to Metlakatla in the fall of 1864. In a letter to his father, he wrote: "I am buying one or two curiosities, but very few: I sent you a really good collection at the beginning of this year, and there is no object in getting more of the same: I shall however get a dozen or so of mats, which I think you will always be glad to have." [43]

It is not clear if Verney collected those remarkable chiefs' staffs in the same year. It does appear that everything he collected, including the latest series of mats he referred to, was shipped to England by the middle of December in 1864. [44]

Benjamin Carey, Simon Carey's son and Rev. Dundas's great-great-grandson, suggests that his ancestor was somewhat jealous of Verney. [45] With a gunboat at his command, Verney was able to collect large objects such as totem poles (he acquired two Coast Salish house posts at Comox on Vancouver Island). Rev. Dundas's comment about Verney's "luck" certainly confirms that there was a hint of competitiveness in their friendship and their shared interest.

In addition to the Heiltsuk staffs that he may have acquired on the voyage to northern British Columbia in 1863, Verney also obtained at least two frontlets and an elaborate wooden crest hat while he was at Metlakatla. One of the artifacts in the Dundas Collection is the small carving of a whale, which is actually a missing component of a wooden hat that used to be part of the Verney Collection and is currently in the British Museum. According to the Dundas family, there could have been some mixing of the two collections when they were shipped from British Columbia to England. [46]

The SS *Grappler*, after being dismantled as the gunboat HMS *Grappler*.

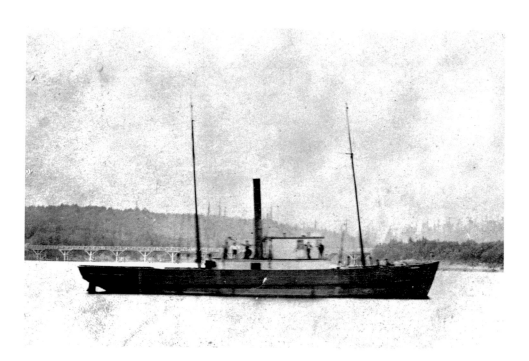

William Duncan

Opposite page: In order to preach his Christian message effectively to the Tsimshian, William Duncan, pictured here, acquired fluency in their language.

Below: Paul Ligeex, the highest-ranking chief of all nine Lower Skeena Tribes.

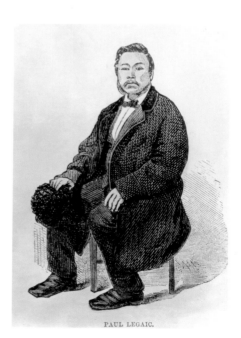

PAUL LEGAIC.

Lay missionary William Duncan (1832–1918) is undoubtedly the best known of the three non-Native individuals at the centre of this story. He arrived in Victoria in 1857 with the sponsorship of the Church Missionary Society, the first Anglican missionary group devoted exclusively to converting indigenous peoples to Christianity wherever Britain established colonial outposts. The Church Missionary Society was formed some 50 years before Duncan became one of its missionaries.[47] Its basic tenets reflected a strict hierarchical perspective that positioned British Victorian society at the top and firmly believed that material accomplishments are closely tied in with Christianity.

Duncan was sent to Fort Simpson at the recommendation of Captain James Prevost, commander of the HMS *Satellite*, who was stationed on the coast of British Columbia in 1854. A visit to the Hudson's Bay post at Fort Simpson convinced Prevost that the Tsimshian, who left their villages at Metlakatla Passage after the Hudson's Bay post was moved in 1834, would benefit greatly from instruction in the "knowledge and arts of civilized life."[48]

Duncan began his missionary work at Fort Simpson in October of 1857. In order to preach his message of Christianity effectively to the Tsimshian, Duncan acquired fluency in their language. By May of 1862, he had gathered 50 followers and established a Christian community at one of the old village sites on Metlakatla Passage, south of Fort Simpson at the western edge of Prince Rupert Harbour. Later, many more Tsimshian joined Duncan.

In the spring of 1862, a smallpox epidemic began in Victoria. It originated from a ship carrying miners from San Francisco and was carried up the coast by canoe loads of fleeing First Nations peoples who had been driven out of Victoria. As many as 250 perished in Fort Simpson, but only five died at Metlakatla and, by August of 1862 the population at this safe haven soared to 600.[49]

Initially, Duncan's missionary efforts attracted primarily marginalized people who did not have the resources and family relationships to advance in the traditional, class-conscious Tsimshian society. In Duncan's Christian community, even slaves and their descendants were assured equal status with their former owners.[50] However, he was also able to convert high-status Tsimshian, particularly after the outbreak of smallpox. When their chief converted to Christianity, almost the entire Gitlaan tribe followed him to Metlakatla.[51] Then in the spring of 1863, Ligeex of the Gispaxlo'ots, the highest-ranking chief of all nine Lower Skeena Tribes, came to Metlakatla and was baptized by Bishop Hills.[52]

Unlike the Gitlaan chief, however, Ligeex did not lead the Gispaxlo'ots into Duncan's fold. Quoting Duncan, Bishop Hills noted in "Indian Converts of Metlakatla, April 1873," that Ligeex, in converting, has "made greater sacrifices than any other in the village…and has left his tribe and all greatness."[53] Only six people accompanied Ligeex to Metlakatla and none were of high status.[54] The tribe maintained his house in Fort Simpson

and, on occasion, attempted to persuade him to attend ceremonial events there. In December of 1862, Duncan wrote in his journal: "Clah [is] at Metlakatla to draw away Legaic [Legeex] to a feast."

Approached by Arthur Wellington Clah, Duncan's former Tsimshian-language teacher, who asked if Ligeex could attend the feast, Duncan refused, later noting in his journal: "I gave him some convincing reasons for so doing."[55] The modern majority opinion suggests that Ligeex converted for political reasons. He had suffered a number of setbacks to his prestige when he became chief, in 1840, after the death of the previous Ligeex.[56] According to a more radical theory, the tribe elders decided, after a secret meeting, that Legeex should leave Fort Simpson and join the converts at Metlakatla.[57] Based on field work at Port Simpson conducted in 1940, the anthropologist Homer Barnett recorded that it was Ligeex who requested the elders meet in secret to decide his future with the tribe: "They agreed that he should clear out entirely, but that his chief's name and place would not be filled as long as he lived…[and] at the same time, he was to retain his rank and the privileges which went with it in accordance with the continuing native pattern at Fort Simpson."[58]

Conversion to Christianity and the Transfer and/or Destruction of Material Culture

William Duncan had strict rules of conduct for those who wished to join his Christian community. One of these rules dictated that converts may no longer participate in the potlatch, a ceremonial feast held to demonstrate wealth and generosity, and to celebrate Tsimshian social organization. A vital part of Northwest Coast culture, potlatches provided a venue for crests, which are the emblems of clan membership, to be validated and displayed, and for those coming of age in Tsimshian society to assume their inherited names. Chiefs who have made the conscious decision to no longer participate in potlatches would then have made it clear that they need not keep any crest regalia, as such emblems are used only at feasts and potlatches.

For Duncan, conversion to Christianity was an either/or proposition. Converts were required to demonstrate full loyalty to their newfound faith by giving up all aspects of the traditional Tsimshian way of life.[59] For high-ranking chiefs, this meant no longer participating in traditions that were the cornerstones of Tsimshian culture. They could not participate in the potlatch and in the winter ceremonials in which they initiated high-ranking children into secret societies and exhibited prestigious and dramatic privileges in the form of masked dramas and other impressive displays of spiritual power.

Duncan's autocratic style and his unbending opposition to the potlatch were made clear in his diary note in the fall of 1862 citing a conflict between him and a certain individual who defied him: "John's case gives me the greater pain because he seems violently set upon evil & to do all the mischief he can. He even dared to denounce me as the cause of all the evils which have come upon the Indians & all because I rebuked him for having called the heathen together last Sunday & distributed property to them."[60]

William Duncan with some of his Tsimshian Christian converts.

The matrilineal Tsimshian society was comprised of "Houses," which are given traditional names.[61] These Houses owned land and village sites, food-gathering territory and the resources upon and within them, as well as intellectual property, which included origin myths, songs, names and crests. In turn, Houses belonged to one of four non-local clans, each clan identified with particular, usually animal, emblems. Called crests, these emblems were a highly regarded feature of the Tsimshian social structure.

Table 1 lists the four Tsimshian clans and their crest animals. Enclosed within parentheses are the English translations of the clan names. Table 2 divides the Dundas Collection artifacts according to clan, based on the crests depicted on the artifacts.

Table 1: Tsimshian clans and their primary crest animals	Laxgibuu (Wolf)	Gisbutwada (Killer whale)	Ganhada (Raven)	Laxsgiik (Eagle)
	wolf	grizzly	raven	eagle
	bear	killer whale	frog	beaver

According to the late University of British Columbia anthropologist Dr. Marjorie Halpin, the data compiled in the lists of crests[62] collected by National Museum of Canada folklorist and anthropologist Dr. Marius Barbeau and Tsimshian linguist and ethnographer William Beynon indicate that only certain artifacts could be considered crests. The crest artifacts in the Dundas Collection are those classified as headdresses or hats, the weapons and possibly the sheep-horn ladle with its handle carved to depict a raven.

Four Dundas Collection artifacts featuring carved figures that may portray the eagle – a primary crest animal of the L̲axsgiik clan – are either dishes or bowls. Classified in the category of feast dishes and ladles, the bowls are not excluded from being crest objects but were less often considered as such.[63]

Two bowls (only one bowl is pictured in this book) in the collection do not show evidence of having been used much. These items were crafted perhaps as part of Duncan's economic strategy of producing items that could be sold to outsiders to support his Christian community's development projects, which Duncan alluded to in his journal: "I had a good deal of talk with several friends about what the Indians might be able to provide if set to work. Oil – Fur – Dried Fish – Berries – Yellow Cypress – Indian Curiosities – Mats – Native Paints – Resin – Grease & Shingles are our very first for Exports."[64]

Deciding that it would be to the village's advantage to ship products to Victoria, Duncan purchased a schooner, the *Caroline*, in the summer of 1863. On board the *Grappler* on his way to Metlakatla, Rev. Dundas met the *Caroline* on one of her first trips down to Victoria, noting in his journal: "They were taking down a cargo of Furs – Indian Curiosities & fish."[65]

The bowls that could well be among those objects produced specifically for selling are very different from the four bowls with the deep patina suggesting prolonged use. The two combs in the collection are typical examples of this utilitarian but often highly decorated object, but they are, interestingly, also very different from each other. Combs are not included in the Barbeau–Beynon list of crests, nor are they in the list of paraphernalia used by Tsimshian shaman or other *halaayt*.[66]

According to the Barbeau–Beynon crests list, "mosquito" is listed as a general L̲axgibuu crest and also as a wooden headdress showing the head of a mosquito. The owner of the mosquito headdress is recorded as the L̲axgibuu House of wElck from the Gitsiis.[67]

William Beynon[68] recorded that Nisła̱ganú's was the Gitlaan chief who came to Metlakatla with his entire tribe. This chief, identified in the Barbeau–Beynon list of Houses as the first-ranking chief of the L̲axgibuu clan of the Gitlaan tribe, is probably Neeash Lahah, the "Lame Chief" who was 70 years old when baptized by Bishop Hills in April of 1863.[69]

Table 2: Crest artifacts in the Dundas Collection attributed to clan	**L̲axgibuu** (Wolf)	**Gisbutwada** (Killer whale)	**G̲anhada** (Raven)	**L̲axsgiik** (Eagle)
	Mosquito [?] headdress (page 75)	Killer-whale fin (page 77)	Frog hat (page 71)	
	Bear headdress (page 73)	Killer-whale attachment (page 79) to Grizzly Bear headdress[70]	Horn Raven ladle (page 125)	

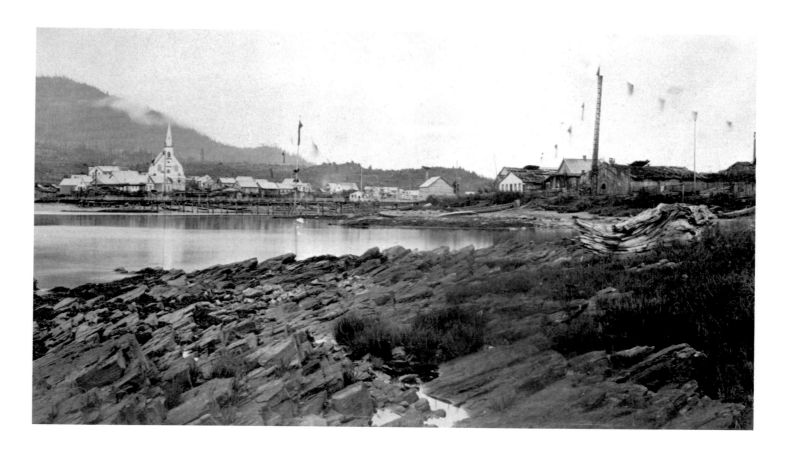

Sponsored by the Anglican Church Missionary Society, William Duncan began his missionary work in October of 1857 at Fort Simpson, pictured above.

The bear headdress could be a Laxgibuu or a Gisbutwada crest, as both clans claimed a number of bear emblems. Without specific documentation, it is difficult to distinguish a grizzly or brown bear crest from a black bear crest. The mortise (hole) at the back of the figure's head may have held a fin, which meant that the headdress was depicting a sea bear. This would then transform an otherwise general bear crest into a high-status crest that might be worn by someone from a councilor-class House or even a much higher-ranking House.[71]

There is a high-ranking crest called the "Fin of Scalp" belonging to the Gisbutwada clan. It is described as a fin attached to the head with a strap.[72] There is no extending wooden tenon on the base of the Dundas fin that would allow it to be inserted into a mortise on a headdress, but there is a heavy piece of leather to which it is attached by thongs. This may identify the Dundas killer-whale fin as a Gisbutwada "Fin of Scalp."

The wooden frog hat with a human face on its lower jaw appears to fit a crest category indicating clan membership as well as high status. The crest is modified by the presence of the human-face, making it a "Supernatural Frog" and the exclusive prerogative of a high-ranking House within the Ganhada clan.[73]

The two large war clubs, apparently made of elk antler, are probably also crest objects. Heirloom weapons, like all crests, were accompanied by narratives detailing their histories. Such a narrative for "The War Club Representing a Woman" was recorded by Beynon in 1916. It describes how that club was made and then used in a battle with Ligeex over trading rights on the Skeena River. Afterwards, the club became a crest in the Gisbutwada House of Gayemtkwe from Kitlaktla.[74] The bird figure on the end of the less archaic Dundas club may be an eagle, suggesting a

Laxsgiik origin. Assigning these objects to a particular clan or House
without the narratives that give the crests' histories is, at best, an academic
guessing game. Unfortunately, the majority of the Northwest Coast
artifact collectors – including Duncan and Rev. Dundas – never made the
effort to record primary information essential to identifying the objects.

The prototype of these Tsimshian war clubs, made of caribou antler,
was carried by the warriors of some Athapaskan groups. In some cases,
the clubs' short projecting arms had sharp blades of stone or metal.
Similar crest clubs made both from antler and from wood were collected
from the Tsimshian. A fine wooden example was acquired by U.S.
government agent James G. Swan, probably in 1876 from the Reverend
Thomas Crosby (1840–1914), a Methodist minister at Fort Simpson.
The third Dundas war club, which is much smaller and appears to be
made from caribou antler rather then elk, may initially have been of
Athapaskan origin. Two miniature antler clubs, dated 500 B.C. and very
similar in form to the clubs in the Dundas Collection, were found at an
archaeological site in Prince Rupert Harbour. These small clubs were
probably used for ceremonial or shamanic purposes. Perhaps the small
Dundas club was used in a similar fashion.[75]

The Christian membership charter at Metlakatla required converts to
give up any involvement in the *halaayt* winter ceremonials, which Duncan
called "Indian deviltry."[76] On Thursday, February 19, 1863, Duncan wrote
in his journal: "I gave them a long talk to about their conduct last night –
calling the Ahlied."[77]

As celebrations of spiritual power, the *halaayt* ceremonials highlight
the dance performer and the dance ritual. *Naxnox* is the spirit power
animating the performance. Duncan noted: "The old chief told me that
he had burnt all the instruments of heathenism called Noknok – as he
did not want to have them near him.[78] I have bought two of the
celebrated Noknok today for 1/6 worth of soap. These things with which
the [illegible] are made in the winter & said to be supernatural."[79]

In the potlatch, chiefs are dressed in crest robes and headdresses,
their faces uncovered. In *halaayt* ceremonies, the chief wore a Chilkat
blanket (*gwis halaayt*) and a frontlet (*amhalaayt*) and used a raven rattle
(*hasem semhalaayt*). In his role as *semhalaayt* (true *halaayt*), the chief as
priest strengthens children with his supernatural power by throwing it
into them. In his role as *wihalaayt* (great dancer), he initiates adults into
one of the two secret societies open to families who could afford to pay
for the ceremony.[80] Initiates wore cedar-bark neck and head rings as did
the chief who initiated them. The initiates of the *MitLa* (Dancers) society
carried clappers instead of rattles. It would appear that the four clappers
in the Dundas Collection were the accoutrements of one or more
initiates of the *MitLa* who converted to Christianity. The *NuLem* (Dog
Eaters) apparently did not carry clappers.

Paul Ligeex was an initiate of the Dog Eaters, so it is unlikely that
the Dundas clappers were once his or his daughter's property. The

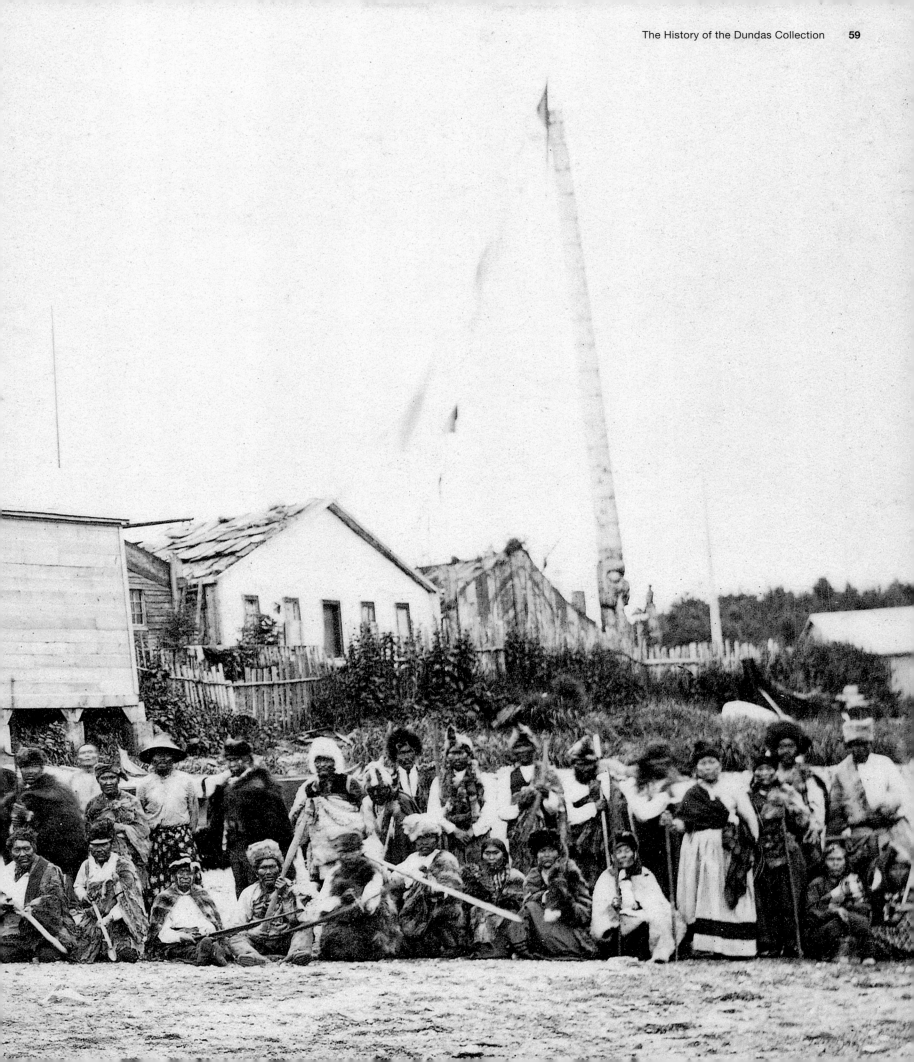

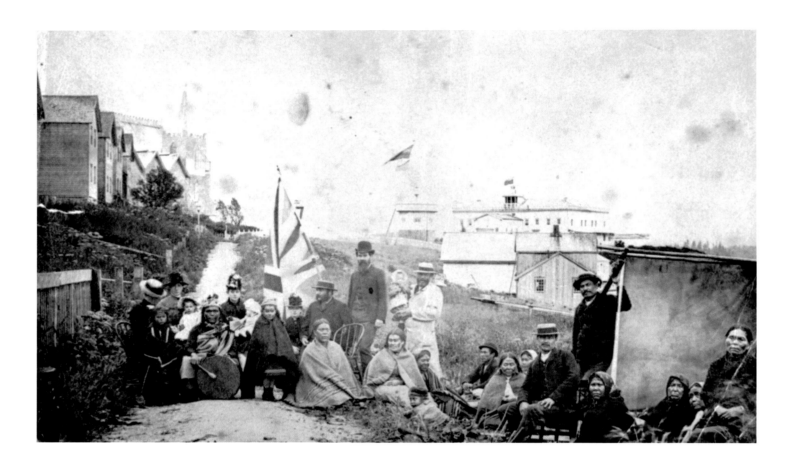

Metlakatla's residents celebrating Dominion Day.

conflict at Fort Simpson between Ligeex and Duncan took place during the initiation of Ligeex's daughter into the Dog Eaters' dancing society. Ligeex was concerned that Duncan's incessant ringing of the school bell could bring spiritual harm to his daughter as she approached the end of her transition back to the secular world. Duncan thought that Ligeex was simply annoyed by the sound of the bell.[81]

In addition to the power-throwing ceremonies and the dancing societies, there were also *Naxnox* dramatizations. These involved the spirit names owned by the house lineages that were separate from crest names. Named characters were presented to the audience as charades by masked dancers who provided, through actions and mannerisms, clues, so the audience could guess the characters' identities.[82] The identities of the *Naxnox* names portrayed by the two Dundas masks are lost to memory.

However, the following description, recorded at Port Simpson by anthropologist Dr. Viola Garfield in the 1930s, of Ligeex's sister welcoming guests to a 19th-century potlatch offers a glimpse into how these masks were used in *halaayt* ceremonies:

"The visiting canoes drifted in close to shore. In her dance, Ligeex's sister went through the motion of grasping her guardian spirit power from the air and throwing it toward the canoes. The chief in the foremost canoe caught it. He wrestled with the power and then threw it back and she caught it again. Once, long ago, so tradition states, visitors neglected this formality and there was strife between the guests and hosts as a result. The guests then landed and were received.

The power used by the chief's sister was "All Calm Heavens" (Txa-gaksem-laxha'). She wore a mask, on which was portrayed a human-

supernatural face representing this spirit, when she greeted the visitors. A man accompanied her, blowing a whistle which was the voice of the spirit. This was one of the spirit representations used by Ligeex in power ceremonies."[83]

The only clue we have to a possible identification of the two masks in the Dundas Collection is Duncan's diary entry: "Leequneech [sp.?] has given me two masks."[84]

The identity of the individual who provided the masks is unclear. He is referred to by Duncan as "the 3rd chief" when he spoke at a Christmas Day "feast" at Metlakatla in 1862. When this chief was prepared for baptism by Bishop Hills in April of that year, he rendered his name as "Leeqe-neesh (39) (a chief)."[85] It has not been possible to identify this chief's name in the Barbeau–Beynon list of Tsimshian Houses.

Duncan was also the source for a third mask, a human face with a small paper-clip-like metal object below its lower lip, representing a labret (lip ornament). Currently in the Royal BC Museum, this mask was in the collection of Rev. Edward Cridge and was a gift from his good friend William Duncan.[86]

The medicine man, or shaman, was also a *halaayt*, specifically a "*swensk* (blowing) *halaayt*." The artifacts that were used by the *swensk halaayt* included round wooden rattles (with or without carved designs on them); carved bone charms; wooden human-like dolls or statuettes; and bone tubes, referred to as "soul catchers," often with carved animal heads at each end.[87] It appears then that the Dundas Collection's two wooden figures – the globular rattle and perhaps the carved bone charm – may both have been the property of a curing shaman. Rev. Dundas called the bone charm and one other item – apparently a soul catcher, which was subsequently stolen from Simon Carey in the 1970s – "soul holders." On reflection, this is a more apt descriptor then "soul catcher."[88]

On October 27, 1862, Duncan wrote in his journal: "An Ahlied sent first & then came himself this morning about building here… He has long since desired to give up being the blowing doctor and he will give it up if he remains here."[89] The next day, Duncan wrote: "I went to see the individuals this afternoon that had been talking to & against the Constables & they were made to understand that I would have no swnsconse [*swensk halaayt*] here."[90]

Then, on February 19, 1863, Duncan noted: "Leegaic also gave me his rattle & gambling tools – also some fish hooks of the ancients."[91]

This is the only reference that was found regarding the artifacts that Ligeex gave up when he converted to Christianity. The rattle referred to would most likely be a raven rattle – a regular part of a chief's priestly regalia – but perhaps Duncan is referring to the globular rattle. According to anthropologist Marjorie Halpin, chiefs in a role as priest could act as a curing shaman when it was necessary to remove excess, and therefore dangerous, power that they had thrown into an initiate. The excess power was removed by sucking it out of the body and blowing

it out the smoke hole in a similar manner to a *swensk halaayt* when the latter was removing illness from a patient. If the chief acted as a curing shaman, perhaps the globular rattle in the Dundas Collection was once the property of Ligeex, not that of a shaman.[92]

Early characterizations of Ligeex as a shaman, including Rev. Dundas's description of him as "the Chief Sorcerer or Medicine Man of the Chimpsean tribe,"[93] can now be perceived as confusing the roles of the chief as priest, *semhalaayt* or *wihalaayt*, with the role of the curing shaman, the *swensk halaayt*. Canadian anthropologist Marie-Françoise Guédon states categorically that none of her First Nations consultants "ever identified the chief with the shaman."[94]

Based on journal entries in the late 19th and early 20th centuries and on the written works of modern scholars, the conversion and baptism of Ligeex, the highest-ranking chief among the Lower Skeena Tsimshian, is perceived as a "considerable coup for [William] Duncan."[95] This popularly held opinion led to the assumption that a significant portion, if not all, of the older artifacts in the Dundas Collection came from Ligeex's Laxksik House. It must be noted that members of the Tsimshian community did not share this perspective. This brief examination of the Barbeau–Beynon files as presented in Marjorie Halpin's 1973 doctoral dissertation has confirmed the contemporary Tsimshian position that the name/title Ligeex was not a major source of artifacts in the Dundas Collection. However, it is not inconceivable that several other people gave Ligeex their ceremonial objects and that he in turn gave them to William Duncan.

Tsimshian wood carver at Metlakatla.

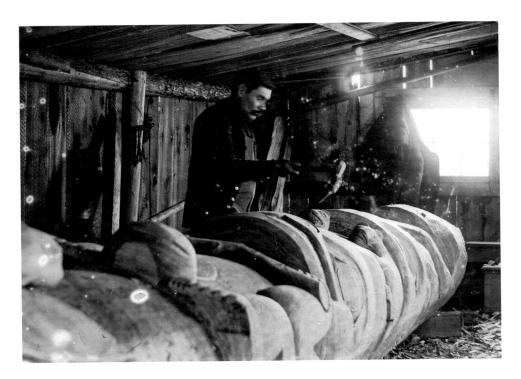

Summary

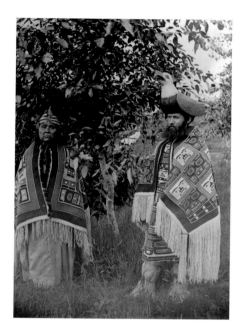

The Reverend Thomas Crosby, pictured with Victoria Young, a high-ranking Tsimshian chief, was the Methodist minister at Fort Simpson. He too collected artifacts from the Northwest Coast.

The Dundas Collection was the first missionary-acquired collection of artifacts from the Northwest Coast. A decade later, Rev. Thomas Crosby, the Methodist minister at Fort Simpson, began to collect artifacts too, but unlike Rev. Robert Dundas and his friend Edmund Verney, Rev. Crosby obtained cultural materials in order to sell them. His first transaction was the sale of three totem poles and a house front to U.S. government agent James Swan, who was collecting artifacts for the 1876 Centennial Exhibition at Philadelphia. Researcher Joanne MacDonald has noted that Crosby was very directive in assembling his collections, sending members of an Indian council to seek out "the medicine-man's rattles and charms."[96]

In 1908, George Heye of the Museum of the American Indian, Heye Foundation, purchased a substantial collection from Crosby. This collection is now part of the new National Museum of the American Indian, Smithsonian Institution, which opened in Washington, D.C., in September of 2004. It is estimated that Crosby sold approximately 300 Northwest Coast artifacts to American collectors and museums in the 1880s.[97]

Crosby was also the source for 23 objects that came to the Canadian Museum of Civilization in 1886. In 1977 a further 18 artworks were obtained from his son, Robert Crosby. These later acquisitions include the Chilkat tunic and unique blanket that Thomas Crosby was photographed wearing in the late 1870s.[98]

Commenting on Crosby's approach to collecting, University of British Columbia authors Jan Hare and Jean Barman wrote in *Good Intentions Gone Awry: Emma Crosby and the Methodist Mission on the Northwest Coast*: "Perhaps tweaked by Swan's interest, Thomas thereafter collected the very same items he was encouraging peoples to get rid of – everything from carved figures to dancing masks."[99]

According to MacDonald, the missionaries' unrelenting disparagement of traditional practices resulted in more ceremonial artifacts being collected by them than any other group or class of collectors.[100]

Among the important missionary collectors of artifacts were father and son W. H. and W. E. Collison, who collected from the Haida, Tsimshian and Nisga'a. W. H. Collison was at Metlakatla in 1873 and established a new Anglican mission at Masset in 1876. His son, W. E. Collison, replaced him at Masset in 1899 and later became a federal Indian Agent responsible for the Nass and Skeena agencies. The Museum of Anthropology at the University of British Columbia acquired 200 artifacts from the Collison family in 1960.[101] In 1974, the Royal BC Museum obtained 42 artifacts from Dr. J. A. Macdonald, the son-in-law of W. E. Collison and a medical missionary at Kincolith. Some of these artifacts came from the Collisons, some from Dr. Macdonald.

There were two other collectors of note, both Methodist missionary doctors. Dr. George H. Raley – who arrived in the village of Kitamaat in 1893, later moving to Port Simpson in 1906 and then to the Coqualeetza

Tsimshian artist at work.

Residential School at Sardis in 1934 – collected some 800 objects, which were Tsimshian, Haisla and Coast Salish in origin. The University of British Columbia acquired Raley's collection in 1948.[102] Dr. Richard Whitfield Large, who worked at the Heiltsuk village of Bella Bella from 1898 to 1910, assembled and sent to the Ontario Provincial Museum during that period of time two collections comprised of a total of 284 artifacts. Royal BC Museum curator Martha Black suggests that he assembled the collections in response to a request from the Provincial Archaeologist of Ontario. One hundred and thirty-nine of these artifacts are in the collections of the Royal Ontario Museum in Toronto.[103]

Missionaries in Alaska also collected artifacts. The most prominent of these was Dr. Sheldon Jackson, a superintendent of Presbyterian missions. Between 1877 and 1886, he sent material to Princeton College (which later became Princeton University) in New Jersey. After 1886, Jackson redirected his collecting efforts toward providing artifacts for a new museum in Sitka in Alaska, which was later named after him.[104]

Christian missionaries acquired the artifacts of indigenous peoples for a number of reasons. They wanted to demonstrate that their converts' former way of life was pagan and idolatrous. More importantly, they believed that giving up these heathen objects demonstrated that their missionary objective had been achieved, that Christianity had won and these people were now securely within the fold. These artifacts were also displayed for purposes of fundraising. At least two objects that Edmund Verney obtained – the house posts from Comox – were featured at a missionary-sponsored exhibition in Manchester in the 1870s.[105] Rev. A. J. Hall, an Anglican missionary who served briefly at Metlakatla and then for many years at Alert Bay, sent back artifacts to the Church Missionary Society, presumably to support its missionary activities.[106] Rev. A. E. Price, the Anglican minister at Kitwanga in the late 19th century, gave four objects to the Church Missionary Society, three of which he had collected himself.[107]

Rev. Dundas did not collect for a missionary society. Neither did he function as a "picker" for professional collectors as did his colleagues, who acquired objects in the 1870s and after.[108] It can be argued that Rev. Dundas collected for his family's "cabinet of curiosities." His collecting was a continuation of the long-standing European tradition of collecting by princes and scholars, with the artifacts as markers of travel to exotic, untamed regions.[109] This was collecting for family status, not to supplement a paltry income or to support the Christian mission. It was simply collecting for the love of collecting.

Alan L. Hoover
Victoria, April 2007

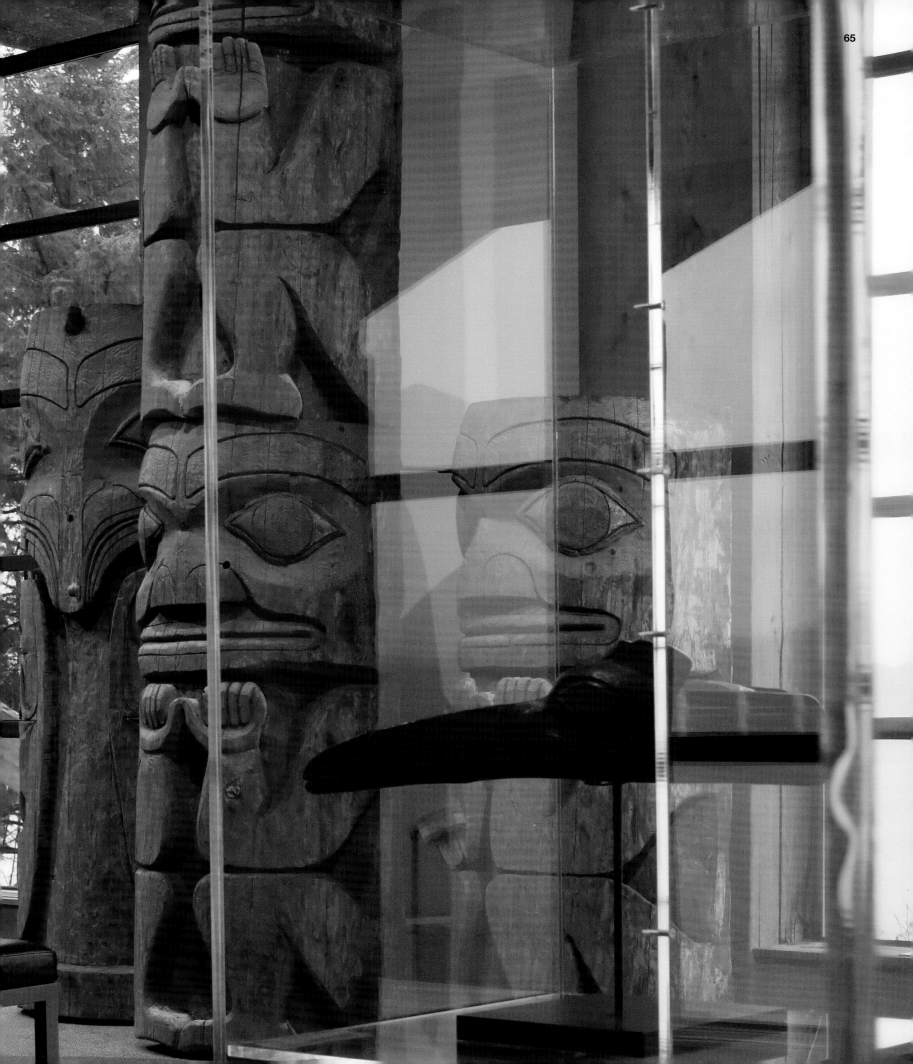

20

off inside, for separate sleeping places. Any one coming as a resident to Metlakatlah applies to Mr. D. to allot him a house-site: on this he must erect his house on an approved plan. Some of the villagers have already gardens in front of their cottages where the space admits: & a good pathway, to be by & bye widened into a road, is being carried along between the cottages, & slope of the bank. All the space round, & in front of the School House, has been levelled & covered with gravel: & a handsome Flag staff with the English Ensign, occupies a com- manding position – the said Flag

21.

being hoisted every Sunday, & when- ever a Queen's ship enters the harbour. It was rigged for them by the "Devastation" when she took the Bishop there last April. Any Indian, against whom nothing is known – is received, to settle here – The conditions are – 1. That he renders implicit obe- dience to Mr. Duncan, & observes all the Laws he lays down, for the government of the place. 2. That he renounces entirely & for ever – all heathen practices. 3. That he attends the Sunday Service, & becomes at least, "a hearer" of Christian teaching. —

This excerpt from Rev. Robert Dundas's journal details the village of Metlakatla's layout and the rules of conduct for its Native residents.

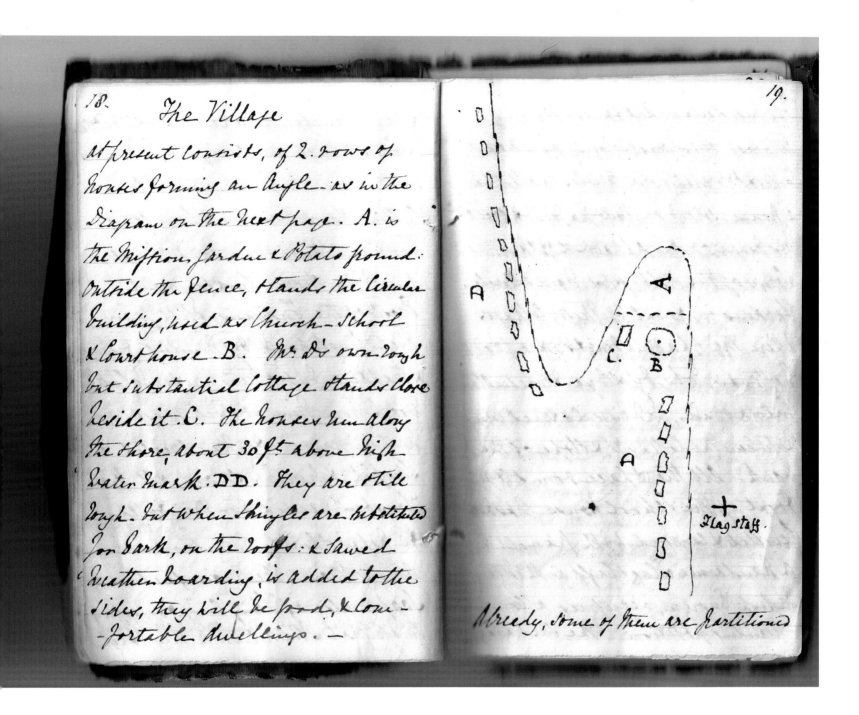

18.

The Village

at present consists, of 2. rows of
houses forming an Angle – as in the
Diagram on the next page. A. is
the Mission garden & Potato ground.
Outside the fence, stands the Circular
building, used as Church – School
& Court house. B. Mr. D's own rough
but substantial Cottage stands close
beside it. C. The houses run along
the shore, about 30 ft above high
water mark. DD. They are still
rough. but when Shingles are substituted
for bark, on the roofs: & sawed
weather boarding, is added to the
sides, they will be good, & com-
-fortable dwellings. —

19.

A

A

C.

B

✝
Flag staff.

Already, some of them are partitioned

In this diary entry, Rev. Robert Dundas
describes the buildings in the Christian village
of Metlakatla.

Bent-Corner Chest

Highly decorated rectangular chests often served as containers of a clan's treasures. Masks, ceremonial regalia and woven robes of the noble class were kept in such chests, which were decorated with images designed to protect the contents from adverse spiritual forces. In essence icons for the high-status members of secret societies and ceremonial leaders, these chests held the paraphernalia that made the powers of the chiefs visible and manifest in the world. They were the vessels of social structure and tradition, and kept their important contents from the eyes of the uninitiated.

To make these chests, a large plank was split and hewn to an even thickness, then cut across the grain with three specially shaped cuts, or kerfs, at the points where three of the corners would be. Steamed and bent at 90 degrees along the kerfs, and the last corner rabbeted and fastened by pegging or sewing, the plank then became a four-sided box or chest. A bottom piece was split from red cedar, hewn flat and fitted to the sides, then fastened by pegging or sewing. Red cedar was almost invariably used for the bottom and lid of a bent-corner container, due to its relative stability and resistance to splitting and cracking. The chest pictured has a bottom piece that is either a replacement of the original, or an original one made with an unusual adaptation – it's made up of five tongue-and-groove milled boards.

Traditionally, the top of the chest would be split and hewn from a thick block of red cedar, then hollowed out to make it lighter and better able to dry evenly. Evenly drying out makes a wood section less prone to cracking, which takes place when some areas dry out and shrink faster than others. This particular chest also has a nontraditional top made of thin milled boards like the bottom. It is attached to the sides with steel hinges, making it much easier to open and close the top of the chest. Such adaptations were not common in the early 19th century, but in areas like Fort Simpson, access to milled lumber and Euro-American style fittings and fasteners was available through the Hudson's Bay Company. First Peoples made use of methods that suited their sense of purpose, while retaining ancient traditional techniques and knowledge that they were used to and that continued to serve them well.

This chest was painted with traditional black and red "formline" designs, followed by the relief-carving of the background and negative (carved-away) areas of the designs. Some of the carved-out areas were then painted the greenish or blue-green hue that the northern coast artists used so often. The design and carving of this chest are exquisitely executed, offering a grand example of a style that had evolved in this region of the Northwest Coast to a greater degree than anywhere else. The old 18th-century design style that had been common to all of the Tsimshian, Tlingit and Haida First Nations began evolving in different ways through the efforts of artists that worked in the decades leading up to the early 19th century (see Brown, 1998). In the Tsimshian region, artists pushed the archaic design style toward a new convention of much thinner black and red formlines and much larger carved-out areas that were painted blue-green. The result was an elegant, highly sophisticated style that was inspirational to other artists on the northern Northwest Coast. This chest is a superb example of this design development composed, painted and carved by a master artist. It may once have had a top and bottom of traditional form that were replaced with Euro-American boards and hardware for a new purpose in a newly established life in Metlakatla.

c. 1840–1860
Yellow cedar, red cedar,
paint, hinges, nails
31½" long by 17¾" wide

Collection of Michael Audain and Yoshiko Karasawa

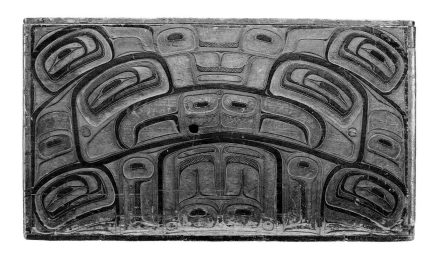

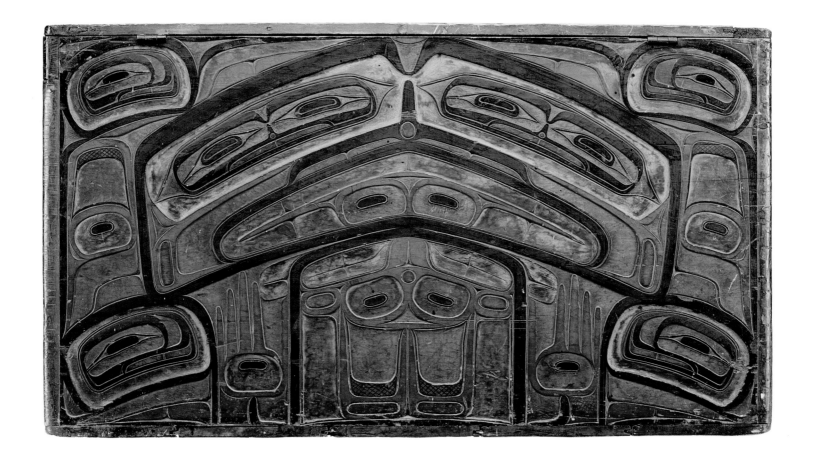

Frog Crest Hat

Clan crest hats of this type are carved of a single block of wood, hollowed out to the extreme, and often sculpted with a three-dimensional image that wraps around the hat form. Though there is a visual relationship between this type of headpiece and sculptured war helmets, this hat's semi-conical shape is based on the form and proportions of the spruce-root woven hat tradition. Spruce-root hats were frequently painted with design images that reflected the clan affiliations of the owner and manifested the history and power of the clan in a portable display object. Hats woven of spruce roots are masterpieces of the weaver's arts and feature complex shapes that require a great deal of experience to perfect. The greatest number of existing woven hats that were painted appear to be Haida in origin, but it is likely that Tsimshian artists also wove and painted this type of head covering. Many carved headpieces like this one replicate not only specific features of the hat form, but also the texture of the weaving on the spruce-root hats. Such carved texture patterns emulate the designs found on the brims of woven hats, which were created

c. 1830–1860
Alder, paint, abalone shell
13" diameter by 9¼" high

Collection of Westerkirk Works of Art Ltd.

using self-patterned twining. In this example, however, the hat form is finished with a smooth surface.

At what point in time a carver first created a wooden version of a woven crest hat and incorporated a sculptural crest figure in place of the painting is unknown. The earliest such hats in existence today, which exhibit artistic styles and feature characteristics suggestive of 18th-century creations, are Tlingit in origin. Some of these hats are housed in museums, while others have remained in Native hands and continue to be employed in the traditional ways for which they were created.

Tsimshian-style hats, like this one, are found in museums and private collections and exhibit a wide range of design imagery and compositional styles. This beautifully made hat combines a classic spruce-root hat shape seamlessly blended with the sculpture of a supernatural frog, a crest of the Ganhada, or raven clan. The frog's head protrudes far out over the flared rim of the hat, while its body and legs encircle the crown, and its feet rest on the surface of the hat brim. The limbs of the frog are painted black with red spots to imitate the varying colors and textures of the animal's skin. The simple raised ridge of an eyelid line outlines the domed eyes of the frog. As is common in Tsimshian-style totem poles, the eyelid ridge is not flattened off and painted black, which is the usual method in Tlingit and Haida styles of carving. The elegant rise of the rounded brow ridges and the shallow relief of the eye socket are also Tsimshian stylistic traits.

Beneath the lower jaw of the frog, a masklike human face peers out as if the total image is that of a human wearing a frog's skin. Bright pieces of iridescent abalone shell are inlaid in the eyes of this deeply carved small face. Though it could have been carved of one piece with the rest of the sculpture, the face is actually carved from a separate piece of wood, which is inlaid into a large opening on the lower jaw. Through this opening, the carver entirely hollowed out the frog's head, between the shape of the hat and the tip of the animal's snout. This effort was undertaken to lighten the entire headpiece and also to deter any cracks from forming as the wood initially dried out while the sculpture was completed. Lastly, the jaw covering and its human face were carved and fitted tightly into the opening. Even the face is hollowed out like a mask from behind to make everything as light as possible.

The human face represents the inner essence, the spirit of the supernatural frog and its connection to the Ganhada lineages. The overall image of this grand headpiece is a remarkable example of the heights to which Northwest Coast crest display aspired. Adorned with this finely sculptured hat, the wearer of this frog-spirit projected a regal and noble image that would glorify and reflect the power and the history of his clan and lineage.

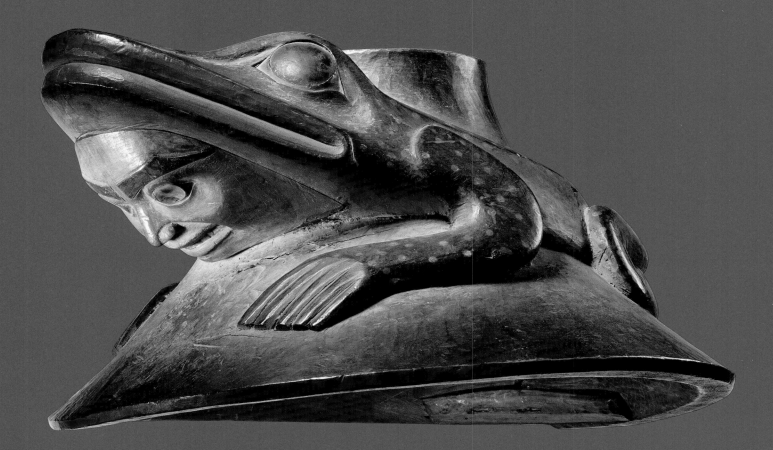

The finely carved and smoothly finished image that adorns this crest hat could be that of either a bear or a wolf, and arguments could be made in favour of either representation. The short, rounded ears and relative broadness of the short snout, however, strongly suggest the bear attribution.

The face of the bear is a masterful combination of Tsimshian sculptural conventions with the naturalistic forms of a bear's real-world features. The overall form of the face matches quite well with the characteristics of a bear's skull and head shape, and the traditional design features embellishing the image overlay that form and fill out its sense of character and identity. Tsimshian stylistic traits include the thinness of the red formline that establishes the shape of the ears, the narrow width of the eyebrow that arches over the eye socket, and the smallness of the eye itself in relation to the surrounding socket. The use of parallel dashing in the eye sockets behind the nostrils and the crosshatching painted between the eyebrows and ears are also more common in Tsimshian work than in objects from either the Tlingit or Haida First Nations. The head of the wearer of this remarkable crest hat fits into the inverted bowl form of a "cap" that makes up the rear portion of the headpiece. With the exception of the U-shaped ears, the entire object is made of one piece of wood, creating the strongest sort of bond between the cap and its sculptural embellishment. The bear and wolf are crests of the Laxgibuu, or wolf clan, and the brown bear or grizzly is a crest of the Gisputwada, or killer whale clan. Precisely which type of bear this crest hat represents and which of these clans it once belonged to are not known at this time.

Crest Hat

c. 1840–1860
Alder, paint
14" long by 7½" wide

Collection of Westerkirk Works of Art Ltd.

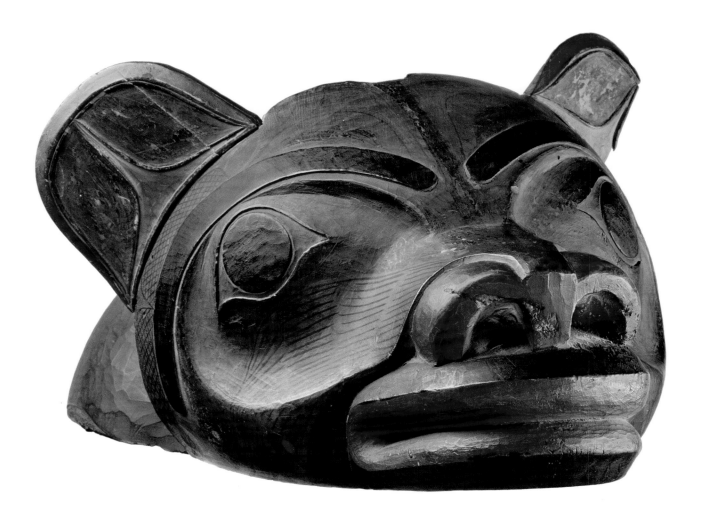

This magnificent forehead mask, with its long, toothed beak (or proboscis), appears quite similar to certain other masks and headgear that have been identified as representing the mosquito. Many aspects of this headpiece exhibit a master's hand, including both the cleanly carved and finished sculpture and the beautifully conceived and executed two-dimensional design work. Like the bear crest hat (page 73), this example features a masklike head that is incorporated into an integral wooden skullcap.

The ovoid-shaped eyes appear as if they once held shallow inlays, perhaps of abalone shell or, more likely, copper or some other thin material. The small faces painted so finely on the front of the ears are similar to images that appear in box and chest compositions. This headdress is carved from a single piece of wood, including the ears, unlike the bear crest hat.

Crest Hat

c. 1840–1860
Yellow cedar or spruce, paint
21½" long by 8" wide

Private collection, courtesy of Donald Ellis Gallery Ltd.

The formline designs painted on the wing panel on each side of the head define the physical structure of the wings. The large ovoid shape depicts the "shoulder" joint of the wing, and the arrangement of the layered U-shapes replicates the arrangement of primary and secondary wing feathers of a bird. This ancient design convention has been transposed in this case onto the representation of a mosquito's wing.

The black painting on the head flows over the carved definition of the forehead, the eye sockets, the cheeks and the "beak," while parallel lines of vermilion red dashing add not only colour, but also visual texture to the whole image. The contrast of vermilion red against the black paint gives strong emphasis to the red pigment, a reminder of the blood that is the essential food of the mosquito.

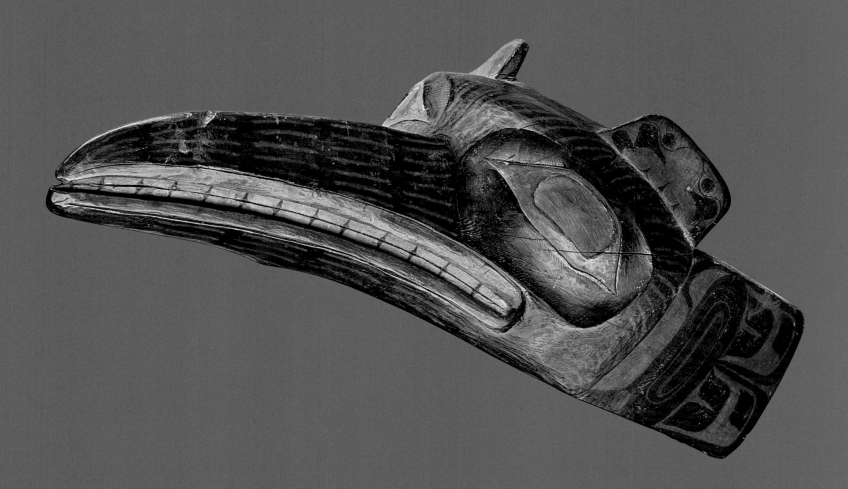

Dorsal Fin

The dorsal fin is a clear, iconic symbol for the killer whale, foremost crest of the Gisputwada, or killer whale clan. Some examples of carved fins like this one were made to be attached to a sculptured wooden hat or headpiece by way of a carved tenon on the fin that fit into a corresponding mortise on the hat or headpiece. This masterfully carved and painted fin was made as a headpiece by itself, and such fins of this type were known by a title that translates as "Fin of Scalp" (see Hoover essay, pg. 57).

The wooden fin is attached to a small piece of thick hide with two iron nails. The hide piece was then tied atop the wearer's head with tanned-leather chin straps that are now broken off and missing. The hide piece has dried and curled with age, but once may have featured small tufts of human hair set into the small holes near its outer edge.

A masklike humanoid face is relief-carved at the base of the fin, a convention often seen in this type of free-standing dorsal fin representation. This example of shallow face carving is similar to those commonly seen in elaborately carved chest designs, where small, masklike faces peer from within the swirling formlines of the painted image. The round eye with very short eyelid points and the use of the blue-green colour in only the upper half of the eye socket are both traits of Tsimshian style. The use of a red modified U-shape in the lower half of the eye socket is a very unusual feature, but one that balances well with the use of red on the upper part of the fin.

All the expertly carved and painted work on this fin suggests that its maker was an inspired and highly respected artist. Standing tall above a crowd and tilting with the turns and movements of its wearer's head, such a fin would have been an impressive sight at a feast, dance performance or other ceremonial occasion.

c. 1840–1860
Softwood (possibly spruce), paint, hide, nails, hair remnants
13½" high by 4¼" wide

Collection of Westerkirk Works of Art Ltd.

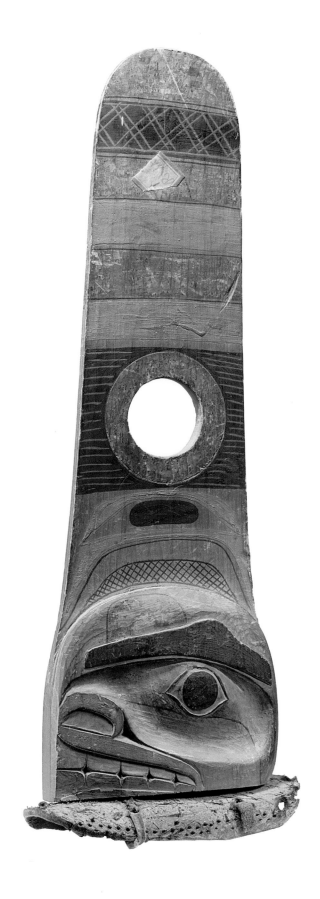

This small carved and painted figure was once part of an elaborate crest hat that included a number of appendages that were carved as separate attachments. It was originally attached to a crest hat that is now housed in the British Museum and was acquired by naval officer Edmund H. Verney, possibly on his 1863 voyage to Metlakatla with Rev. Robert Dundas. The Verney crest hat features a nearly identical whale figure on one side and an empty space where this one was once fastened on the other.

This small image may represent a killer whale, or may be intended to portray a baleen-type whale, such as a humpback. The related image on the Verney crest hat more closely resembles a typical killer whale representation, with its large teeth and taller dorsal fin. It's possible that the Verney whale is a male and the smaller fin on the Dundas figure is meant to convey a female killer whale, which does not develop the tall dorsal fin seen on the male. Just how the figure was separated from the original crest hat and became part of the Dundas Collection is not known.

Whale Figure

c. 1850–1860
Yellow cedar, paint
9" long by 1¾" wide

Collection of Westerkirk Works of Art Ltd.

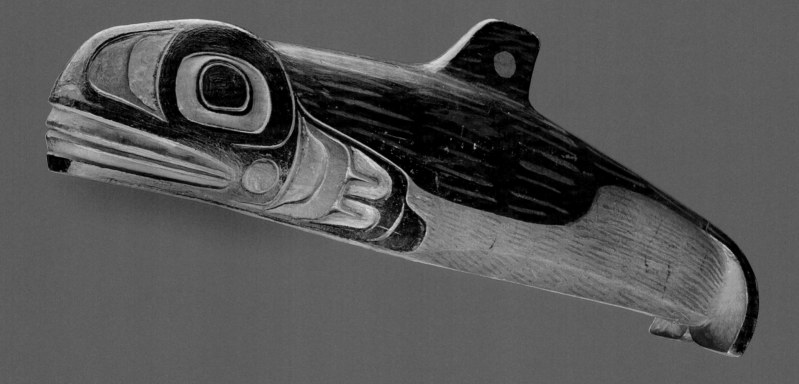

Antler Club

The old, archaic style of two-dimensional design that envelops this remarkable and fearsome weapon, along with the golden tone of its surface patina, is the best indication that this is one of the oldest artifacts in the Dundas Collection. Northwest Coast formline design traditions began with a core group of basic principles and conventions that steadily expanded over time, passed on from generation to generation. The art style grew with the incorporation of new ideas and innovations contributed by individual artists along the way. Each innovation picked up and retained by successive practitioners became part of the region's evolving tradition. By the time Rev. Dundas visited Metlakatla in 1863, Tsimshian artists that worked in the formline style had already developed an extraordinary new design manifestation, as exemplified by the thin, ribbonlike formlines that adorn the carved and painted chest (page 68). Here, the angular corners and movements of the formline shapes and the comparatively tiny size and the number of carved-out areas exemplify an approach to design that is generations closer to the old core conventions of Northwest

c. 1750
Elk antler
18½" long

Private collection, courtesy of Donald Ellis Gallery Ltd.

Coast art, upon which all subsequent styles were based. The circa-1750 time period attributed to this club may, in fact, be somewhat conservative. The appearance of the club has more in common with formline art of 500 to 1,000 years before 1750 than with formline art from 100 years after 1750. This club and other examples indicate that 19th-century Tsimshian formline art developed through an earlier period of what we now look back on as the archaic style of Northwest Coast design.

The imagery of this club is as interesting as the beautifully executed relief carving and sculpture that define its parts. The protruding animal head, carved from the stub of an antler tine, appears to represent a wolf, based on its length and proportions. The humanoid head above it at the top of the club may represent the progenitor of the clan, the first owner of the wolf crest. The shoulders and forelegs of the wolf are tucked below and behind its head, with its forepaws reaching forward and turning down near the centre line of the club.

Below the wolf's forefeet, another creature image is composed using only a few simple design movements. It has a fairly long, powerful head and neck, with sharp, triangular teeth clearly depicted. A movement composed of three U-shapes flows downward from the back of the head, and another design movement reaches forward from the grip area of the club handle toward the back corner of the wolf's lower jaw. This set of formlines suggests a hind flipper of the kind that is seen in sea lion designs. If this figure is indeed a sea lion, then the design composed here represents the head, pectoral flippers and tail flippers of this powerful sea mammal.

Objects like this are impressive on many levels – as a fearsome weapon wielded by a trained warrior, as a visual display of clan history and mythology, as a beautifully adapted natural material and as a grand piece of utilitarian sculpture darkened and polished by generations of handling and use.

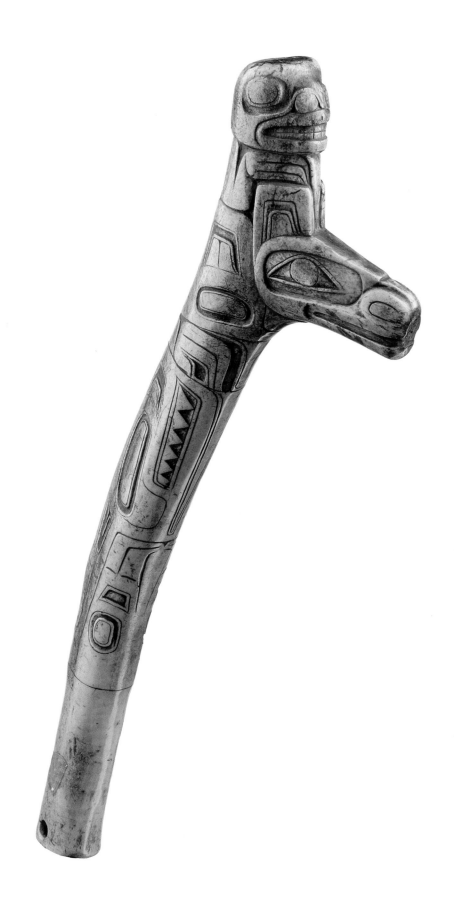

Antler Club

In addition to the design style of an artifact, depth of patina and evidence of wear are often usable measures of its age. Curiously, with its relatively bright colour, apparent lack of advanced wear patterns and unusual two-dimensional design characteristics, this club doesn't appear to have been in existence for a long time prior to being acquired by Rev. Dundas. It may have been made as an object for trade in the local economy, or it may have been made as a clan heirloom that represented the history and power of its owner's clan.

The imagery on this club is as ambiguous as its possible history. The protruding snout is comparable in form to that on the much older club (page 81). It features a mouth with rows of teeth, including sharp canines, but no eyes, ears or other typical animal characteristics. The bird at the top of the club appears to be seated atop the snout, its feet extending out parallel to the snout itself and with the tail feathers draping behind. The face of the bird was conceived as a mask form, which is common in the northern Northwest Coast tradition. The back edge of the bird's face is clearly defined on the sides of the figure's head, making it appear as though the bird is wearing a mask. The wings are shown as simple layers of U-shaped feather forms, which is something of a departure from the classic formline conventions, but the pattern serves its purpose well. The engraved designs that decorate the shaft of this club are not as clearly representative as those on the older weapon, but they are finely and precisely incised into the smooth, rich surface of the antler shaft. Regardless of the details of its origin, the graceful form and tactile surfaces of this sculpture place it solidly among the relatively few examples of this type of club that are known to exist.

c. 1850–1860
Elk antler
17½" long

Collection of Westerkirk Works of Art Ltd.

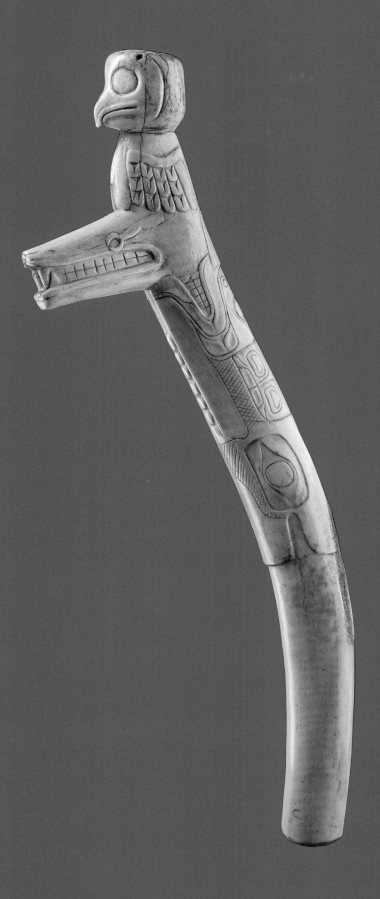

Antler clubs of this type were made, and possibly originated, in the Athapaskan regions in the continental interior beyond where the mainland rivers cut through the coastal mountain ranges. These are the lands of the caribou, which once travelled in huge migratory herds and were among the primary animals that provided sustenance to the First Peoples of the area. Clubs from this region were made from antler of either caribou or elk. The small size of this club indicates a caribou origin, as those antlers are much lighter and thinner than those of bull elk.

The crudely scratched-in eyelike form at the juncture of the stub of the antler tine and the handle was most likely done after this club arrived in the coastal area, perhaps indicating someone's intention to start the incisings of an animal representation. This club evidently has travelled some distance in trade, a common occurrence among the coastal and interior First Peoples, who exchanged resources and products. This weapon may have been decades-old when it was acquired by Duncan and, in turn, Rev. Dundas.

Antler Club

Early 19th century
Caribou antler
12¼" long

Private collection, courtesy of Donald Ellis Gallery Ltd.

Among all the collections of carved Northwest Coast objects that still exist in the world, there are few artworks that remain in an unfinished state. This small but powerful image of a bear with a face between its ears is one of those rare and revealing artifacts. When an object remains unfinished, one can almost see the hands of the artist at work, as if you're looking over the carver's shoulder while the work is in progress. The initial, most important cuts and forms are revealed by the resultant transparency of the sculpting process, documenting the steps taken in creating the bear figure.

In this comb, the snout and teeth of the bear are nearly finished, while the eye sockets have only been initially shaped out and lack the further development of the eye details that are yet to come. The tall, rounded ears have been left as a flat surface at this point, later to be incised with narrow cuts that will define the edges of design forms and embellish their appearance. The small face outlined by the ears has both humanoid and bearlike characteristics, perhaps suggesting a blend or transformation between the two. The lips are closed and can be seen as humanlike, though the volume and protrusion of the nose is suggestive of an animal's snout. The eyes and forehead are just a bulging form at this stage, allowing the intention of the artist's work in this figure to remain a mystery. The comb's teeth are all beautifully defined and tapered, and exhibit no visible wear, a further indication that the comb was not yet finished and ready to be used when it left its maker's hands.

Comb

c. 1850–1860
Hardwood
5½" high by 2¾" wide

Collection of the Canadian Museum of Civilization

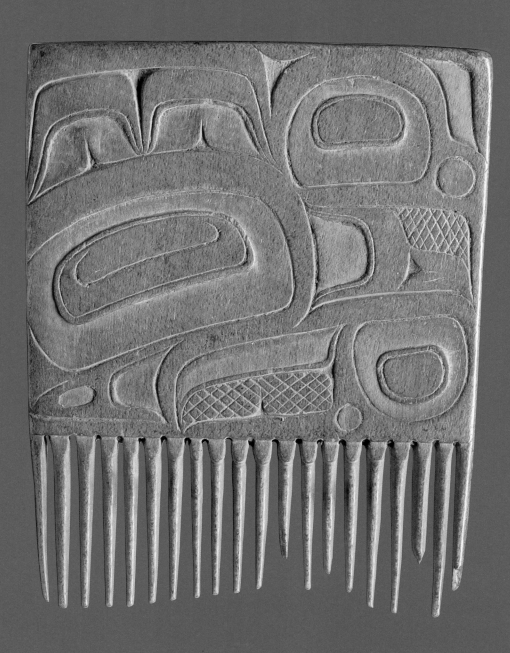

Small hand combs vary widely in the way they were decorated. Styles range from delicate relief-carved, two-dimensional designs, as seen in the fine example here, to those that feature complex compositions of multiple creatures and images that have much in common with the central sculptures seen in many headdress frontlets. Certain wooden combs feature images with shamanic themes, though it is said that shamans would not allow their hair to be combed, believing that it would diminish their powers. Other comb images appear to represent crest emblems or themes from clan origin stories and mythology that would relate to the owner's lineage history.

This comb appears to have received a great deal of use, as it shows advanced wear at the base of the teeth and erosion of their thickness toward the centre of the comb. The formline design that fills the nearly-square design field was conceived and carved by a master artist. The visual balance of the ovoid and U-shaped forms, and the harmonious distribution of positive (on the surface) and negative (carved-away) areas illustrate the artist's facility with traditional design principles. The formline image is most likely that of a bird, possibly a raven, though the artist has focused on powerful design forms and graceful junctures rather than the elements of a more naturalistic style of representation. Another comb exists that is possibly the work of the same artist (see Brown, 1998, page 79, figure 4.21). Information that has remained with that comb indicates that it was collected in the same area and period of time as this one acquired by Rev. Dundas.

c. 1830–1860
Hardwood (possibly maple)
4½" high by 3½" wide

Private collection, courtesy of Donald Ellis Gallery Ltd.

Comb

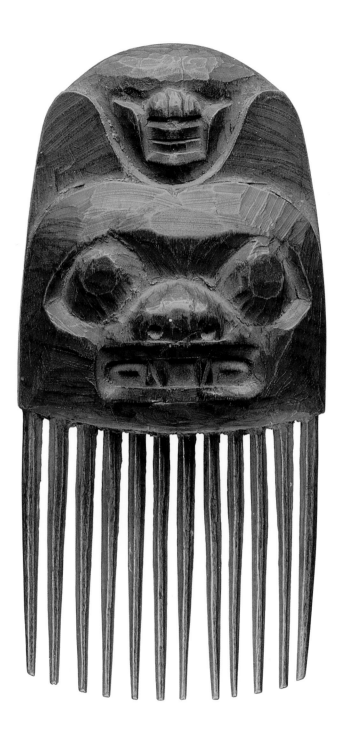

Grease Bowl

This fulsome, elegantly shaped wooden bowl was made for serving eulachon oil, commonly referred to by First Peoples in English as "ooligan grease." Eulachon, sometimes pronounced "hooligans," are deep-water, smeltlike fish that migrate into the lower reaches of mainland rivers to spawn in the early spring. Making eulachon grease is a complex process that includes "fermenting" the fish to release a greater percentage of the oil content and to give the oil special properties. The fish are then placed in water heated to just below boiling, where the oil slowly rises to the top. Once skimmed off and screened, the rich and nutritious oil is ladled into storage containers. Long ago, eulachon oil was stored in bent-corner boxes and hollow kelp bulbs; nowadays, it is commonly stored in two-pound salmon cans, glass jars or bottles and plastic tubs.

The pungent oil is strong to the nose but less of a challenge to one's taste. It compares somewhat to eating strong cheeses such as Stilton or Limburger. Eulachon oil is a delicacy that is an acquired taste, currently consumed – as it has been in the past – with smoked and dried or fresh fish (usually salmon) and boiled potatoes. It is credited with health benefits similar to those ascribed to cod liver oil.

So much eulochon oil has been served in this bowl that it has seeped through the sides of the vessel and oxidized to almost black on the outside surfaces. The bird's head and beak are noticeably lighter in colour, due to less build-up of the oil on these surfaces.

The compact image of what appears to be an eagle was composed in the bowl's corpulent form, its wing and feather designs only slightly separated from the facelike design on its breast. The undulating character of the flat-topped rim, high on the ends and lower on the sides, is a traditional convention of many northern-coast vessels. Fine grooving creates an ordered texture on the head of the bird and on certain design elements like inner ovoids and secondary U-shapes. Somewhat analogous to the use of dashed lines in painting, this grooving of positive design elements is found with more frequency in Tsimshian work of this period than in the art styles of other northern Northwest Coast groups.

c. 1830–1850
Hardwood
10¾" long by 6" wide

Collection of Westerkirk Works of Art Ltd.

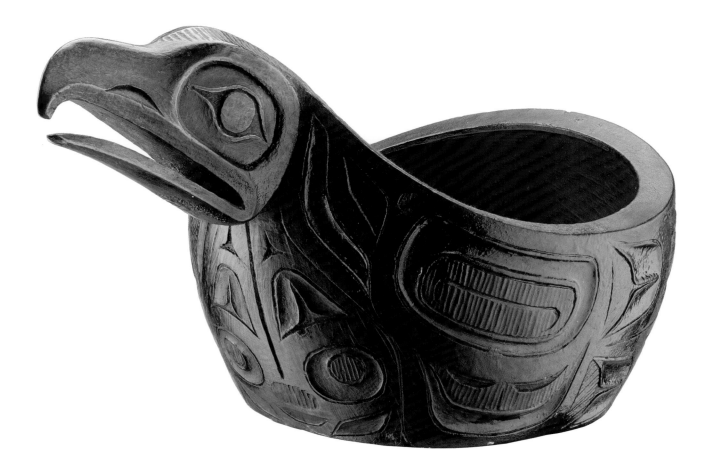

Grease Bowl

Also used to serve the rich fish-oil condiment known as eulachon grease, this small bowl is more deeply and completely oxidized than the eagle bowl (page 91). The image is that of a proud and stern bird, and the attitude of the head and shape of the beak clearly suggest a raven, though that is a mere attribution and not a fact realized through the bowl's original owners. The opening of the vessel, which is slightly wider than it is long, is a beautiful oval bordered by a thinly carved and undercut rim. Across the opening, opposite the bird's head, is a wide, shallowly relief-carved face, which may represent the perceptive qualities of the tail and its feathers.

Several characteristics of this bowl indicate its extended age in relation to other objects in this collection. The aforementioned deep oxidation of the entire surface is one such indicator, a condition that requires decades to develop to this extreme level. More reliably, the design elements in the two-dimensional surface embellishment point directly to an 18th-century origin. Just how far back into that hundred-year time span this bowl was created is impossible to pinpoint.

The simple and direct sculpture of the raven's head and the tail face suggest that the inspiration for this work came from some very early, archaic-style sculptures, and not from the sculptural conventions commonly practiced in the 19th century. The use of angular and even square-cornered design shapes – such as those in the rim designs near the raven's neck and at the centre of the bowl on each side below the undercut of the bird's wings – also indicates an 18th-century style. The large ovoid shapes on either side of the bird's breast are very wide, and the inner ovoid forms are relieved by only a narrow incised slit running from side to side. These last two characteristics are seen with great regularity in objects whose origins have been documented to the 18th century, such as those collected by Spanish and English explorers and fur traders in the 1780s and 1790s (see Brown, 1998). The rows of short, parallel incised lines on the bird's body are similar in effect to the painted red-on-black dashing seen in many later works in this collection.

18th century
Hardwood
7½" long by 5¾" wide

Private collection, courtesy of Donald Ellis Gallery Ltd.

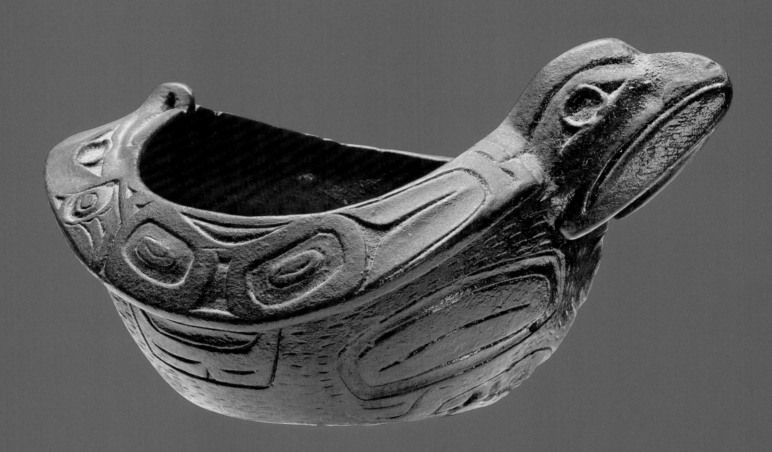

Grease Bowl

The same type of surface patina that helped point toward great age in the raven bowl (page 93) also suggests that this small and unusual vessel was many decades old by the time it was acquired by Rev. Dundas in 1863. The first European mariners to reach the northern Northwest Coast arrived between 1774 and 1800. During this 26-year period, the limited voyages of these explorers and fur traders only made contact in a few far-flung locations. They nonetheless often found trading partners that could provide what they had come for – sea otter pelts primarily, but also fresh or preserved foods to supplement the hardtack (unleavened bread) and salted beef and pork that were their dwindling daily fare during an extended voyage at sea. Profitable relations brought certain ships and captains back to the same locations as often as they could make the extensive round-trip journey. They had to sail from the Northwest Coast to China, then return to the Atlantic coast of North America or Europe for refit and resupply, then sail back again to the Northwest Coast to trade anew. In those days, such a voyage would take a year or two, limiting the number of trips a single ship or trader could accomplish while the otter populations remained strong, and the coastal peoples were still willing to barter their pelts at rates that were highly profitable to the mariners.

We may never know precisely whose visage has been immortalized in this remarkable and early oil bowl. Was it a trading captain of the 18th century that somehow ingratiated himself to a local clan leader? It would seem that only a positive relationship would lead to the inclusion of one's image on an important object of ceremonial feasting, but what was the particular nature of the event or the meeting that spawned this enigmatic image? It surely has the character of a portrait, with facial characteristics and a hair style that could point to a specific Euro-American personage, if only we knew who that might be. In any case, this bowl illustrates the remarkable facility that the early Tsimshian artists had with wood and portraiture, even on a very small scale.

c. 1780–1820
Hardwood
6¾" long by 4¾" wide

Collection of the Canadian Museum of Civilization

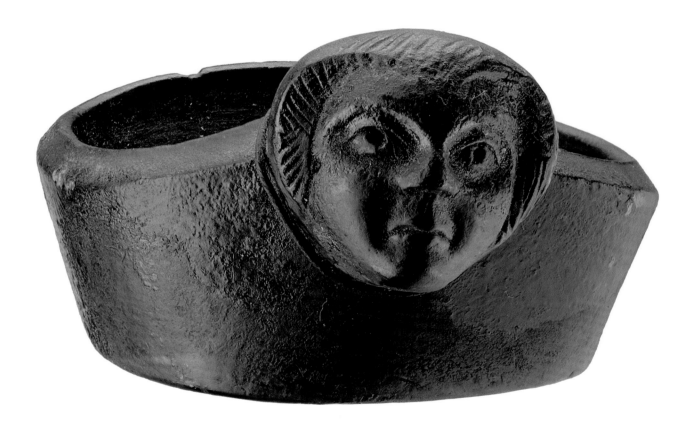

Seal-Oil Bowl

First Peoples that lived on or near the outer sea channels often preferred seal oil to that of the eulachon, a fish that spawned in more remote mainland rivers. Seal oil is obtained by rendering the thick layer of blubber found just beneath the skin of the seal. By heating the blubber with a small amount of water, the oil "melts" out of the blubber, eventually leaving the fat cracklings floating in nearly clear, slightly viscous oil. The bowls in which this high-caloric food was served are often carved in the form of the animal that provided the resource. In this way, the carvers and the culture were paying homage to the life of the seal that gave sustenance and life to the people.

Like the dozens of similar bowls in seal form that followed after this one, the seal is shown here with its head and tail flippers rising upward in a tensioned U-shape. This vessel's shape succinctly captures the image of a seal perched with its body arched on a small rock or an ice floe. The body of the seal has been hollowed out, matching the conventional style of bowl shape with high ends and lower sides. The head and tail flippers are the only sculptural developments present in the vessel, and the remainder of the outer surface retains a smooth finish. Many subsequent seal bowls feature two-dimensional design representations of pectoral fins and other formline embellishments, but there are others, also from this earlier period, that let the unembroidered form of the bowl come through on its own.

c. 1800–1840
Hardwood
6¾" long by 3½" wide

Private collection, Vancouver, British Columbia

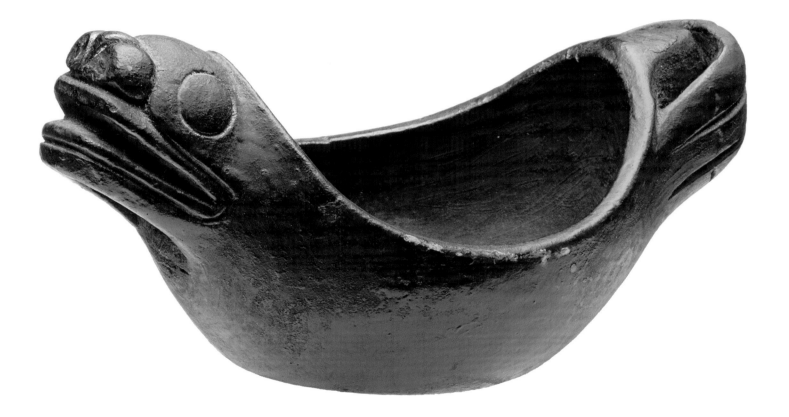

The almost perfectly round shape of this bowl is unusual when compared to the more commonly oval forms of the great majority of Northwest Coast food and grease bowls. Some of the recently made bowls that Rev. Dundas acquired are quite round as well, suggesting the influence of Euro-American standard shapes for food vessels. This example, however, clearly shows evidence of at least a respectable amount of use in the darkened end grain of the interior. The wide rim is quite flat, also an unusual characteristic, but the shallow groove that parallels the rim on the inside is a trait that is often seen in both canoe and food bowl forms. The composition of a head on one end and the tail on the other is a regular feature of Northwest Coast bowls, but in this case the head is facing up, not forward as is more often seen. The eaglelike beak arches over the top of the rim, and humanlike hands are seen on either side of the face represented in the tail.

The eye forms in both the head and the face in the tail appear to be incomplete, in that no eyelid lines with their usual points are carved in either face. That the bowl may not have been finished makes a strange contrast with the appearance of the end-grain stains that suggest a period of use. Even the faces themselves appear to have darkened high areas and lighter hollows that would indicate extensive handling. Just how and why this particular bowl came to look the way it does is something of a mystery. It remains, however, beautifully carved and for the most part finished, and an interesting example of the variety of food-bowl shapes and embellishments made by Tsimshian artists.

Grease Bowl

c. 1860–1863
Hardwood
9¾" long by 7¼" wide

Collection of the Canadian Museum of Civilization

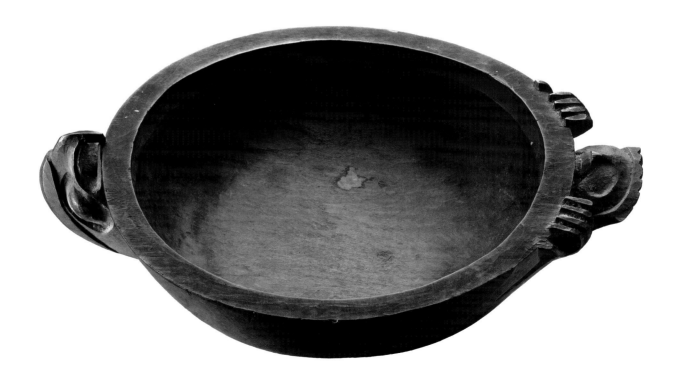

Canoe-Shaped Bowl

Grease or oil bowls were sometimes carved in the shape of the creatures that supplied the food resource, like the seal bowl (page 97), and were also carved in the shape of the canoes that were employed in hunting various food resources. Such objects were a means of paying homage to the creatures and the vessels that made the pursuit and capture of the resource possible. Without these, life in the region would have been marginal at best, likely to be devoid of the cultural development we associate with the First Peoples of the region. In some areas, canoe hulls were employed as vessels for the rendering of seal and/or eulachon oil, further involving the canoe in the food preparation process.

This beautifully encapsulated small canoe is of the type commonly known as the "northern style" canoe, which was developed around the turn of the 19th century and was used from the northern Vancouver Island region into northern Southeast Alaska. Nearly all the classic features of the full-sized canoes are present in this bowl, though the scale and proportions have been greatly foreshortened. The canoe in this context is more than half as wide as it is long, much wider than the typical canoe of this kind, whose length was about six to seven times its width.

The bowl exhibits a shallow groove below the rim, or gunwale, that carries to each end much as it does in full-size canoes of this type. The outward slant of the bow and stern and the outward flare just beneath the rim also echo the typical seaworthy form of these canoes. The bowl shows a fair degree of eulachon- or seal-oil saturation, indicative of decades of use as a container for serving these important traditional foods.

c. 1810–1850
Hardwood
7" long by 4" wide

Private collection, Vancouver, British Columbia

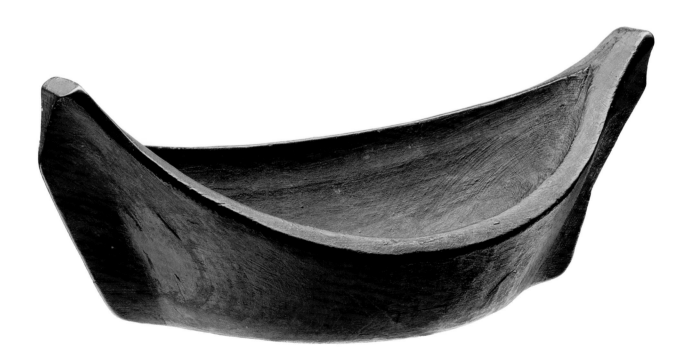

In contrast to the bowls in this collection that show evidence of advanced age and a long history of cultural usage, certain other vessels appear as though they were made not long before they were put in Rev. Dundas's hands. This unusual bird bowl is one of the most apparent of these, as is the eagle bowl (page 101). The overall black colour and the shape of the beak together suggest that a raven is represented; however, the long neck, the overall red dashing and the shortness of the beak raise the possibility that the artist intended to depict some type of seabird. In some cases, First Peoples who lived in villages on the outer coast acquired emblems that included sea birds such as the cormorant and the murrelet. The precise intent of the original carver can only be partly deduced, given the absence of primary information from the initial owners and the length of time that has passed.

The sleek body of this bird was hollowed out until it was quite evenly thin, and yet it still retains a slight rise and fall of the rim that is traditional with food bowls in this region. Rather than "embroider" the wings and tail with painted and carved formline designs, as would have been common on an older bowl made for traditional use (see page 91), the maker of this vessel chose to depict only the bird's large round eye in the typical manner. The physical condition of the bowl suggests that the vessel did not receive much use prior to being handed over to its new owners.

Both the Hudson's Bay Company and Mr. Duncan appear to have encouraged local carvers to produce new works for use in trade as well as to collect older examples for the same purpose. "Indian curiosities," as Mr. Duncan and Rev. Dundas often referred to them, were known to have value to certain individuals outside Native cultures. Rev. Dundas, for all his evident Anglican Church–based disdain for First Nations' cultural practices, had a keen interest in the "craftwork" of the First Peoples of the territory in which he served. Artifacts were traded for goods with the Hudson's Bay Company or sold on-site, or taken to Victoria to sell in order to raise funds for the growth and support of the Metlakatla community. It was, in fact, for the financial support of this community that Mr. Duncan assembled these artifacts and sold them to Rev. Dundas. As the numbers of older, antique cultural objects steadily dwindled over time, new ones appear to have been made to maintain the supply for this trade.

Grease Bowl

c. 1860–1863
Hardwood, paint
10¼" long by 4" wide

Collection of Westerkirk Works of Art Ltd.

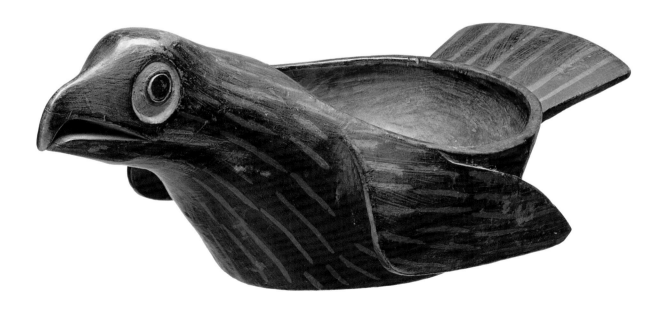

Grease Bowl

This perky, upright eagle image is another example of a bowl that appears to have been relatively new when it was transferred to Rev. Dundas. This bowl and others that he acquired may even have been made by craftsmen at Metlakatla in the months prior to his and Verney's arrival on the *Grappler*. Nonetheless, these bowls offer highly respectable examples of traditional sculpture in that particular area and period of time. The paintings on the wings and tail of this eagle, though not relief-carved in the manner of some of the older bowls included here, are still composed and laid down in the same manner and general style as the earlier carvings.

In addition to the painted embellishments, this eagle includes a perfectly round inlay of abalone shell for the eye, which has an extremely fine and shallow eyelid line cut around it. The head is not painted (except for the vermilion red inside the mouth) indicating a bald eagle representation. This is not a common technique in older works, where such naturalistic portrayals are subordinated to the conventions of the ancient two-dimensional design tradition. The appearance of the growth rings of the wood on the inside of the bowl clearly indicates that this vessel was carved from spruce. Along with hemlock and cedar, spruce is one of the most common trees in the northern Northwest Coast rain forests and, in some areas, the most abundant species of large trees. Its use is rarely mentioned in ethnographic and art historical literature, except in reference to war helmets and canoes among the Tlingit. Tight-grained spruce, however, was in fact employed for a wide range of carved objects, such as combs, headdress frontlets, masks, small figures, and other objects like bent-corner bulged bowls and red-corner boxes. Spruce was more commonly used in carvings made before the early 19th century. Northwest Coast artists seldom use it today, though fine-grained fresh spruce is a grand wood to carve, and it bends under steam more readily than any other local wood. Like alder and maple, spruce is an ideal wood for making food storage boxes and grease bowls because it imparts no unpleasant flavour to the food.

c. 1860–1863
Spruce, paint, abalone shell
6½" long by 3¾" wide

Collection of the Canadian Museum of Civilization

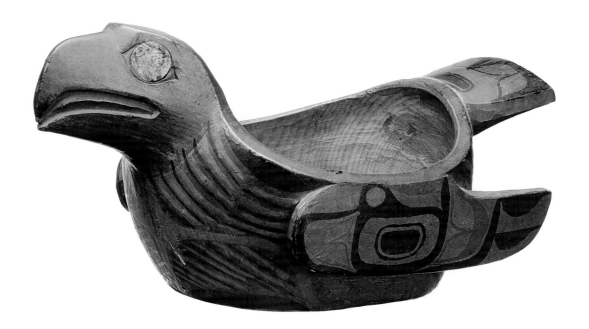

Masks of the human face from any culture are some of the most engaging and intriguing of sculptural objects. They have the power to capture one's gaze and imagination with the humanity of their expressions. Human-face masks from the Northwest Coast are imbued with an exceptional power of this kind, in part because of their sculptural prowess and further due to the nature of their painted surfaces and added embellishments, such as human hair, or animal hide or fur. This mask is certainly one with powers of engagement that exceed those of many others, the shape of its eyes and the glistening surface pulling us in like a magnet.

Somewhat smaller in size than most face or portrait masks, this compelling example is the size of an average human visage. Many other makers have enlarged this form of mask for greater effect. Here, the eyes are pierced through in a wide and tapering slit, with the upper eyelids defined by a shallow incised cut that adds life to the image. The eyes seem to echo the sensual appearance of the mouth, with its slightly open, full lips, behind which one can see the

Face Mask

c. 1820–1840
Hardwood, paint, hide
7¾" high by 7" wide

Private collection, courtesy of Donald Ellis Gallery Ltd.

vertical cuts defining an upper row of teeth. The bony ridge of a pronounced cheekbone borders the hollow of the eye socket, below which the cheek area shows a slight hollow that enhances the naturalistic feel of the face. Small, fairly high-set ears are carved with ridges and grooves that reflect the appearance of real human ears. Almost the entire face is painted with graphite-laden paint that creates a shimmering surface, enhancing the textures of the pigments and brush marks. Asymmetrically arranged across the forehead and each cheek are small zones of formline designs in vermilion red and black painted on the bare wood. These areas contrast nicely in colour and texture with the graphite overlay on the remainder of the face.

There are at least two other masks in different collections that were made by the same accomplished artist. Though the painted designs differ widely in the three masks, the characteristics of the sculptural work clearly indicate the same hand. One of these is now in the Menil Collection in Houston, Tex., and the other is in the British Museum [1949AM22.62]. Both masks are illustrated in *Form and Freedom: A Dialogue on Northwest Coast Indian Art*, by Bill Holm and Bill Reid (Rice University, 1975, pages 222–224). Both masks have nearly identical overall shapes (particularly the curves of the back edge) and are similar in ear size, form and placement as well as eyebrow shapes, noses, cheekbones and chins. The eyes of this one and the Menil mask are also essentially identical, though in the British Museum mask, the eyes are articulated, lending them a very different appearance. The Menil and British Museum masks both feature soft ridges and hollows carved on the lower cheeks, suggesting wrinkled jowls, which are not present in this mask. All three masks have had hide pieces attached to the surface, either by pegging or adhering with spruce pitch, to represent the moustache and narrow beard that were common among Northwest Coast men. Only this one, however, has had hide pieces adhered to the forehead, temples and below the ears. All three masks have the same style of two-dimensional formline paintings on the face, but the composition and placement of those designs differ significantly on each example. The upper forehead paintings on this and the British Museum mask, however, have a great deal in common. A third example, now housed at the Smithsonian National Museum of Natural History [73,332-B], also appears to be by the same carver. That one has eyes that are open, more like the majority of human-face masks, giving it a slightly different look than this one or the other two mentioned above. Other characteristics nonetheless indicate that it is by the same carver as the other three. It is also illustrated in the Holm/Reid volume (page 224).

Who this master artist was, when he produced these works and which Tsimshian village he lived in are all unknown at this time, but his sculptures remain a great inspiration for all who have succeeded him.

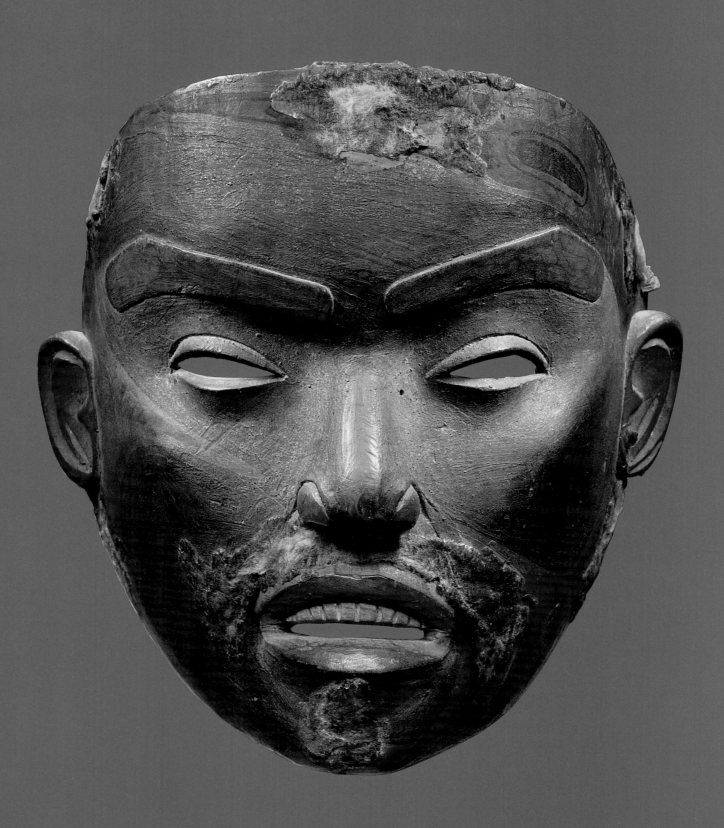

"This is a collection of monumental importance. It is like a time capsule has been found and we have just opened it."

– William White

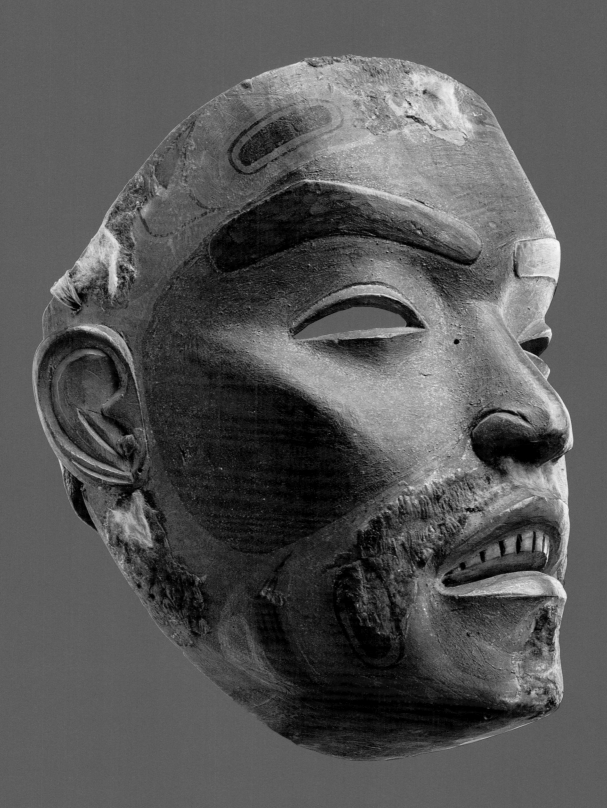

Globular rattles were made by the Tsimshian and other Northwest Coast groups, primarily for use by shamans. Among this general type, only a relative few were made with relief-carved surfaces or sculptural protrusions, and only a few among those were created by such artistic masters as the carver/designer of this exceptional example. Consummate skill was employed in the composition and relief-carving of the formline designs on both sides of this rattle, now worn and dark with a patina of advanced age.

On the front, the side on which the largest, central eye socket ovoids are oriented upright (page 107), there is a narrow, turned-down beaklike shape between and below those eye forms. The presence of this beak shape in the centre of the mouth and the featherlike designs extending to the rim above the brow area both suggest that some species of bird is represented. Below the lower jaw of the central face is another, wider face structure with broad ovoid eye sockets and irises with widely extended eyelid lines. This face may, in

fact, represent the body of the bird, a convention that is often seen in chests, boxes and other two-dimensional design work.

On the reverse side of the rattle, a formline design that equals the compositional elegance and fine relief carving of the front covers the entire surface. The overall design may represent the body, abbreviated wings and broad tail of the subject bird whose face is on the obverse, or front, side. The two central, inverted ovoid shapes form the base of the tail, and layered U-shapes extend outward and downward from them to the edges of the rattle. On both sides, the design work incorporates simple, uncomplicated design forms that are indicative of a relatively early origin. The medium-width formlines and fairly large negative (carved-out) areas suggest that this rattle was made sometime between the turn of the 19th century and about 1830 or 1840. Three small holes can be seen in the surface on the front and five on the reverse side of the rattle, piercing the inner ovoid shapes and other design elements in a deliberate pattern. These holes may have been used to peg small tufts of human hair into the surface for kinetic embellishment, as can be seen in certain early masks and other objects. It is one of the most accomplished and remarkable rattles of this type in existence.

Rattle

c. 1800–1840
Hardwood, sinew ties
11" high by 6" wide

Private collection, courtesy of Donald Ellis Gallery Ltd.

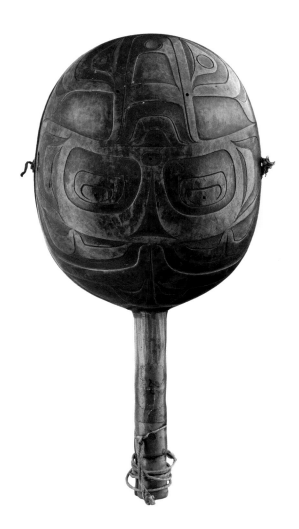

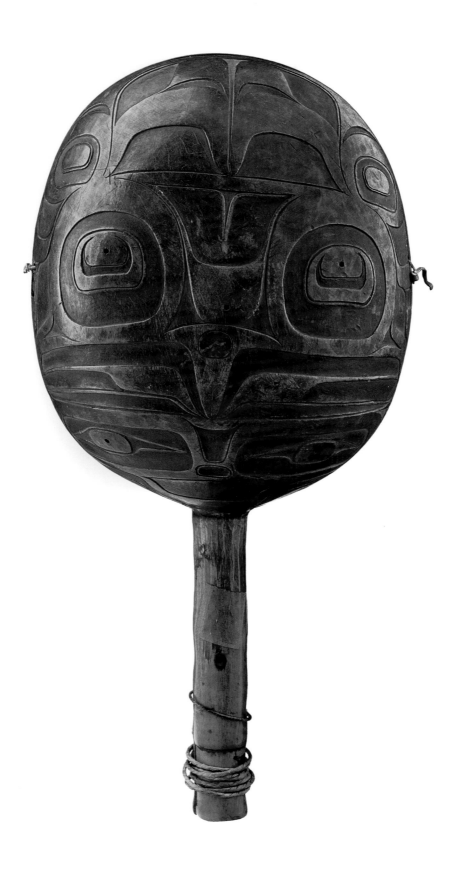

The bone amulets known as "soul catchers" or, as Rev. Dundas referred to them in his journal, "soul holders," were once common among Tsimshian shamans, as evidenced by the numerous examples now located in museums and private collections worldwide. These bone tubes were used as containers for the lost souls of the shaman's patients, and the open ends were capped with plugs of cedar bark to "hold" the soul within until it could be brought back from the spirit world and returned to its owner.

The typical shape of a soul holder was derived from the shape of a hollowed grizzly bear's femur, a large and strong bone that is appropriate for such an object. The amulet was cut from the bone so that the ends flared symmetrically outward, and then the surface was incised and engraved with formline designs. Relief-carved faces with masklike features were often composed at the centre of two opposing creature images, the identities of which may have reflected the clan affiliations of the owner. The top centre of a typical soul holder

Amulet

c. 1840–1860
Bone
7¾" long

Collection of Westerkirk Works of Art Ltd.

was drilled with two holes, through which a leather thong was tied to suspend the amulet from the shaman's neck.

This amulet differs in several respects from most soul holders, the most apparent being the asymmetrical composition of the figures. The great numbers of these amulets that survive illustrate that a symmetrical arrangement of the figures is an essential definition of the object type. This amulet has a great deal of piercing-through to the hollow centre of the bone between the carved features of the figures, which lends a more sculptural appearance to the work but is antithetical to its supposed use as a soul holder.

The two figures on this bone carving illustrate a visual technique that is ubiquitous in Northwest Coast art, known as punning. On one end is the head of what appears to be a four-legged mammal with its front and hind legs drawn up against its belly, its knees and elbows touching. Large ovoid forms define the shoulder and hip joints, and S-shaped incised lines depict the ribs. The lower jaw of this head has been broken off neatly through the cheek area, but the upper jaw exhibits a row of teeth, and a large, prominent nostril flare is carved at the snout. At the opposite end of the bone tube is a deeply relieved human face. Behind this head, a wide taillike feature extends to the end of the tube, with a short leg and little foot between it and the back of the human head. Is this the hind leg, tail and foot of the mammal at the other end? The ovoid hip joint and hind legs first mentioned can also be seen as the shoulders, arms and hands of the human figure, with the hands held before the chin as if it were resting upon them. This is punning, the composition of two ambiguous figures within the same space, each sharing parts of the other.

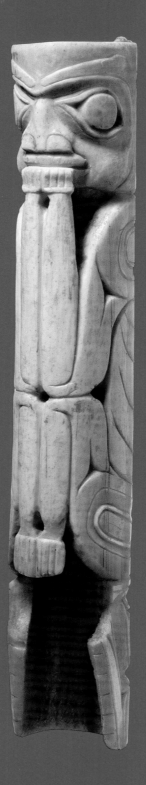

Shaman Figure

This figure, which is much smaller than the crouching human image (page 113), was carved in a more basic, less refined style that has a special spirit and attraction about it. The face of this figure is proportioned much like a stylized face mask, but the execution of the relief carving was done in a more improvised and direct manner. The eyes are by far the largest and most prominent features of the face, while the nose and mouth were rendered in a very simple and direct style. The body and limbs of the figure are entirely minimal but nonetheless convey a great deal of spirit and personality. As in many small images like this, the hands touch the body at the hips, and a simple piercing slit separates the arms and torso. Human hair is pegged into the top of the head, which gives the image an additional measure of life and attitude. The head is slightly hollowed on the back to look more like the back of a mask than a rounded human head, which is altogether typical of small Northwest Coast human images.

c. 1830–1860
Alder or yellow cedar, paint, human hair
7¼" high

Collection of Westerkirk Works of Art Ltd.

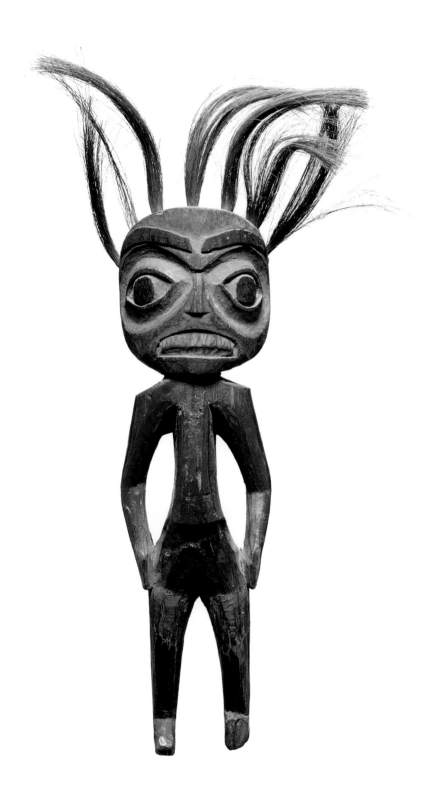

Human Figure

Small human images are often found among the paraphernalia of shamans on the Northwest Coast and are said to have represented or encapsulated the spiritual power of the shaman. These figures would assist the shamans in their work and were at times left with a patient to better effect a cure. The majority of these figures are smaller than this example, and often much less refined in the carving and finish. This sculpture is carefully and precisely detailed and may have been made for another purpose, such as representing a particular spirit or entity in the reenactment of a historical event or mythological encounter. It may have been part of an ensemble that included a box or other platform on which it sat, and that played a part in the story that was being represented.

In his crouched position, with his hands on his knees, the attitude and proportion of this image is similar to many figures on Tsimshian totem poles. The head is a little more than a third of the total height of the figure, which is a common proportion seen in Tsimshian poles. The finely sculptured face on this figure is a perfect miniature of a Tsimshian-style mask or totem

c. 1830–1850
Alder, paint, human hair, sinew
11" high

Collection of Westerkirk Works of Art Ltd.

pole face, with thin lips, a wide, flat-bottomed nose and, in this case, large naturalistic ears and comparatively small eyes. The painted forms on the face also reflect the kinds of painted patterns seen in masks. Pigment with a very greenish hue has been applied on the upper part of the eye sockets and also forms a thin moustache and small narrow beard, as well as covering the figure's torso. Red paint was applied to the arms and legs and the lips, ears, nostril flares and eyebrows.

Long human hair has been bound into bundles with sinew and pegged into holes atop the head. The length of the hair reflects how Northwest Coast shamans are said to have never cut their hair for fear of losing their powers. Mr. Duncan and Rev. Dundas, of course, were of the belief that the shamans epitomized what they called "Indian Devilry," the aspect of First Nations cultures that stood between their Native way of life and supposed "enrichment in the Christian faith." That men like Rev. Dundas were apparently intrigued by and interested in the paraphernalia of what they believed to be "evil men" makes for a curious juxtaposition in their belief systems. Or perhaps, they merely perceived those objects as the trophies of their own spiritual conquests.

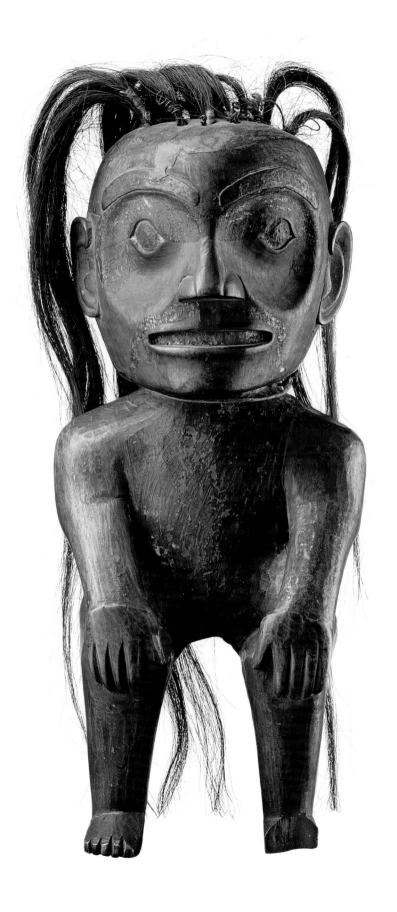

Naxnox Mask

Mechanical masks with articulated eyes and mouths were common in the ceremonial known as Naxnox, which can be translated as "power beyond the human" or "spirit power," each indicating unseen forces that originate on the "dark side." Such spiritual forces are opposed to the socializing strength and sense of order established in the ancient histories of high-caste lineages, and the ritualists and chiefs that are the personification of that order. The more chaotic and powerful the negative spiritual forces are thought to be, the greater is the perception of positive spiritual strength and power in those whose ritual duties are to tame and repress the dark forces in order to strengthen the society as a whole. The performances of the Naxnox amplify the belief in those dark spirit powers, which in turn amplifies the perception of spiritual and cleansing power seen in those who manage and perform the rituals.

The overall black colour and stark form and decoration on this mask are typical of the Naxnox tradition, as are the articulated eyes and beak. The opening and closing of the eyes would not only give the mask life, but would also communicate the recurring presence of negative spirit forces. The use of lines of dashing on the black painted areas is a common technique among artists in this region and generational time frame, and is seen in many other examples of works in this collection. The series of unpainted triangular forms, also known as trigons, which create lobes of black around the brow area, are drawn from the essential elements of the ancient design tradition.

Pulleys, strings and a wooden bite plug on the inside allow the wearer to put on the mask and to manipulate its movable parts. About half of the upper mandible has been added onto the face of the mask, no doubt reorienting the grain of the wood from vertical to horizontal in order to strengthen the thin tapered end of the beak. The wood grain, with its long cell fibres, is oriented horizontally in the lower mandible for the same reason, to keep the thin, fragile tip from breaking off.

c. 1840–1860
Alder, paint, fibre
12" high by 14½" deep

Collection of Westerkirk Works of Art Ltd.

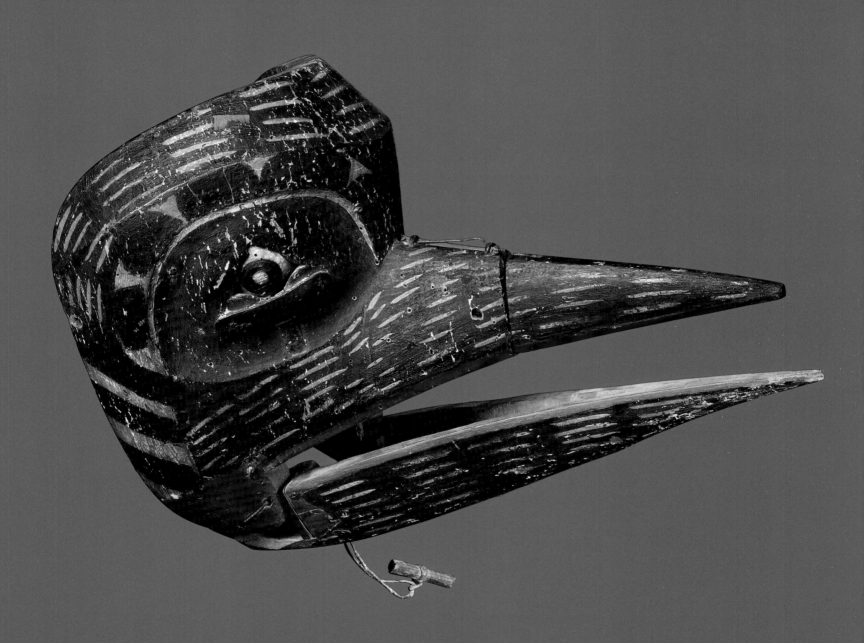

Clappers, like rattles, are made of two pieces of hard wood, each hollowed out until quite thin in order to amplify the resonance of the instruments. Instead of using percussive elements such as small pebbles, glass beads or lead shot on the inside like a rattle, each side of a clapper is thinly carved in the handle area behind the hollowed sculptural image. A much thicker grip section is left at the end of the handle, where the two sides of the instrument are bound together. This enables the two halves of the clapper to vibrate against each other as the instrument is rapidly shaken, creating a "clapping" sound. Clappers are also generally smaller and narrower than most rattles, such as the well-known raven rattle or other related types of bird rattles. The clapper tradition appears to have a long history, judging by the existence of some early examples

that most likely date from the 18th century (see Holm, 1984, page 29, figure 21, which was identified at that time as Tlingit, and early 19th century). Other known clappers appear to date from the first half of the 19th century, between about 1820 and 1850, based on the carving and design styles of the objects. (See Brown, 1998, page 87, figure 4.42; Brown, 1995, page 166, figure 62).

It is said that the Tsimshian secret dancing society known as the MitLa (Dancers) carried clappers instead of rattles. Other northern First Peoples like the Haida appear to have made some clappers that are currently housed in museums, and very few, if any, clappers are known to have originated among the Tlingit.

Clappers

This may be the oldest of the four clappers included in the Dundas Collection, based on the use of formline designs covering the entire figure, and greater evidence of wear. Likely depicting an orca whale, this clapper once had a tall dorsal fin with a small face carved at the base, which was still present as recently as the late 1970s. A combination of red and black primary formlines is seen here, an unusual feature, as artists would more commonly compose the primary formline elements in either one colour or the other, but rarely both.

This clapper shares more stylistic characteristics with the old formline tradition than do the other clappers in the Dundas Collection. It appears that this animated sea mammal has seen the firelight of many ceremonies and has been shaken by more than one generation of MitLa dancers.

c. 1830–1850
Yellow cedar or spruce,
paint, fibre ties
8¼" long by 2" wide

Collection of Westerkirk Works of Art Ltd.

Clappers

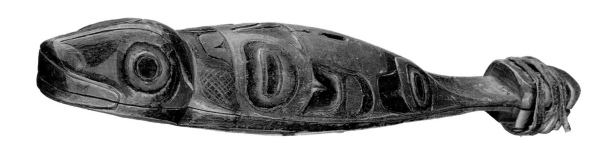

This energetic sea mammal image may represent an orca, or killer whale, or may just as likely be intended to represent a species of dolphin, a creature commonly encountered in the straits and channels of the Northwest Coast. Both orcas and dolphins have similar colouring and white bellies, so to be able to distinguish them in such a small symbolic form would require the insider knowledge of a Tsimshian ritualist. This congenial swimmer was painted with graphite pigment, giving its coat a "wet" sheen. The pectoral fins have been painted with black hatching and red crosshatch lines that alternate with the black in rows. The pitch of the dorsal fin and the under-turned tail suggest active movement. The hand grip on this clapper is unusual, likely designed for ease of grasping.

c. 1840–1860
Yellow cedar or spruce, paint
9" long by 1¾" wide

Collection of Westerkirk Works of Art Ltd.

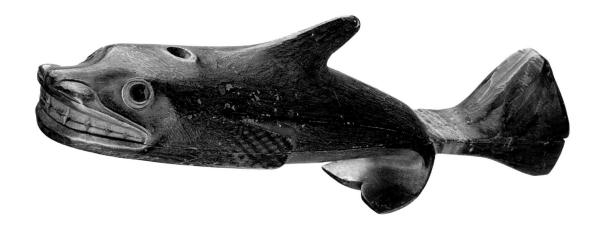

This slim bird clapper has been tentatively identified as a raven, but due to the shape and position of its body and head, it could also represent some variety of seabird. Only the wings and tail on this example are painted and relief-carved with formline designs, while the rest of the body, neck and back of the head are painted black with red dashing. The red-on-black and the unpainted eye sockets were perhaps meant to represent the colouring of some variety of duck or other bird. The designs on the wings and tail include some unusual, personal features that are minor departures from the mainline of the ancient design tradition, but they are consistent with other works produced in the mid-19th century.

c. 1840–1860
Yellow cedar or spruce,
paint, fibre wrap
9¾" long by 1⅞" wide

Private collection, courtesy of Donald Ellis Gallery Ltd.

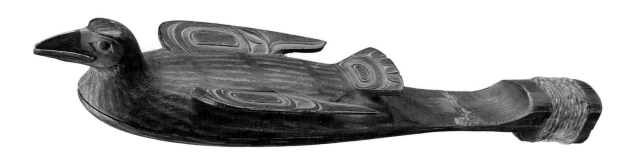

This example more clearly represents a whale, but exactly which type is unknown. There are no teeth in the mouth, and the dorsal fin is not large, suggesting that it may not depict an orca. The shape of the head is more blunt and elongated than an orca as well, and may indicate that a baleen type of whale, like a humpback, is the subject of this clapper. Again the red-on-black combination has been used over the body, and only the head and pectoral fins feature formline designs.

c. 1840–1860
Yellow cedar or spruce,
paint, fibre ties
10¼" long by 1¾" wide

Private collection, courtesy of Donald Ellis Gallery Ltd.

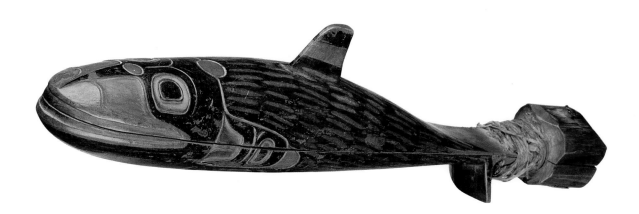

Elegant spoons and ladles from the Northwest Coast are some of the most beautifully conceived and sculptured food utensils to be seen anywhere. The bowl of this ladle reflects this tradition in its curvature, the shallow groove parallel to the rim and the delicately formed tip, all of which illustrate the best of the old established forms.

The three sculptural figures on the extended handle are carved in a style that suggests the work was done within a few years of 1863, perhaps as much as a decade or so prior to its inclusion in this collection. The deeply relieved carving of the figures and the deep cuts around their eyes suggest a maker that was not traditionally trained in the more subtle aspects of older Tsimshian-style work, such as what is seen in the frog hat, human mask and the more refined small figures in this group of objects. The relief-carved two-dimensional designs on the bird's wings and on the back of the bowl indicate that the carver had a certain amount of familiarity with the ancient design system.

Except for the human figure on top, the identities of the images are difficult to define. The bird has an unusually long beak, suggesting a heron or crane of some type, but precisely what kind of bird is depicted is not clear. The lower animal head has the general appearance of a wolf or a bear, but other clues such as body characteristics are lacking. It's probable that this ladle was created for traditional use in the ceremonial feasting tradition, as it shows a certain degree of wear and polish from extensive handling. The bowl has been broken and repaired, probably at some time after it left Metlakatla.

Ladle

c. 1850–1860
Hardwood
12¼" long

Collection of Jake and Fiona Eberts

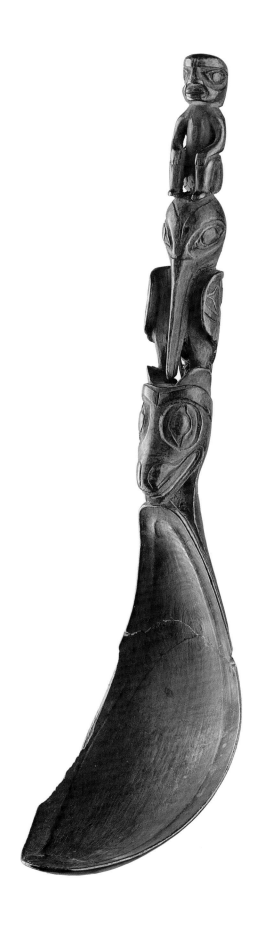

Wooden spoons made by Tsimshian artists are among the most elegantly shaped and refined of any that were made on the Northwest Coast. This is especially apparent in examples that have no sculptural or two-dimensional embellishments to the form itself. The graceful curves and refined lines of a well-made spoon or a larger ladle are some of the most satisfying forms that are found in Northwest Coast art, revealing echoes of canoe shapes, the shells of sea creatures and the movements of water in river currents and ocean swells. This ladle exhibits many of these refinements in its thin and understated shape, with the added interest of the stout and upright-looking human figure holding on to the top of the handle. The asymmetrical pattern of red parallel lines painted on the front of the handle is a characteristic not often seen in such spoons, but there are a few early examples known in which similar lines are carved as fine grooves in the surface.

The small figure's hands grasp the top edge, and its feet touch each side of the handle below. The remarkably fine and detailed sculpture of the man's face elevates this ladle to a level of special status. It may have belonged to a high-ranking individual, and the figure could represent a particular personage from the mythology and lineage history of the owner's clan. This tiny face is carved with as much skill and detail as a full-sized mask or headdress frontlet, and was certainly done by a master artist who must have made many examples of each in his lifetime. Certain extant headdress frontlets appear as though they may have been carved by the same master artist, including one or more collected at this same time by Edmund Verney, which are now in private collections.

Ladle

c. 1840–1860
Hardwood
11" long by 2½" wide

Collection of the Museum of Northern British Columbia

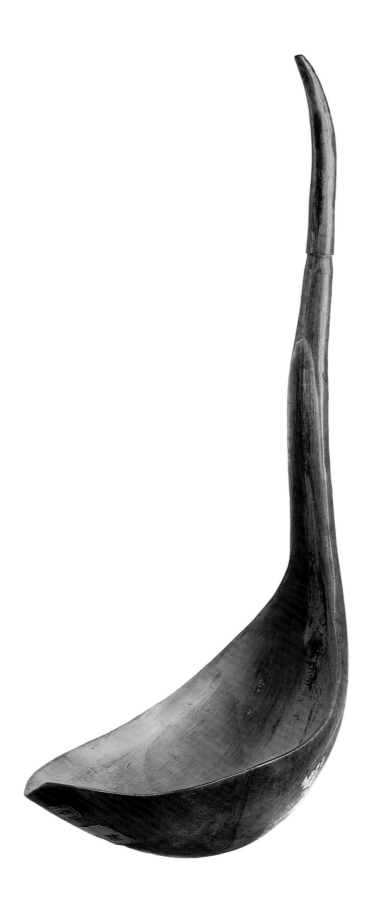

Canoe Model

Canoe models were evidently common objects of household use since the most ancient times. They were most frequently made as children's toys, as were many other miniaturized versions of adult tools and implements. The cultural importance of canoes is almost immeasurable, as they were central to food gathering, migration to remote resource sites, warfare and defense, and trade with other First Peoples as well as outsiders. When the first Euro-American mariners arrived on the Northwest Coast, they often commented with respect on the beauty and seaworthiness of the Native watercraft. It was in these waterborne vessels that the First Peoples, having paddled out to look at and trade with the men on the ships, experienced their first face-to-face contacts with Euro-Americans.

The oldest canoe models known were recovered in fragments at the Ozette archeological site in Washington State. These 300-to-500-year-old models show that tiny canoes were a part of Aboriginal homes well before the advent of models made for trade. Once trade had been established

c. 1850–1860
Alder, paint
30" long by 5" wide

Collection of the Canadian Museum of Civilization

along the coast, however, canoe models soon became one of the favoured items of Native handwork among the seamen and were taken back home as mementos of their voyages to the region.

Curiously, the Ozette models are of the same vessel type as this one, a design that was employed from the lower Columbia River to the most northwest shores of Vancouver Island. Identified in the ethnographic literature variously as the Chinook canoe, the Nootkan canoe or the Nuu-chah-nulth canoe, these vessels were well known as seaworthy types that saw use in fishing, travelling and sea-mammal hunting, including the stalking and harpooning of whales among the Makah and Nuu-chah-nulth First Nations.

This one is representative of the form, with a snoutlike protrusion just below the outward flare of the gunwales at the bow, and a small break, or "lump," in the curve of the bow stem just below the snout and "chin," known as the "Adam's apple" or the "uvula" by differing bands. At the rear, these canoes always have a vertical stern line that flares out in a flat-topped rise well above the general run of the gunwales. That feature is missing in this model, having been broken off at some time in the past. The painting on the outer hull is representative of the Nuu-chah-nulth or Makah models of this mid-19th-century period, with geometric shapes and curving lines (and sometimes rows of dots) in red and black rather than representations of creatures. Less common are the painted forms seen inside this canoe, though some others exist with elaborate interior paintings as well. The snout on this model is pointing forward and not far from parallel to the line of the gunwales, which is the usual format in canoes of this type from ancient times and up to about 1880. After that time, canoe makers increased the upward rise of the gunwales at the bow, a change that made the angle of the snout more nearly perpendicular to the curving line of the gunwales.

The question, of course, is, how did this model from the west coast of Vancouver Island become a part of the Dundas Collection? It's possible that the model made its way north to the Fort Simpson area with the Hudson's Bay Company or via trade from the Victoria area, where this style of canoe was commonly seen. However, it's much more likely that Rev. Dundas acquired this model himself in the vicinity of Victoria where he lived and worked during most of his time on the coast. He did missionary work in some of the Native communities in the area and could well have come upon this fine model either there or from one of his acquaintances in the capitol itself. This may have been one of his very first acquisitions of "Indian Curiosities" and may have been part of what inspired his journey to Metlakatla on the *Grappler*.

The collecting and employment of birch bark for use in containers was practiced among the Athapaskan-speaking First Nations of the continental interior. These were the upriver neighbours of the Nishga'a and Gitk'san, who had been trading partners for centuries with the coastal and river-dwelling Tsimshian. Athapaskan peoples are spread over an expansive area of the Canadian north, and many of these individual First Nations differ greatly in language dialects, material culture and spiritual practices.

Relatively small in scale, these baskets are beautifully constructed and decorated with geometric patterns. To make them, the bark was peeled and prepared, then cut to a traditional pattern. The cut shape was scored with a knife, then bent, folded and stitched with black-spruce root to secure the container. The near-white outside layer of the bark is on the inside of the vessel, so the inner surface of the bark is the outer face of the basket. A thin wood splint was bent around the top edge of the basket and wrapped with a root stitch to strengthen the rim. Designs were produced by cutting or scraping away the darker surface layer of the inner bark, exposing a lighter sublayer, which creates the contrasting hues of the design.

Athapaskan bark-working styles vary greatly across the northern Canadian interior, both in the shapes and construction details of containers and in the methods used in their decoration. These baskets most likely originated within the Carrier First Nation upriver from the Gitk'san in the Skeena and Bulkley valley regions.

Baskets

c. 1860
Birch bark, spruce root
5¼" high, 4" high

Collection of the Canadian Museum of Civilization

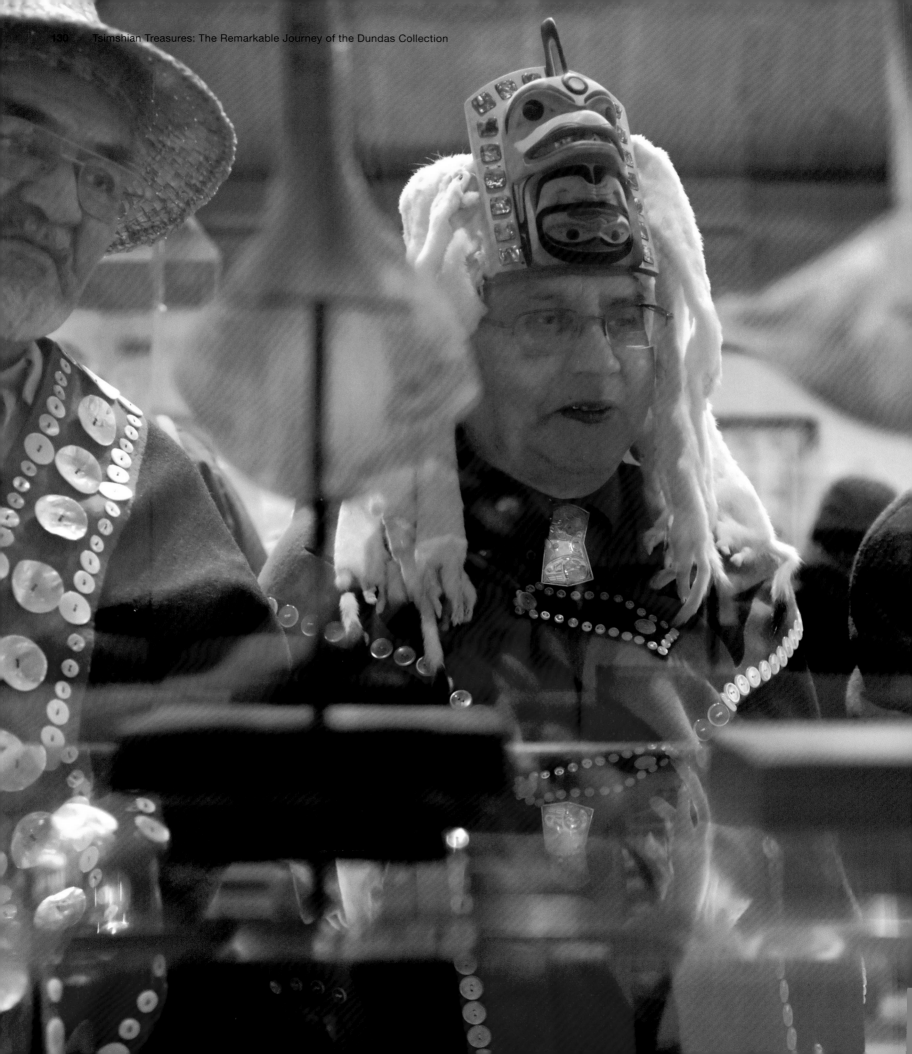

N`luumskm`Amwaal
We Respect Our Treasures
by William White

Afterword

In 1863 a Scottish missionary, named Robert James Dundas, visited Mr. William Duncan, a lay minister who had established the new Christian Tsimshian community in Metlakatla, B.C., just a few years earlier. Mr. Duncan had acquired an important collection of exquisite Tsimshian art from his followers. Like other Christian missionaries of the time, he had told our ancestors that these ceremonial objects and other items were not good for their "new" life, and that they must give them up to become "proper" Christians. They were told that they must give up their heathen ways and follow the new religious order of things. Although the Tsimshian had given up their regalia and tribal inheritances, they were, and continue to be, mystified by these so-called Christian missionaries.

In order to try and convert the Tsimshian to Christianity, Duncan had told them that his god's *halaayt* (spiritual power and ability) was much greater than the *halaayt* possessed by the great chiefs and shamans of the period. Duncan had told the high-ranking people of the time that his Christian powers were much greater than their supernatural powers. Our people were always trying to gain greater *halaayt* through fasting and prayer and by having supernatural experiences. These experiences were completely real to them. It was not a hoax or a ruse used to persuade people into believing what they had to say, or to teach them "their ways."

Nonetheless, Duncan sold the artifacts to Rev. Dundas (and Lt. Edmund Hope Verney), who took these tribal treasures to a far-off country, never to be seen by their rightful owners again.

Time wandered on and the Tsimshian started to inquire as to the whereabouts of their old possessions. About 125 years slid by, a blink of an eye in terms of our history, before the appropriated objects would resurface in the present-day "art market." They spoke with Mr. Simon Carey and attempted to negotiate the return of the collection but were unsuccessful. After all the time had passed since the carvings had been taken from their home territory, it was being made clear to the Tsimshian that they would have to buy the objects back if they really wanted them returned. The churches had nothing to say on the matter, the governments of two countries had nothing to say on the matter, and the repatriation of the Dundas Collection was at issue.

As the world took notice in 2006 of the impending auction of these remarkable artifacts, the Tsimshian were trying to have someone address their issues of cultural

appropriation that had been going on in at least the last 140 years. We had never given up on our dream of one day having these objects repatriated to us. We thought that the churches and governments would acknowledge the unjust way in which these treasures were removed from our homeland and would step forward to right the wrongs from the past. Alas, it was a dream that was not to be fulfilled.

In the background of all the intense rallying for these objects were a few great Canadians who started talking to one another about Canada's great First Nations art that had quietly slipped out of sight and country over time. These were ordinary people, although it must be said they were from families who had the necessary funds. They genuinely care about First Nations art remaining in its country of origin. They are a group of people who believe individual Canadians should take the initiative to ensure that our country's Indigenous art remains here. They decided to make a statement by purchasing the majority of the items, so they would be returned here. It is hoped these people set a precedent for future Canadians to follow.

As the Tsimshian leadership heard of the plans of these people, they began to dream again. They wanted the art to be brought back to its homeland. When the auction was over and we heard of the great success of the Canadian bidders, we were elated. Maybe these "ordinary" people had honour amongst them. Maybe these people would have ears that worked, maybe our people would at least have the chance to see their objects of great pride back in their original land once again. Through the honourable actions of these great philanthropists, a dialogue began between them, the museums and the Tsimshian leaders. The new owners stated they wanted the greater Canadian public to have a chance to see the collection. They worked with museums and art galleries to create a travelling exhibit. The hereditary chiefs of the Allied Tribes of Lax'kw'alaam (Port Simpson) heard of this and asked, with respect, that the first place the collection should be viewed be in Tsimshian territory. In time and through mutual respect, the deal was struck and the traditional people would have their ancestors' treasures back in their homeland.

The Museum of Northern British Columbia would be the first institution to exhibit the "Dundas Collection." This museum has one of the best collections of Tsimshian art in the world, and the curator, Susan Marsden, has worked extensively with the Tsimshian in the past, always making sure the ways of the traditional people and their protocols are followed. Ms. Marsden has had an ongoing relationship with the hereditary chiefs and matriarchs for many years. She continues to honour the Tsimshian within the museum by continually asking what the people would like to see happen with their artifacts.

This is often a thankless job, but one in which she has succeeded. As for the opening ceremonies surrounding the exhibit, Susan Marsden followed the required Tsimshian protocols. The Tsimshian told her they wanted the name of the exhibit to truly reflect what the objects were. In other words, "The Dundas Collection" wasn't going to satisfy them as the title for the exhibit. She worked with a team of organizers from the museum as well as a group of traditional people from the Tsimshian nation. The exhibit would be named "Nluut`iksa Lagigyedm Ts`msyeen" (Treasures of the Tsimshian), and through discussions with other partners who felt it was important, the addendum "From the Dundas Collection" was added. It took some time to talk things out, as negotiations always do. As a result of the respect that was given from all sides, an incredible exhibit of Tsimshian art now exists. The collected ceremonial objects

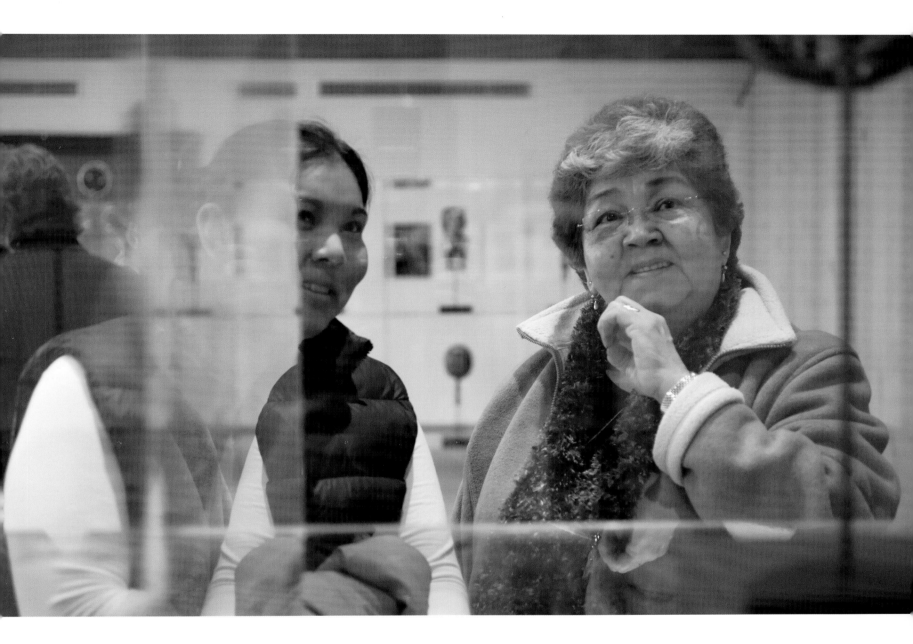

represent a slice out of time – a time in which artists created, with the tools they had, treasures now recognized as "high art."

The chiefs and matriarchs worked with Susan Marsden and her staff and protocol consultants to ensure that the opening of the exhibit would be carried out with the respect that the returning treasures deserved. It was a tremendous amount of work, but anything that is great has a way of making determination and dedication appear effortless.

The ceremony surrounding the opening would be distinctly Tsimshian. There would be a ceremony to officially welcome the dignitaries from various parts of Tsimshian territories as well as dignitaries from the rest of Canada. One of the chiefs from the territory where the pieces were being displayed performed the peace dance. He spread eagle down amongst the dignitaries to show the great respect being afforded them. This dance is considered sacred to the Tsimshian and is done only at official events. The hereditary chiefs thanked the various collectors and museum curators who had worked so hard to make the exhibit possible, gifts were exchanged, and speeches were made.

The next portion of the event would be the blessing of the artifacts. Everything that had happened before was the protocol of our people, to ensure proper respect for the art

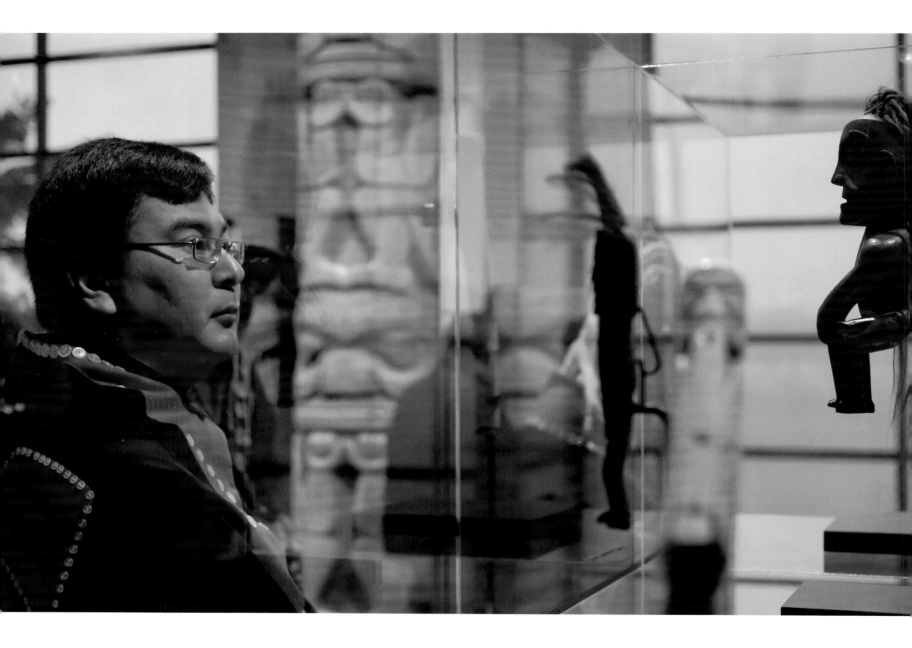

that had been missing from our lives for so many years. Four of our traditional leaders would each give their blessing to the collection, as well as welcome the objects back home. We truly believe the spirits of our ancestors are held in these objects and we could feel the warmth of their spirit coming out from behind the cases containing them. They were finally home, home to hear their original language spoken to them and to hear the drums and songs being sung in their honour. The gathered guests stood outside the gallery waiting for the elders to finish their blessings. When they were finished, the people were allowed to enter and view the exhibit for the first time. There was a respectful lull in the audience, a feeling of utter reverence for what had just happened and for what the people had just witnessed. For the first time in generations, the traditional people were seeing their ancestors' work. It was hard to read everyone's reaction as they all milled around the cases. It was like they were waiting to hear something from the objects, as if the pieces were holding court. People took time in front of each piece, examining them, looking at the fine detail work, pointing fingers at the favourite section that interested them.

A group of artists were lost in the mists of time, as their minds were trying to bend around the sheer beauty of the master works in front of them. They were somewhere

else, standing in front of their teachers, waiting to be taught some ancient secret hidden within the carved wooden objects. Some time went by as the crowd began to interact with one another, talking about the event. Then, in true Tsimshian style, the drums began to beat to announce the next portion of the night's events. There was a local dance group that was led by a man with a great respect for the traditional ways of his people. Sampson Bryant is his name and he led the rest of the celebration. He said he would be celebrating the return of the objects to their original homeland, and his dancers were in fine form that night. The group consists of young people, from 8 years old to mid-20s. The drums started and the guests made room for the dancers. As in the ceremonies from the past, they began to sing a song calling in the spirits of our ancestors. As they sang, a masked dancer entered the space wearing an ancestor mask. The mask represented what the singers were singing about. The people were awestruck by the spiritual feeling in the room as if the collected pieces were giving their approval. It set the pace for the rest of the evening. Several more songs and dances were performed by the group. Other First Nations leaders and artists requested time to celebrate with their hosts by making speeches and singing, all of which were well received by the appreciative crowd.

There has been a perspective expressed to me from many people about this collection of Tsimshian art. The majority of people who have talked to me are of Tsimshian descent, while others are either from other First Nations or are non-Natives. The overall view has been that this is a collection of monumental importance. It's very interesting to hear the opinions of these people because they all come from different backgrounds. However, they seem to share a similar view on some key issues surrounding the art. I have come to realize that positive and negative conclusions are almost universal among them. There is a general feeling of loss and of recovery. It is like a time capsule has been found and we have just opened it. What was found inside is a part of Tsimshian identity that was taken away but has found its way home after a long absence. The frustrations of many have been expressed in various statements. "Why was this stuff allowed to be sold at auction when it was simply taken from us?" "It should be given back to the Tsimshian people."

There were also expressions of gratitude to the Canadian collectors. "Thank God for those people!" "What if they never came forward? We would have never had the chance to see our ancestors' work." "I'm glad the museum in Prince Rupert and Victoria worked with the chiefs and the collectors to have the official opening in our territory." It must also be said that the level of frustration about repatriation is at an all-time peak throughout the collective Tsimshian First Nations. The shared opinion of all has been that the collection should be brought back to reside in Prince Rupert after it has travelled. I feel the same way. It is the Creator who will decide if the collectors feel the same way, too. No one can predict what the outcome of this exhibit will be. We can only hope and dream and pray.

Everyone has talked about the beauty of the art and how this is only a fraction of Tsimshian art being housed in museums around the world. All have looked at the fine formlines and the delicate movement within the pieces. "They are all master works," declared one artist who visited the exhibit.

We are a people who are proud of our artists – the ones from yesterday, today and in the future. When Tsimshian artists look at this collection, they are being taught by the old masters. It is as if the pieces are saying, "Look at the detail, think about the vision needed to create this – refine your work." Tsimshian artists have always been famous for creating

great pieces of art. They have been commissioned in the past, as well as the present, by First Nations up and down the coast to express, through their art, the crest images of many different people. I know the artists of our time will be influenced by these great works to enhance their own abilities. They will understand that the Tsimshian esthetic has been around for many generations and that it is our responsibility to share that with the rest of the world. We are a proud people, a people who continue to expect to have great art as part of our daily lives. This expectation has never left us. Even when we were being forced to assimilate into a foreign religion and culture, we still held onto the artistic views of our ancestors.

This collection has been pushed to the forefront of the world's view because of the amount of money that was spent to acquire the items. Over recent years, the rest of the world has decided to think of Tsimshian art as "high art." It is, of course, a concept not unfamiliar to us. Has the greater Euro-Canadian society decided to afford the Tsimshian with their seal of approval? Have the prices being paid for these works raised our art to a new level that was not afforded us when they were being sold and bought for a few pieces of silver by the people who appropriated the art 150 years ago? Have the prices paid for these objects changed the way the world will view our art from now on? Or has the world only now just opened their eyes to a culture they have ignored for far too long? Are the Tsimshian impressed with the monies paid for these objects? Or are we bewildered by the sudden acceptance on the world stage? We have always accepted our artists to be of exceptional talent and have afforded them the highest honour as ambassadors for our culture throughout time.

While this collection is being viewed by our people today, we continue to give the artists who created these ceremonial objects the respect they deserve. Within living memory, our people have seen examples of most of these objects. We have seen them in the homes of our grandmothers, aunts, uncles and tribal leaders. The efforts of the churches and governments to wipe these images and ideas from our collective souls have not worked. We are a people with deep respect for the earth and the spiritual forces that surround us. The art is an extension of our worldview. There isn't even a word in our language for "art"! That is how deeply rooted in our culture these objects come from. They are simply WHO WE ARE! When the collection leaves our territory again, we are hoping it will return to us to provide an assurance for future generations to see and to learn from. It is our hope that in the future, the work of current Tsimshian artists will sit side by side with these master works.

We are, after all, still a vibrant and active culture whose traditions remain the same even in transition from one generation to the next. The collection here has only increased our desire for the world to listen to us. We want to tell the truth about our history within this country and to have the proper respect given to our past, our present and our future. As the rest of the world looks at our ceremonial objects, we hope they realize that every item they see is based on our oral histories and traditions and is the Tsimshian worldview as seen through the eyes of our carvers' incredible artistic vision. These pieces are our written history, created from the trees that still grow on our land. The visions of the present-day Tsimshian still hold true to their ancestors' view of the supernatural and of the spiritual. When we hear a rattle or a clapper being used in a dance, it reminds us of these things. The masks bring us closer to the spirits of our land and our waterways. The images being carved today hold the people's collective souls within them the same way

they always have. Our crests and privileges are being passed down in the same manner in which they have always been. The Tsimshian have survived for thousands of years on these lands and we will continue to do so.

In conclusion, I will say that the missionaries who tried to force us to assimilate into the greater society have failed. We have risen above all of the afflictions poured down upon us by the churches, governments and the public by never forgetting who we are as a people. Our way of feasting and potlatching remains an integral part of who we are. We will continue to use the carvings, weavings, dances and language that were inherited from our ancestors. With the help of our elders, leaders and artists, our culture will continue to thrive. The Tsimshian believe in reincarnation and that we return time after time. While looking at this collection of art, we are being reminded of who we are and who we will become.

Li Aam Laxhuu, (William White)
Tsimshian Chilkat Weaver
Prince Rupert, April 2007

Notes

1 The spelling for *Metlakatla* is "modern" English style, as used in the *Gazetteer of Canada: British Columbia* (1953). The language spoken by the Tsimshian people is Sm'algyax, and the spellings used herein are those found in the *Sm'algyax Living Legacy Talking Dictionary* <http://smalgyax.unbc.ca/>. Original spellings are maintained when quoting sources.

2 The Tsimshian comprise the nine tribes whose traditional territory includes the watershed of the Lower Skeena River and the offshore islands north and south of the river's mouth. The people to the south of the Skeena are known as the Southern Tsimshian. The people just below and above Kitselas Canyon on the Skeena are called the Canyon Tsimshian.

3 This individual was the holder of the name-title Ligeex. He died in 1869. The name has been spelled many different ways, including Legiac, Legaix and Legeex. The spelling followed is the one used in the 1992 series of books from the Prince Rupert School District.

4 See Gunther, 1972; Brown, 2000.

5 Carpenter, 1975:14; Cole, 1985:2; Cruikshank, 2005:145; Dzeniskevich & Pavlinskaia, 1988:83; King, 1999:9; Mallory, 2000:xvi.

6 Feest, 2002:37; Collado, 2000:15–16.

7 Kendrick & Inglis, 1991:17; Holm, 1989:105–106, quoted in Brown, 1998:13.

8 King, 1997:157.

9 Dzeniskevich & Pavlinskaia, 1988:83–85.

10 Anonymous, 1990: 9; Vaughan, 1982:27

11 Cruikshank, 2005:139, 145.

12 Malloy, 2000:40, 44; Grimes, 2002:17, 20; Holm, 1982.

13 Work & Finlayson, n.d.; quoted in Campbell, 1992:43.

14 Tolmie, 1963:327–328.

15 Kaeppler, 1985:140–146; Wright, 1977:48.

16 Peake, 1959:28; Bagshaw, 1996:24, 105; Pritchard, 2000:29.

17 See Downs, 1980:53–55; Smith, 1974:7.

18 Howay 1916: 629.

19 *Daily Colonist*, March 17, 1863, p. 3; April 14, 1863, p. 3; Pritchard, 2000:29.

20 Keddie, 2003:45–46. The term *ranch* comes from the Spanish word *rancho* for the barrios of the Native peoples adjacent to the newly established missions of Mexico and California, referred to as *rancherías*.

21 Bagshaw, 1996:58.

22 *Ibid*. 96–97; see Miller, 1997:170, note 11.

23 Bagshaw, 117. See also Howay, 1916:620.

24 Hills, vol. 4, 1862:9.

25 Smith, 1974:18; quoted in Carey, n.d.:6. Perhaps, Dundas had collected the two argillite pieces that were part of the collection before 1861 (see Roche, 2006:90–91).

26 Hills, n.d.; March 29, 1863.

27 Dundas, n.d.:14; Simon Carey (n.d.:6). This interaction may have taken place at Bella Bella.

28 Duncan, n.d.:10446; Dundas, n.d.:16.

29 Simon Carey (n.d.:7) quotes Sophie Cracroft (see Smith, 1974:7-8) as to his ancestor's perilous financial situation. Benjamin Carey (personal communication, 2007) noted that Dundas did not write his sisters about the cost of the collection, as was his habit; negative evidence that he did not pay for it.

30 Peake, 1959:28; Carey, n.d.:7.

31 Black, 1997:45.

32 Information kindly provided by Benjamin Carey (personal communication, 2007).

33 Carey, n.d.:2.

34 *Ibid*. 8.

35 Pritchard, 1996:10–12. See *Ibid*. 51 for discussion of a scandal that affected Verney's later career.

36 *Ibid*. 47, 50.

37 See Pritchard's comments, pages 41–42, on Verney's attitudes concerning conflict between Indians and European colonizers.

38 Gough, 1984:85–94.

39 Dundas, n.d.:3.

40 Pritchard, 1996:269; 58, n71; King, 1999:9 notes that "curiosity" did not have a pejorative connotation, but at the time meant "worthy of scientific interest."

41 Brown, 2000:170–171.

42 Ostapkowicz, 2005:73; Mowat, 1993:77; Pritchard, 1996:58, n74.

43 *Ibid*. 226.

44 The two spoons are illustrated as lot 28 in Roche 2006:58. The two staffs are RBCM #16959 and an artifact in the André Nasser Collection (Brown, 2000:171, #135). There is apparently a third Heiltsuk-style staff collected by Verney in the British Museum (Martha Black, personal communication, 2007). The staff in the RBCM was purchased at a Christie's auction in London in 1979. The RBCM did not realize who "E.H.V." was until after the publication of Pritchard's book in 2000. Verney had sent an earlier collection to England in February of 1863, before the Metlakatla trip (Pritchard, 1996:122–123, 197–198). The 1863 list includes a "bundle of walking sticks" and a "model of a Cape Flattery canoe." Is the latter a second artifact collected by Verney that is in the Dundas Collection (see lot 42)? Pritchard, 1996:236.

45 Benjamin Carey, personal communication 2007.

46 Thanks to Bill Holm for drawing attention to the two frontlets in the Verney Collection. They can be seen in the photograph of the Museum at Claydon House, Verney's home (Pritchard, 1996:facing 121); Burke Videodisk; Benjamin Carey, personal communication, 2007.

47 Usher, 1974:8.

48 *Ibid*. 27

49 Barnett, 1941:170–171; Galois, 1998:136–137. On two days in July, Duncan vaccinated approximately 50 people, mostly children (Duncan, n.d.:10239, 10240).

50 MacDonald & Cove, 1987: Narrative 62, page 233; Barnett, 1942:22, 30; Beynon, 1941:83. Tsimshian society was divided into four classes: royalty, nobility, commoners and slaves. According to Miller, almost everyone belonged to the nobility, very few people were commoners without family prerogatives, and no more then five percent of the population was enslaved (Miller, 1997:17, 46–47).

51 Alexander Begg (1906:5) records that "some 300 souls, forming nearly the whole of the tribe of Keetlahn, with two of their chiefs," arrived in Metlakatla on June 6, 1862. According to Barnett (1941:166), this move was also motivated by politics.

52 Welcome, 1887:51.

53 Hills, 1864:28; Garfield, 1966: 9.

54 Barnett, 1941:168.

55 Duncan, n.d.:10309.

56 Barnett, 1942; see Marsden & Galois (1995) for a discussion of the older Ligeex's trade monopoly.

57 Miller, 1997:139. This position appears to be at odds with Clah's attempt at persuading Ligeex to attend an event in Fort Simpson.

58 Barnett, 1941:165.

59 Neylan, 2003:65, 71. There were many individuals who converted to Christianity but refused to give up their participation in Tsimshian ceremonial life and did not move to Metlakatla (Beynon, 1941:86, Barnett, 1941:168).

60 Duncan, n.d.:10291.

61 A lineage is group of relations who trace their connectedness through one side of their family, in this case, through the mother's side, hence matrilineage. See Marsden & Galois (1995:180, n5) for a summary of Tsimshian political institutions.

62 The Barbeau-Beynon Tsimshian Files (Duff, 1964; Cove, 1985) are kept at the Canadian Museum of Civilization. The crest lists are found in Halpin, 1973:Appendix II.

63 Halpin, 1984b; see also Halpin & Seguin, 1990:275. Lots 7 & 8 in the Sotheby's catalogue illustrate an eagle and a beaver. Both were probably made specifically for sale and are not included in this discussion.

64 Duncan, n.d.:10421; see also Pritchard, 1996:169.

65 Dundas, n.d.:5. Whereas Duncan seems to spell the name of the schooner as "Caroline," Verney writes it as "Carolena" (Pritchard, 1996:169), and Walbran (1971:82) records the name as "Carolina." Duncan bought the ship for $1,500 from an American, James Jones, on June 26, 1863 (Duncan, n.d.:10420–10421).

66 Emmons, 1991:242; Halpin, 1973:331; Guédon, 1984b:211; 1984a:158–159.

67 Halpin, 1973:336.

68 William Beynon (1888–1958) was a linguist and field ethnographer who gathered traditional narratives and other data between 1915 and 1956. He worked principally for and with the Canadian folklorist and anthropologist Marius Barbeau (Halpin, 1978). He was a member of the Gitlaan tribe.

69 Hills, 1864:30. See Barnett (1941) re the events that led to his injuries.

70 Steve Brown (personal communication, 2007) notes that the headdress may represent a wolf as it has a tail. This suggests that the small whale is actually part of a Laxgibuu crest object.

71 Halpin, 1984b:28.

72 Halpin, 1973:363.

73 Halpin, 1984b:29, Table 4. This crest is not in the Barbeau-Beynon crest list (Halpin, 1973: Appendix II).

74 MacDonald & Cove, 1987: Narrative 86.

75 Burch, 1988:229, 234; Cove, 1976:145, #319; MacDonald, 1983:111-112.

76 Welcome, 1887:20.

77 Duncan, n.d.:10342.

78 Duncan, n.d.:10292.

79 Duncan, n.d.:10342.

80 See Cove & MacDonald, 1987: Narrative 31.

81 Garfield, 1939:295, 304; Drucker, 1950:167, n851a; Neylan, 2003:98; MacDonald & Cove, 1987: Narrative 57 & 58.

82 Halpin, 1984a:284, 289–304. See Halpin (1973:131) for a list of *naxnox* names.

83 Garfield, 1939:202.

84 Duncan, n.d.:10342.

85 Hills, 1864:31.

86 RBCM artifact #16347.

87 Halpin, 1984a:282–283; Guédon, 1984:211. There is a Tsimshian-style puppet collected by Verney in the Cambridge University Museum of Archaeology and Anthropology (catalogue #Z 14856).

88 Dundas, n.d.:24; Benjamin Carey, personal communication, 2007.

89 Duncan, n.d.:10279-10280.

90 *Ibid*. October 28, 1862, page 10280.

91 Duncan, n.d.:10342. There were two sets of gambling sticks in the Dundas auction (lot 26).

92 There was a raven rattle in the Dundas auction (lot 12). Halpin (1984a:286) does not reference her source for this statement. Beynon recorded a *naxnox* in which the performer was clearly imitating a healing shaman (see Anderson & Halpin, 2000:28).

93 Dundas, n.d.:6.

94 Halpin, 1984a:286; Guédon, 1986a:153. The *halaayt* in all its complexity is described and discussed in Halpin, 1973:117–137; 1986a:282–286; Guédon, 1984a; 1984b.

95 Welcome, 1887; Arctander, 1909; Glaois, 1998:137.

96 MacDonald, 1990:203; quoting Crosby, 1914:66.

97 Cole, 1985:22–23, 30; McLennan & Duffek, 2000:73; Halpin & Seguin, 1990:273, figure 6; Todd, 1995.

98 Hare & Barman, 2006:248.

99 *Ibid*. 86.

100 MacDonald, 1990:209.

101 Cole, 1985:243.

102 UBCMOA, 1975.

103 Black, 1997:8.

104 Cole, 1985:74–76, 91–95.

105 Feest, 2002:34–35; King, 1999:174. It is likely that some of the Dundas artifacts were also exhibited at Manchester. Benjamin Carey (personal communication, 2007) suggested that the missing "soul catcher" was part of that exhibition and the paper labels on artifacts suggest that a number of objects were loaned.

106 Cole, 1985:186.

107 Peake, 1959:93; Mowat, 1993:80, 87.

108 In addition to Crosby, Rev. P. Charles at Clayoquot collected for C. F. Newcombe, and Rev. W. E. Collison for G. T. Emmons (Cole, 1985:86, 243).

109 Feest, 2000:36.

References

Alaska: Russian America. Helsinki: The National Board of Antiquities, 1990.

Anderson, Margaret, and Halpin, Marjorie
"Potlatch at Gitsegukla." Introduction to William Beynon's 1945 Field Notebooks. By Willliam Beynon. Vancouver: UBC Press, 2000.

Bagshaw, Roberta L., ed.
No Better Land: The 1860 Diaries of the Anglican Colonial Bishop George Hills. Victoria: Sono Nis Press, 1996.

Barnett, H. G.
Personal Conflict and Cultural Change. *Social Forces*, vol. 20, no. 2, pp. 160–171. 1941.

Applied Anthropology in 1860. *Applied Anthropology* 1 (3):19–32. 1942.

Begg, Alexander
A Sketch of the Successful Missionary Work of William Duncan Amongst the Indian Tribes in Northern BC, 1888–1891. Victoria: [19??].

Beynon, William
Tsimshians of Metlakatla, Alaska. *American Anthropologist* 43 (1):83–88. 1941.

Black, Martha
Bella Bella: A Season of Heiltsuk Art. Toronto: Royal Ontario Museum, 1997.

Blomkvist, E. E.
A Russian Scientific Expedition to California & Alaska, 1839–1849: The Drawings of I. G. Voznesenskii. Translated by Basil Dmytryshyn and E.A.P. Crownhart-Vaughan. *Oregon Historical Quarterly* 73(2): 101–170. 1972.

Brown, Steven C.
Native Visions: Evolution in Northwest Coast Art from the Eighteenth through the Twentieth Century. University of Washington Press, Seattle and London, 1998.

The Spirit Within: Northwest Coast Native Art from the John H. Hauberg Collection. Seattle Art Museum/Rizzoli, 1995.

Brown, Steven C., ed.
Spirits of the Water: Native Art Collected on Expeditions to Alaska and British Columbia, 1774–1910. Seattle: University of Washington Press. Vancouver: Douglas & McIntyre. 2000.

Burch, Ernest S., Jr.
Edited by Aron Crowell and William H. Fitzhugh. "War and Trade." *Crossroads of Continents: Cultures of Siberia and Alaska*, pp. 227–240. Washington, D.C.: Smithsonian Institution, 1988.

Campbell, Ken
"Fort Simpson, Fur Fort at Laxłgu'alaams." Fourth in the Series, Suwilaayamsga Na Ga'niiyatgm, Teaching of Our Grandfathers. Copyright © *The Tsimshian Chiefs*. Prince Rupert: School District #52, 1992.

Carey, Simon H. D., ed.
N.d. Extract from Robert James Dundas Journal 1863. MS Word Document (43 pages). Copyright © Estate of Simon H. D. Carey.

"The Dundas Collection: Responsibilities of a Private Curator." N.d. Paper presented at British Museum conference, Boundaries in the Art of Northwest Coast of America, May 2000.

Coe, Ralph T.
Sacred Circles: Two Thousand Years of North American Indian Art. London: Arts Council of Great Britain, 1976.

Cole, Douglas
Captured Heritage: The Scramble for Northwest Coast Artifacts. Seattle: University of Washington Press, 1985.

Collado, Leoncio Carretero
Edited by Steven C. Brown. "Mámałni Politics, Trade, and Collectionism on the Northwest Coast during the Eighteenth and Nineteenth Centuries." *Spirits of the Water: Native Art Collected on Expeditions to Alaska and British Columbia, 1774–1910*, pp. 11–17. Seattle: University of Washington Press. Vancouver: Douglas & McIntyre. 2000.

Cove, John J.
"A Detailed Inventory of the Barbeau Northwest Coast Files." Ottawa: National Museums of Canada, 1985.

Cove, John J., and MacDonald, George
Tricksters, Shamans and Heroes: Tsimshian Narratives 1. Collected by Marius Barbeau and William Beynon. Mercury Series, Directorate Paper No. 3. Ottawa: Canadian Museum of Civilization, 1987.

Cruikshank, Julie
Do Glaciers Listen? Local Knowledge, Colonial Encounters, & Social Imagination. Vancouver: UBC Press. Seattle: University of Washington Press. 2005.

"Cultural Exchange Across the Gulf of Alaska: Eighteenth Century Tlingit and Pacific Eskimo Art in Spain." *Culturas de la Costa Noroeste de América.* Madrid: Museo de América, 1989.

Downs, Barry
Sacred Places: British Columbia's Early Churches. Vancouver: Douglas & McIntyre, 1980.

Drucker, Philip
"Culture Element Distributions: XXVI Northwest Coast." *Anthropological Records* 9:3, pp. 153–294. Berkeley: University of California Press, 1950.

Duff, Wilson
"Contributions of Marius Barbeau to West Coast Ethnology." Anthropologica n.s. 6(1):63–96. Ottawa, 1964.

Dundas, Robert James
N.d. Edited by Simon Carey. Extract from Journal 1863. Copyright © Estate of Simon H. D. Carey.

"Indian Converts of Metlakatla, April 1863." Fifth Annual Report of the Columbia Mission for the year 1863. London: Rivington, 1984.

Duncan, William
Journals 4–9, 1859–1869. Victoria: BC Archives, Royal BC Museum, n.d.

Dzenishevich, G. I., and Pavllinskaia, L. P.
Edited by Aron Crowell and William H. Fitzhugh. "Treasures by the Neva: The Russian Collections." *Crossroads of Continents: Cultures of Siberia and Alaska*, pp. 83–88. Washington, D.C.: Smithsonian Institution, 1988.

Eastman, Carol M., and Miller, Jay, eds.
"The Structure of Tsimshian Totemism." *The Tsimshian and Their Neighbours of the North Pacific Coast*, pp. 16–35. Seattle: University of Washington Press, 1984b.

Emmons, George Thornton
Edited with additions by Frederica de Laguna. *The Tlingit Indians.* Vancouver: Douglas & McIntyre. New York: American Museum of Natural History. 1991.

Feest, Christian F.
"Collectors, Collections, and Collectibles: Early Native American Collections in Europe and North America." *Uncommon Legacies: Native American Art from the Peabody Essex Museum*, pp. 29–45. By Mary Lou Curran, Christian F. Feest and John R. Grimes. New York: American Federation of Arts. Seattle: University of Washington Press. 2002.

Galois, R. M.
"Colonial Encounters: The Worlds of Arthur Willington Clah, 1885–1881." *BC Studies*, nos. 115–116, pp. 105–147. 1998.

Garfield, Viola E.
"Tsimshian Clan and Society." *University of Washington Publications in Anthropology* 7 (3):167–340. Seattle: University of Washington, 1939.

"The Tsimshian and Their Neighbours." *The Tsimshian Indians and Their Arts*, pp. 3–70. By Viola E. Garfield and Paul S. Wingert. Seattle: University of Seattle Press, 1966.

Gazetteer of Canada: British Columbia. Canadian Board on Geographic Names. Ottawa: Queen's Printer, 1953.

Gough, Barry M.
Gunboat Frontier: British Maritime Authority and Northwest Coast Indians, 1846–1890. Vancouver: University of British Columbia Press, 1984.

Grimes, John R.
"Introduction: Curiosity, Cabinets, and Knowledge –
A Perspective on the Native American Collection of
the Peabody Essex Museum." *Uncommon Legacies:
Native American Art from the Peabody Essex Museum*,
pp. 17–27. By Mary Lou Curran, Christian F. Feest and
John R. Grimes. New York: American Federation of Arts.
Seattle: University of Washington Press, 2002.

Guédon, Marie-Françoise
Edited by Margaret Seguin. "An Introduction to
Tsimshian Worldview and Its Practitioners." *The
Tsimshian: Images of the Past: Views for the Present*,
pp. 137–159. Vancouver: University of British Columbia
Press, 1984a.

Halpin, Marjorie
Edited by Margot Liberty. "William Beynon, Ethnographer,
1888–1958." *American Indian Intellectuals*, pp. 141–156.
Proceedings of the American Ethnological Society.
St. Paul, Minneapolis: West Publishing, 1976.

Halpin, Marjorie M., and Seguin, Margaret
"Tsimshian Peoples: Southern Tsimshian, Coast
Tsimshian, Nishga, and Gitksan." Northwest Coast,
volume 7, *Handbook of North American Indians*,
pp. 267–284. Edited by Wayne Suttles.
Washington, D.C.: Smithsonian Institution, 1990.

Hare, Jan, and Harman, Jean
*Good Intentions Gone Awry: Emma Crosby and the
Methodist Mission on the Northwest Coast*. The Journals
of George Hills, Bishop of Columbia, n.d. Vancouver:
Rare Books & Special Collections, UBC Library, 2006.

Hills, George
"Indian Converts of Metlakatla, April 1863." *Fifth Annual
Report of the Columbia Mission*.
London: Rivington's, 1864.

Holm, Bill
Northwest Coast Indian Art: An Analysis of Form.
Burke Museum Monograph No. 1.
Seattle: University of Washington Press, 1965.

"Soft Gold: Objects of Unique Artistry, Northwest Coast
Artifacts from the Peabody Museum, Harvard University."
*Soft Gold: The Fur Trade & Cultural Exchange on
the Northwest Coast of America*, pp. 32–167.
By Bill Holm and Thomas Vaughan.
Portland: Oregon Historical Society, 1982.

Holm, Bill, and Reid, Bill
*Form and Freedom: A Dialogue on Craftsmanship and
Esthetics*. Houston: Rice University, 1975.

Inglis, Robin, and Kendrick, John
*Enlightened Voyages: Malaspina and Galiano on
the Northwest Coast, 1791–1792*.
Vancouver: Vancouver Maritime Museum Society, 1991.

Kaeppler, Adrienne L.
Edited by Carolyn Margolis and Herman J. Viola.
"Anthropology and the U.S. Exploring Expedition."
*Magnificent Voyagers: The U.S Exploring Expedition,
1838–1842*, pp. 119–148.
Washington, D.C.: Smithsonian Institution Press, 1985.

Keddie, Grant
*Songhees Pictorial: A History of the Songhees People
as Seen by Outsiders, 1790–1912*.
Victoria: Royal BC Museum, 2003.

King, J.C.H.
Edited by James Barnett, Stephen Haycox and Caedmon
Liburd. "Vancouver: Cautious Collector." *Enlightenment
and Exploration in the North Pacific, 1741–1805*,
pp. 149–160. Cook Inlet Historical Society,
Anchorage Museum of History and Art.
Seattle: University of Washington Press, 1997.

MacDonald, George
Edited by Roy L. Carlson. "Prehistoric Art of the Northern
Northwest Coast." *Indian Art Traditions of the Northwest
Coast*, pp. 99–120. Burnaby, B.C.: Archaeology Press,
Simon Fraser University, n.d.

MacDonald, George, and Cove, John J., eds.
Trade and Warfare: Tsimshian Narratives 2.
Collected by Marius Barbeau and William Beynon.
Mercury Series, Directorate Paper No. 3.
Ottawa: Canadian Museum of Civilization, 1987.

MacDonald, Joanne
"From Ceremonial Object to Curio: Object Transformation
at Port Simpson and Metlakatla, B.C. in the Nineteenth
Century." *Canadian Journal of Native Studies*, 1990:
vol. 10, no. 2, pp. 193–218.

Marsden, Susan, and Galois, Robert
"The Tsimshian, the Hudson's Bay Company, and the
Geopolitics of the Northwest Coast Fur Trade,
1787–1840." *The Canadian Geographer* 39, no. 2,
pp. 169–183. 1995.

McLennan, Bill, and Duffek, Karen
*The Transforming Image: Painted Arts of Northwest
Coast First Nations*. Vancouver: UBC Press, 2000.

Miller, Jay
Tsimshian Culture: A Light Through the Ages.
Lincoln: University of Nebraska Press, 1997.

Mowat, Linda
Catalogue of the Native American Collections.
Oxford: Pitt Rivers Museum, University of Oxford, 1993.

*Northwest Coast Indian Artifacts from the H. R.
MacMillan Collections in the Museum of Anthropology*.
Museum of Anthropology at the University of British
Columbia. Vancouver: University of British Columbia
Press, 1975.

Neylan, Susan
*The Heavens Are Changing: Nineteenth-Century
Protestant Missions and Tsimshian Christianity*.
Montreal and Kingston: McGill-Queen's University
Press, 2003.

Ostapkowicz, Joanna
"A Port to the World: Native North American Collections
at the Liverpool Museum." *American Indian Art Magazine*,
vol. 30, no. 2, pp. 66–75, 96. 2005.

Peake, Frank A.
The Anglican Church in British Columbia.
Vancouver: Mitchell Press, 1959.

Pritchard, Allan, ed.
*Vancouver Island Letters of Edmund Hope Verney,
1862–1865*. Vancouver: UBC Press, 1996.

Roche, David M.
"The Dundas Collection of Northwest Coast Indian Art."
New York: Sotheby's, 2006.

Seguin, Margaret, ed.
" 'Seeing' in Stone: Tsimshian Masking and the
Twin Stone Masks." *The Tsimshian: Images of the
Past: Views for the Present*, pp. 281–307.
Vancouver: University of British Columbia Press, 1984a.

"Tsimshian Shamanic Images." *The Tsimshian: Images
of the Past: Views for the Present*, pp. 174–211.
Vancouver: University of British Columbia Press, 1984b.

Smith, Dorothy Blakey, ed.
Memoir 9. "Lady Franklin Visits the Northwest:
Being Extracts from the Letters of Miss Sophia Cracroft,
Sir John Franklin's Niece."
Victoria: Provincial Archives of British Columbia, 1974.

Smith, Dwight L.
*A Tour of Duty in the Pacific Northwest:
E. A. Porcher and H.M.S. Sparrowhawk, 1865–1868*.
Fairbanks: University of Alaska Press, 2000.

Stock, Eugene
*Metlakahtla and the North Pacific Mission of the
Church Missionary Society*.
London: Church Missionary House, 1889.

Todd, Douglas
"Coastal Missionary Cashed in on Indian Culture."
Vancouver Sun, October 23, 1995, section A1.

Tolmie, Wiliam Fraser
*The Journals of William Fraser Tolmie: Physician and
Fur Trader*. Vancouver: Mitchell Press Limited, 1963.

Vaughan, Thomas
Introduction to *In Soft Gold: The Fur Trade & Cultural
Exchange on the Northwest Coast of America*,
pp. 1–30. By Bill Holm and Thomas Vaughan.
Portland: Oregon Historical Society, 1982.

Walbran, Captain John T.
British Columbia Coast Names.
Vancouver: J. J. Douglas Ltd., 1971.

Welcome, Henry S.
The Story of Metlakahtla. London: Saxon & Co., 1887.

Williams, Glyndwr
Edited by James Barnett, Stephen Haycox and
Caedmon Liburd. "George Vancouver, the Admiralty,
and Exploration in the Late Eighteenth Century."
*Enlightenment and Exploration in the North Pacific
1741–1805*, pp. 38–48. Cook Inlet Historical Society,
Anchorage Museum of History and Art.
Seattle: University of Washington Press, 1997.

Work, John, and Finlayson, Roderick
Fort Simpson Journal, May 12, 1842 – June 22, 1843.
Victoria: British Columbia Archives, Royal BC Museum
Corporation, n.d.

Wright, Robin
"Haida Argillite Pipes" (unpublished M.A. thesis).
Seattle: University of Washington, 1977.

Acknowledgments

Design
Barb Woolley, Hambly & Woolley Inc.

Contributing Editor
Dali Castro

Production Manager
Sonja Kloss

Pre-press
Somerset Graphics Co. Ltd., Mississauga, Ontario

Printing
Freisens, Altona, Manitoba

Photography
Objects: Frank Tancredi Photography, Toronto, Ontario

Journals: The Estate of Simon Carey

Pages 4, 6, 10, 12, 15, 20–39, 65, 130–137, 144:
Shannon Mendes Photography, Vancouver,
British Columbia

Pages 44, 49: Robert Reford collection (#2007-16),
Archives, UBC Museum of Anthropology

Pages 52, 53, 62, 64: courtesy of the U.S. National
Archives and Records Administration

Pages 42, 43, 46, 47, 50, 51, 55, 57, 59, 60, 63:
courtesy of British Columbia Archives (image call numbers
PDP00094, B-03573, G-01054, B-03574, I-51693,
G-06346, A-01067, A-00715, B-03552, D-05346,
G-07293)

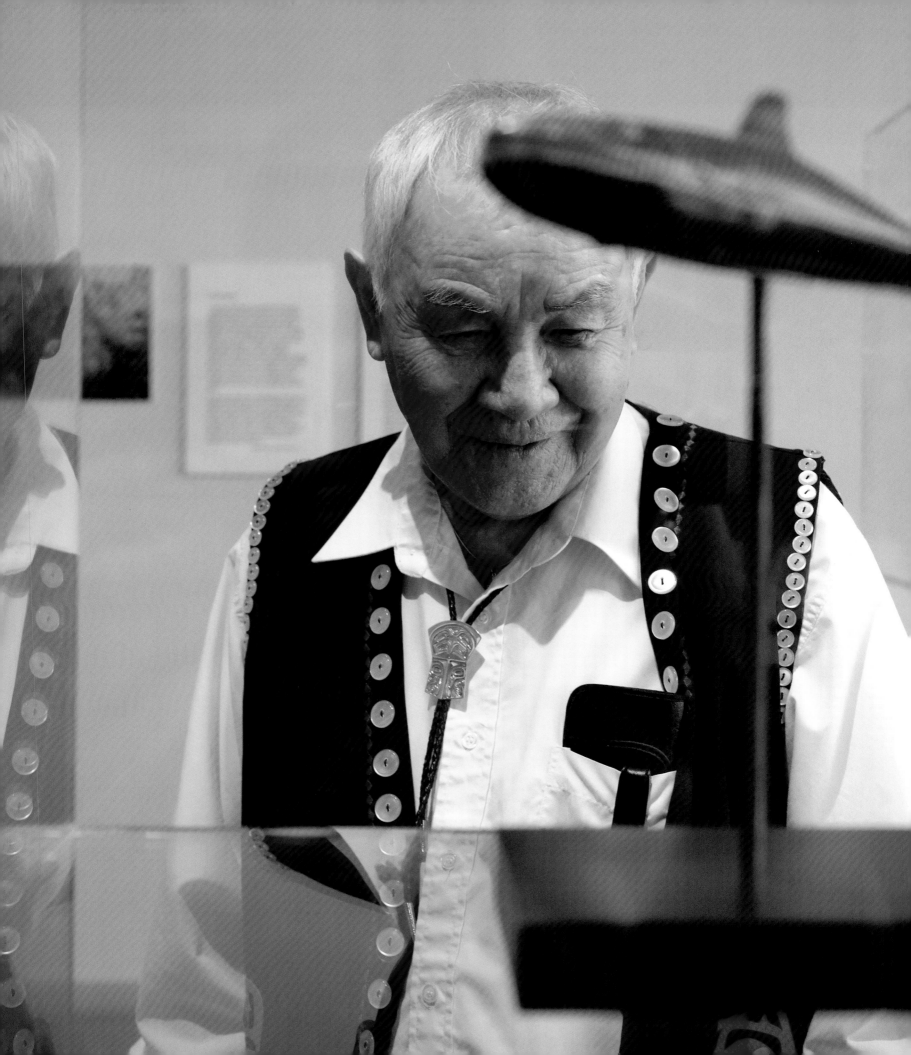